SPERM WHALES

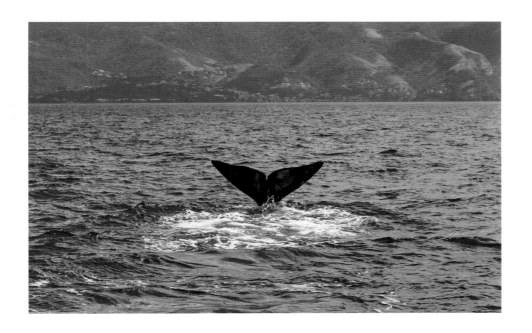

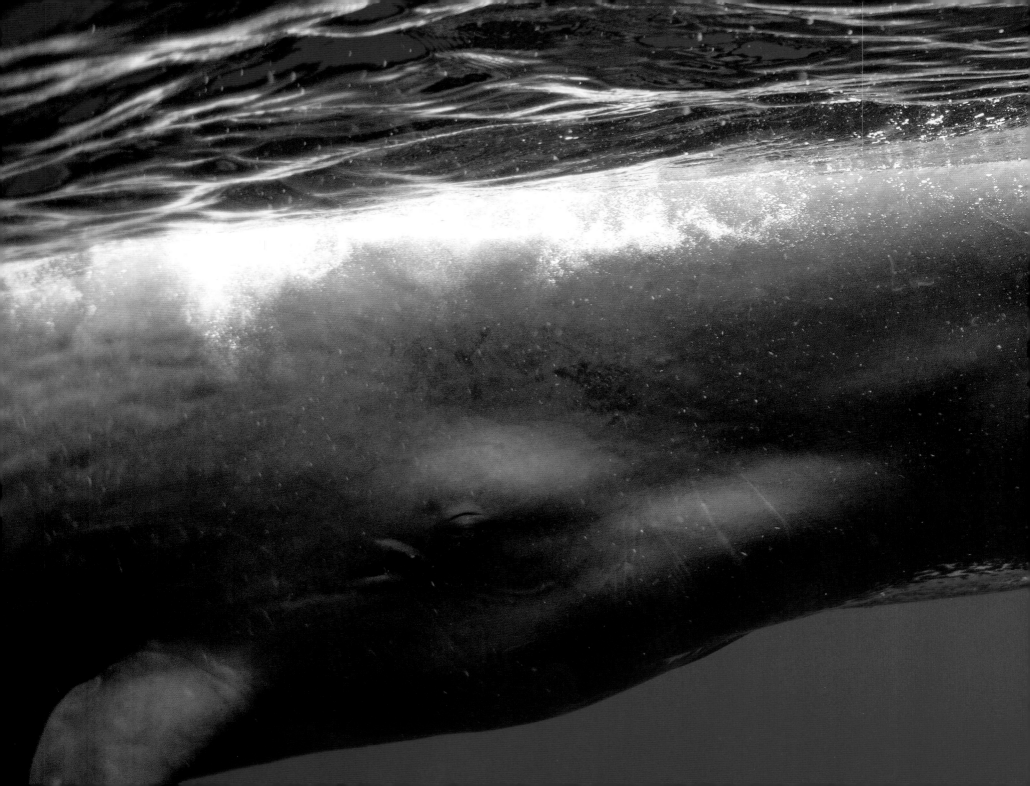

SPERM WHALES

The Gentle Goliaths of the Oceans

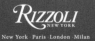

RIZZOLI
NEW YORK

New York · Paris · London · Milan

Foreword by **CARL SAFINA**

GAELIN ROSENWAKS

CONTENTS

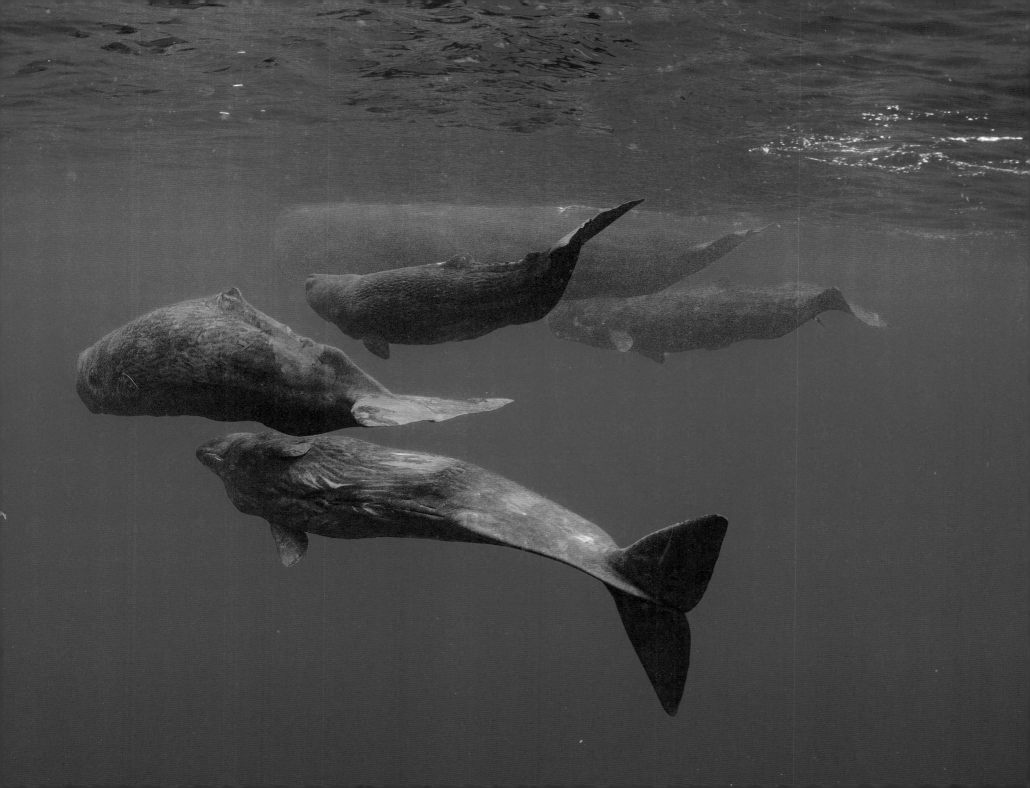

FOREWORD

by Carl Safina

Herein we seek to encounter a classic sea monster, the sperm whale: Jonah-slurping Leviathan of the Bible, catastrophic smasher of the ship *Essex*, Ahab-maddening table-turning star quarry of *Moby-Dick*, the world's largest creature with teeth. In myth, real life, and fiction, this is the whale that looms largest in our psyches. That almost-never-glimpsed being, so frequently framed as the perpetrator of our own rage, we now seek to meet at closest range.

But that's easier said than done. Across millions of square miles of ocean, deep undersea for five-sixths of any hour, they could be anywhere. Sperm whales inhabit a wider and thicker swath of Earth than any other creature except humans, ranging in the ocean from latitude 60 degrees north to 60 degrees south, from the surface to black, frigid, crushing depths. There they transit the realms of frigate birds and flying fish, dolphins and dorado, shearwaters and marlin. Humans seldom glimpse them. People who regularly seek them work mainly in a few places—such as the Galápagos Islands in the Pacific, the Azores in the Atlantic, and Dominica in the Caribbean—where steep volcanic islands plunge directly into waters thousands of feet deep.

Down in those depths, squid often hide where no light sees them. To get at the squid in their dark redoubts, evolution has equipped one creature—the sperm whale—with Earth's most extreme biological sonar. The sperm whale's head is perhaps the weirdest sonic generator in the living world, weighing as much as 20,000 pounds and taking up a third of the whale's body length (it can span 20 feet nostril to eye). The sperm whale is the whale of literature and of bathtub toys, so its strange head is oddly familiar. Ask a child to draw a whale; you'll usually recognize that head.

When hunting in frigid depths where there is no light, the sperm whale's head generates the loudest sound in the living world—sonar that goes *click, click, click*—loud enough to vibrate miles of seawater. Dolphins also use sonar to hunt, but they communicate with squeals and whistles. Sperm whales generate only clicks, which they use for both sonar and communication. They communicate with rhythmically patterned clicks called *codas* that are like simple Morse code. Using patterns of three to 40 clicks, they announce themselves as individuals, determine the identity of other whales, and decide whether they've encountered a group that they can socialize with or must avoid. No one fully understands what information is coded into those patterns. Except, of course, all the whales. When they are done hunting and are traveling several thousand feet back to the surface for air, their sonar clicks stop and they begin exchanging codas with other whales, usually family members. There is a back-and-forth, call-and-response. "I am here," one says. "And I am over here," says the other. A conversation of sorts.

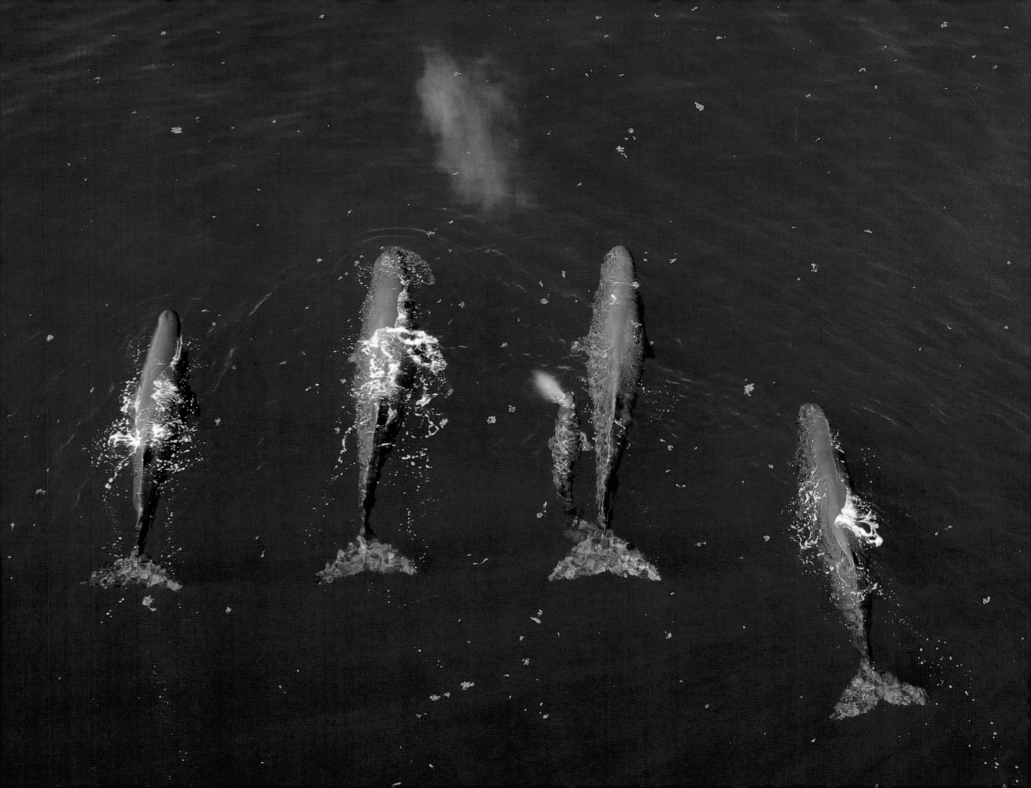

Sperm whales understand themselves as individuals within families. Groups of families that socialize are called *clans*. All members of a clan may socialize with one another, but not with members of a different clan. A clan might have dozens of members; some have thousands.

For sperm whales, it takes a village to raise a child. A baby sperm whale has a lot to learn. Deep-diving skills develop over time; the youngest cannot follow while their mother disappears to forage. The need for reliable babysitters at the surface seems the main reason sperm whales live in stable groups. Young whales learn routes and routines by accompanying their mother and aunts. No other large whales—humpback, blue, fin, gray—live in groups wherein the same individuals stay together for decades. Sperm whales generally live in the orbit of mothers, in a community of related whales, structured for care of young ones. It has been called *mother culture* by the pioneering whale biologists Hal Whitehead and Luke Rendell. It could perhaps better be called *babysitting culture*.

For centuries the only thing humans cared to understand about whales was how to kill them. Like all the great whales, sperm whales were hunted to near extinction. Almost too late we acquired a modicum of respect. The worst was not in the *Moby-Dick* 1800s but in the 1960s. Between 1964 and 1974, various countries reported killing a total of 267,194 sperm whales.

Now most whales are slowly recovering. That's good for whales and it's also good because whales help keep the ocean alive. To leave whales alone is to help ensure that the ocean will produce more fish and squid and seabirds. Sperm whales dive so deeply for food that they are made of matter that had been long lost to surface waters. Often they poop immediately before diving, delivering to the surface their deeply acquired iron and other nutrients, returning them to sunlit waters, where they can nourish and grow the drifting cells of plankton that require nutrients and sunlight and that soak up carbon dioxide to create the green pastures of the sea. All the flying fish, all the fish that chase them, all the birds that eat them, receive into their bodies some of the molecular matter raised from the deep eternal night by the superpowers of Leviathan.

Studying the whales off Dominica, Dr. Shane Gero—founder of the Dominica Sperm Whale Project—has discovered that they have individual personalities and families have their own quirks. The J family is prone to communal baby nursing. In Unit T, a female who has never given birth helps nurse her nieces and nephews. The Group of Seven likes to travel with a family called The Utensils. Families who like to hang out with each other are called *bond groups*. It's a designation borrowed from elephant researchers, and in fact the social structure of sperm whales more closely resembles elephants than that of other whales. Both societies are characterized by tight, stable families of females and dependent young; both possess the largest brains in their medium; even their ivory-bearing teeth are similar. To spend time with sperm whales is to slowly realize that you're no longer seeing just whales. You're seeing a family. Large in comparison to us, but dwarfed by the greater unknowns of their present and their future.

We are about to get a beautiful glimpse. The whales take their inspirations in a few minutes out of every hour. In those fleeting minutes we may share the sea air, possibly even look each other in the eye. And then, as always, they'll burrow deep, leaving us behind in the glittering sea.

A family of sperm whales—four adult females and one newborn—swims in formation. Female sperm whales stay with their families their entire lives, forming a *mother culture* where they share the responsibility of taking care of their young.

INTRODUCTION

by Gaelin Rosenwaks

I'll never forget the first time I saw a sperm whale, his enormous eye staring back at me. It was the spring of 1981. A young sperm whale fell ill and lost his way in the waters off Long Island, New York. I was not even two years old, but this is when my fascination with the ocean and sperm whales began. The 25-foot-long whale stranded himself twice in the course of two days, first in the shadows of the amusement park off Coney Island, where he was coaxed back to the sea, and then the following day a few miles to the east in Oak Beach. Fortunately, he was found while wallowing in the breaking waves by two men, one a veterinarian, the other the head of an organization in charge of whale strandings.

The men were confronted with what to do with this rare sighting of a sperm whale in our nearshore waters.

After much debate, they called in reinforcements, wrapped a rope around his tail, and towed him into the nearby Boat Basin in Robert Moses State Park, where they anticipated doing a necropsy. However, this was not the end of the story. Instead, the whale was taken in by a community of people and nursed back to health, capturing the hearts of thousands before being released back into the open ocean. The young whale, approximately five to seven years old, was nicknamed Physty, a play on the scientific name of a sperm whale, *Physeter macrocephalus*, and how feisty he was when in the Boat Basin.

After careful observation of Physty while he was in captivity, the veterinarians noticed he had labored breathing. They swabbed his blowhole and determined that he had pneumonia. After much perseverance, the veterinarians and watermen were finally able to get Physty to eat squid laced with pounds of antibiotics. It was a monumental feat. After many days of his condition deteriorating, Physty finally began to get better. He swam around the basin using his sonar clicks to learn more about his surroundings.

Meanwhile, people from far and wide heard about the whale and crowds began to gather. The news picked up the story and there were daily reports about him on local, national, and international news. It was a media frenzy, and the crowds of people who came to see Physty continued to grow. Among the crowd was my mother, who brought her two rambunctious toddlers to see this giant from the deep. We were there from day one, right next to the seawall, to get a glimpse of the whale.

The first time I looked into Physty's eye and he looked back at me, it was incredible. It is one of my first memories and remains as vivid today as it was then. Here was

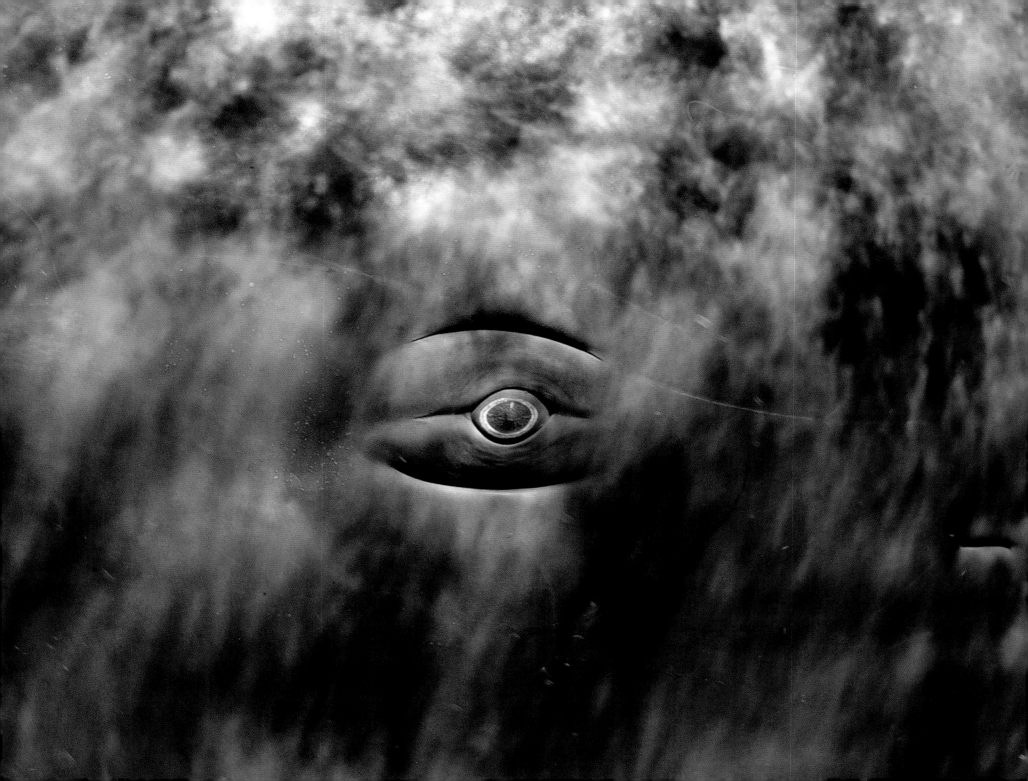

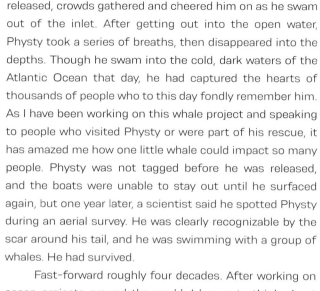

an enormous and mysterious creature that came from the depths of the ocean. What else could be in the ocean's depths? At that moment, I was hooked. Studying the ocean and its conservation has been my life's mission ever since.

Physty remained in captivity for nine days before he was guided out of the Great South Bay into the ocean by the Coast Guard and other small boats. The day he was released, crowds gathered and cheered him on as he swam out of the inlet. After getting out into the open water, Physty took a series of breaths, then disappeared into the depths. Though he swam into the cold, dark waters of the Atlantic Ocean that day, he had captured the hearts of thousands of people who to this day fondly remember him. As I have been working on this whale project and speaking to people who visited Physty or were part of his rescue, it has amazed me how one little whale could impact so many people. Physty was not tagged before he was released, and the boats were unable to stay out until he surfaced again, but one year later, a scientist said he spotted Physty during an aerial survey. He was clearly recognizable by the scar around his tail, and he was swimming with a group of whales. He had survived.

Fast-forward roughly four decades. After working on ocean projects around the world, I began to think about Physty and research the details of his rescue to learn more about the whale that my brother and I had spoken about our entire lives. Every time we crossed the causeway to go to the beach at Robert Moses State Park, we would point excitedly at the basin and say, "That's where Physty was kept." I still do it to this day. It was a magical and impactful experience in our lives.

As a marine scientist, I had many scientific questions: As a young male whale, where should Physty have been all those years ago? Should he have still been with his family? Where would Physty be today, assuming he did survive? I decided it was time to reconnect with these magnificent and enigmatic creatures of the deep, learn more about the whale that I had seen as a toddler, and tell the story of sperm whale families.

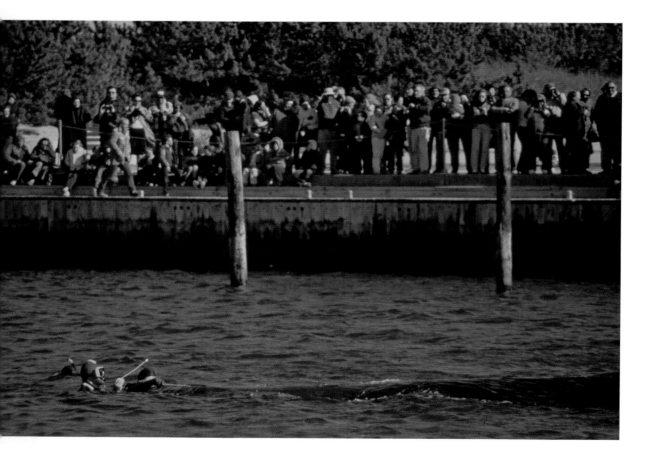

Hundreds of people gather around the Boat Basin to watch as veterinarians swab Physty's blowhole to take a sample, which will help determine if he has pneumonia.

SPERM WHALES ARE AN ANIMAL of superlatives. They are the largest toothed predator on the planet, with males growing upwards of 65 feet and weighing up to 100,000 pounds and females growing between 35 and 40 feet and weighing up to 33,000 pounds. While they are not the biggest whale in the ocean, they have the largest brain and have developed sophisticated ways to communicate and hunt using sonar. They have the ability to make one of the loudest sounds on the planet—approximately 200 decibels. They can communicate with each other over great distances, as their large head and jaw are designed for receiving sound. Their average life span is similar to that of humans—around 70 years. They reach adolescence in their teens and breed around 30 years old. They are one of the best free divers on the planet, diving to depths over one mile, and staying down for up to 60 minutes. For an air-breathing mammal, this is mind-blowing, but they are built for the task as they hunt squid at depth. They are found in every ocean, the females staying in warmer waters and the males roaming into the northern latitudes and between oceans. Because of the great movements of the males, sperm whales make up one genetic stock, but culturally they vary in behavior and can be distinguished by their language, traditions, and codas.

One of the most phenomenal things about sperm whales is that the females stay together their entire lives. The males, on the other hand, stay with their mothers until they reach adolescence around 10 years old, at which point they become socially isolated from the family unit. It is not understood why this happens, but the males go off to roam the ocean, sometimes forming bachelor groups, until they split off on their own and enter higher latitudes

as they become full-grown mature whales. Physty was not yet an adolescent when he stranded. He certainly should have still been with his family, under the protection of his mother, grandmother, and aunts, but somehow he got separated. Perhaps he was at the stage where he was wandering off to explore, thinking that with a series of clicks, he could reunite with his family, but instead he fell ill and ventured

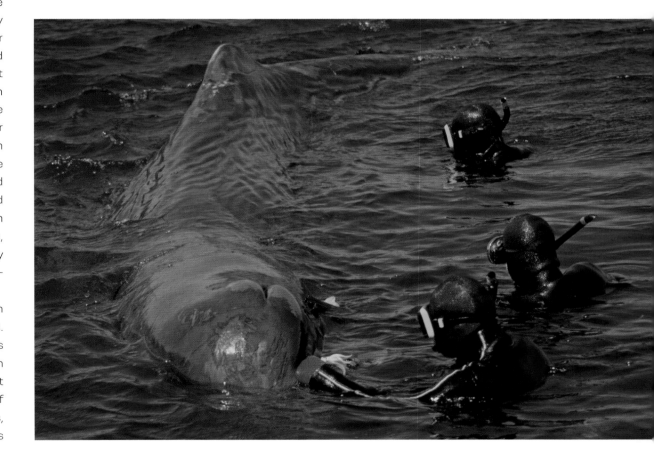

Physty's caretakers hand-feed him squid packed with antibiotics to help him get well in advance of his release.

into shallower waters. This, of course, is pure speculation, but one thing is for sure: Physty should not have been on his own when he found his way to the beaches of Long Island.

Throughout my career, as I went from researching zooplankton in the Antarctic to bluefin tuna in the Atlantic and Pacific Oceans, and then pivoting to sharing stories of scientific research from around the globe, those moments I spent with Physty were always in the back of my mind. I wanted to know more about his story and see another sperm whale in the wild.

The next time I saw one, I was on an expedition in the Norwegian Sea. I was filming for a project on Atlantic salmon when out of the fog I saw the telltale 45-degree blow of a sperm whale. I nearly fell overboard as I tried to get closer to this whale for a better look, but a few minutes later, he sounded and disappeared into the depths. Memories rushed through my mind. Could that have been Physty, who would have been a nearly 35-year-old male at the time? The whale was too distant to see any distinguishing characteristics, but I loved thinking about the possibility of him being out in the ocean somewhere exploring, much like I was.

IN 2018, AFTER YEARS OF experience on expeditions doing scientific research, making films, and photographing the undersea world, I decided to finally embark on an expedition to Dominica to try to reconnect with these fabled giants.

Dominica, a lush tropical island in the Eastern Caribbean, is home to a resident population of sperm whales, which made it the ideal place to begin my journey. Situated in the Windward Islands in the Lesser Antilles, the mountainous volcanic island juts out of the ocean with

Four whales cruise in the deep nearshore waters of Dominica, a lush, tropical, volcanic island that sits between the Atlantic Ocean to the east and the Caribbean Sea to the west.

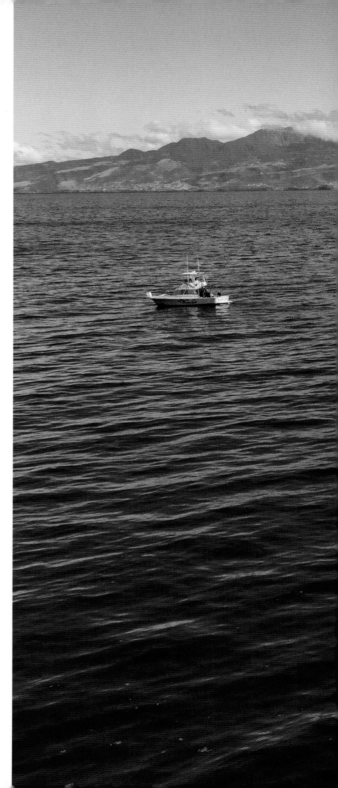

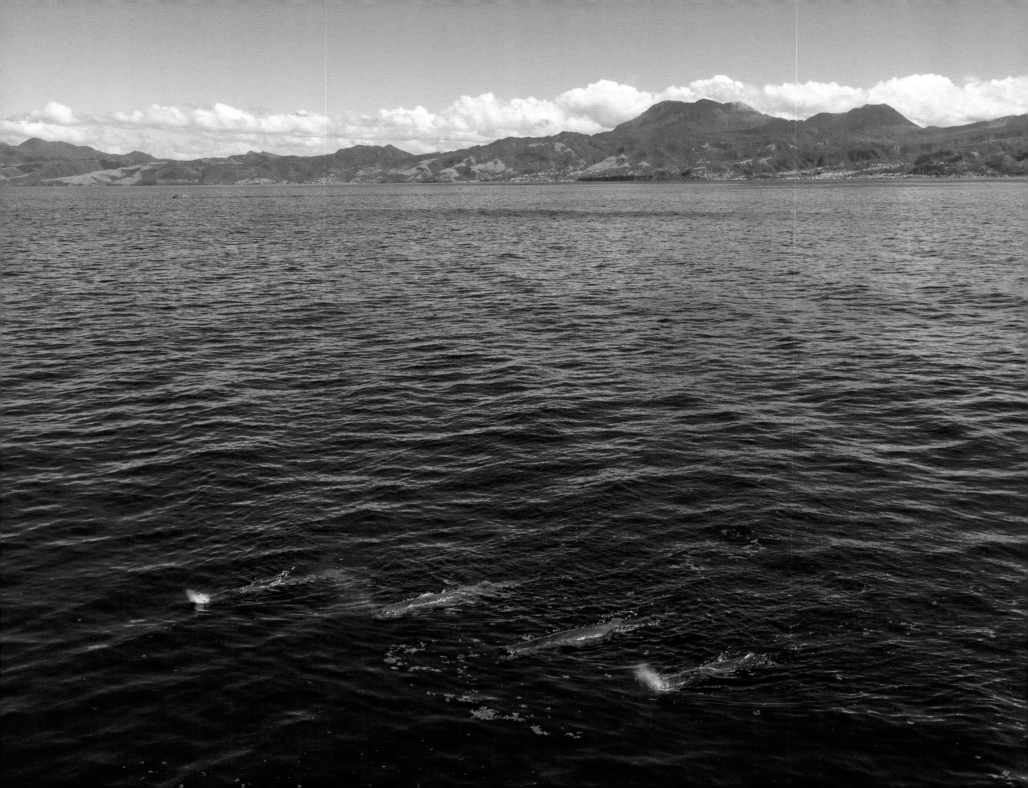

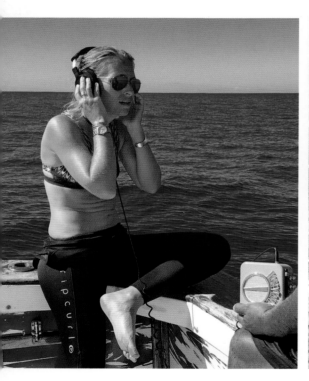

BELOW: In order to find the whales, we listen for their clicks and codas using a homemade directional hydrophone. Once we hear the clicking, we head in that direction and look for the whales on the surface.

OPPOSITE: In 2018, luck was not on our side, as the whales were elusive and the ocean was quiet. However, I did get a glimpse of these two whales as they appeared briefly out of the depths.

the Caribbean Sea to the west and the Atlantic Ocean to the east. Unlike many other islands, the waters of Dominica drop off quickly. Within a half mile of the shore, there are thousands of feet of water below you. The many rivers of the island empty into deep submerged canyons where giant squid and diamondback squid—favorite foods of sperm whales—are abundant. All of these factors make the surrounding waters a perfect location for the matriarchal families of sperm whales to reside. The island is also one of the only places in the world where you can get in the water to swim with the whales, though it is highly regulated

by the government and the permits are expensive and difficult to get. I submitted a research proposal and was lucky enough to get a permit.

With nervous anticipation, my team and I headed out with our captain and whale guide on our first day to look for whales. The color of the water was a deep blue, reminiscent of Kool-Aid, with rays of sunlight penetrating it. The waters were teeming with life; we saw dolphins frolicking, flying fish flying, and sailfish jumping as we headed to our first listening station. To find the whales, we put a directional hydrophone into the water—basically a hydrophone stuck inside a salad bowl attached to a long stick and listened for them. Because sperm whales communicate with one another using a series of clicks and codas and employ sonar clicks for hunting, listening is the most effective way to find them. About three miles offshore of Roseau, the capital of Dominica, we stopped to listen. The ocean was silent except for the hum of an engine from a small fishing boat heading to search for tuna and marlin. At this point, I was not yet discouraged, and we moved north to our next listening station.

This first expedition to Dominica was a solid reminder of what makes wildlife filmmaking and ocean storytelling so challenging. The weather was terrible, and the whales were nowhere to be seen. We spent long days listening for the distant clicking but heard nothing. The ocean continued to be silent. Then, one afternoon in the pouring rain, we heard the sound we were waiting for: the *click, click, click* of sperm whales hunting in the depths. After decades of dreaming about Physty and that quick glimpse of a sperm whale in the frigid waters of the Arctic, this was finally my moment to reconnect with these incredible animals. The interaction

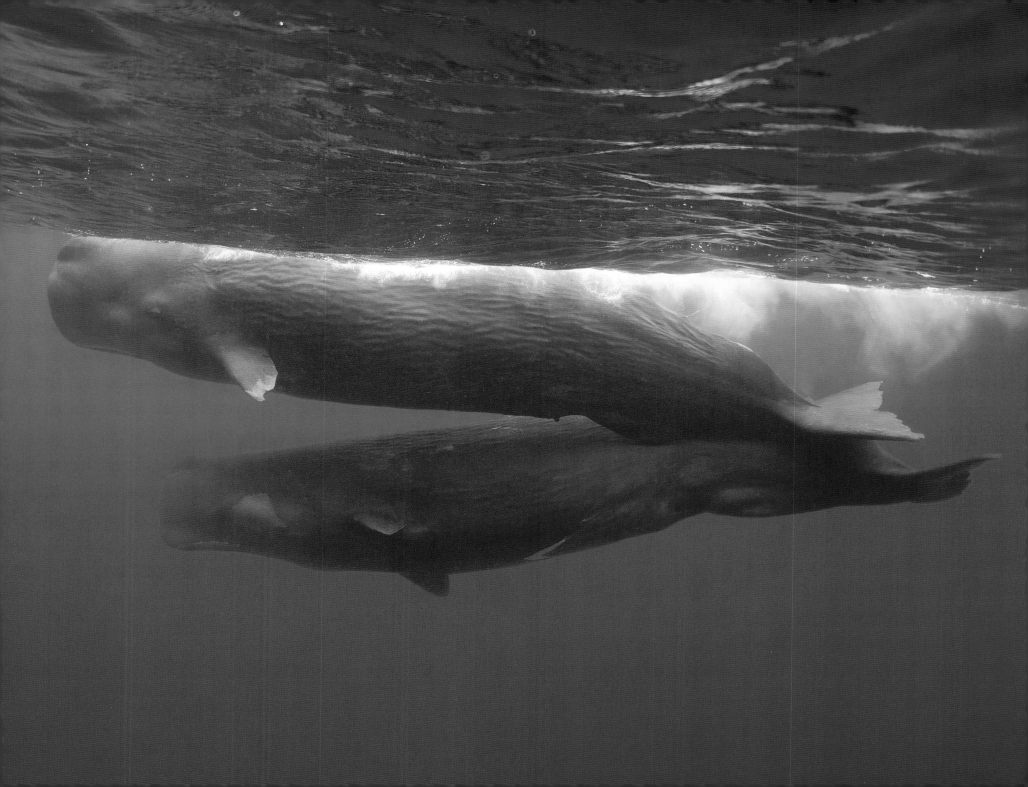

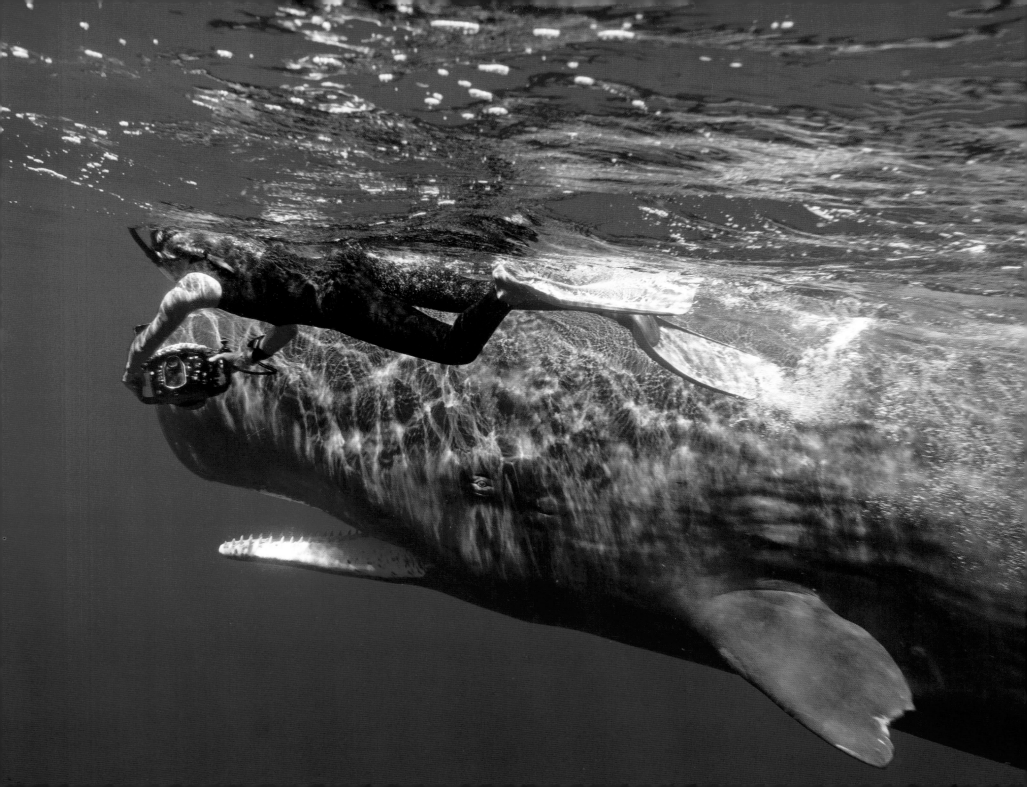

lasted less than two minutes, but it sparked my desire to spend more time in the water and learn more about these whales. I had seen other whales around the world and had spent time in the water with orcas and dolphins, but this fleeting moment solidified for me that sperm whales had captured my heart. I immediately applied for a permit for the following year. I needed to go back. That one moment was not enough.

FORTUNATELY, LUCK WAS ON our side. In 2019, my team and I were back in the deep-blue waters of Dominica and I moved forward with my film project to tell the story of Physty and the family dynamics and communities of sperm whales. On the very first day in the water, we heard the whales clicking and went off to find them. Shortly thereafter, the captain yelled, "There she blows!" and we saw our first sperm whales of the expedition. As we approached, there were two individuals swimming side by side. I was blown away by their massive size and calm as they took measured breaths while recovering from their deep dive. As we positioned the boat carefully, I felt myself taking similar measured breaths in anticipation of coming face-to-face with these enormous animals who, after all, are the largest predators on the planet. I was nervous and excited as I checked my camera settings. Then we got the signal from the captain to get in the water and I gently slid off the swim platform.

 With thousands of feet of water below me and seemingly endless blue in front of me, I swam in the direction of the whales, my heart pounding with excitement. Out of the blue, two shadows emerged and headed straight for me. I stopped swimming and just floated there, hoping they would want to come check me out. I could hear and feel their clicking as they sized me up with their sonar. While we don't know all of the information the whales are able to ascertain from this investigation, it feels like they are penetrating your soul and know everything from what you ate for breakfast to your deepest thoughts. At that moment, time seemed to stop. The whales approached and passed within only a few inches of me. I swam alongside them, gazing into one of the whale's eyes for about five minutes, before they once again took measured breaths, lifted their flukes, and disappeared into the depths to hunt. A tear rolled down my cheek as I lifted my head out of the water. These whales seemed to have so much wisdom, and I was beyond appreciative of those moments and eagerly anticipated the rest of the expedition.

 After 45 minutes down, almost on the dot, the whales resurfaced and approached the boat. Once again, I slipped into the water. These were the same two whales we had seen earlier. Nearly right away, one swam off into the blue, but the other, who seemed to recognize us, came right up to me. I found myself locked in a gaze with her for more than 25 minutes. She seemed to welcome me into her world, clicking on me, sizing me up, and never letting me out of her sight. She swam slowly next to me, trying to get closer and closer. At one point I was swimming backward so as not to touch her; I don't condone touching wildlife. I tried to get out of her way to make sure she wanted me there, but she only got closer. At one point, she went entirely vertical, closed her eyes, and took a nap right next to me. Then she opened her eyes, twirled, and began swimming slowly. Finally, it was time for her to feed again, and, with a gentle flick of her tail, she disappeared into the depths. We saw

There is nothing like looking into the eye of a sperm whale. Their eyes are filled with wisdom that penetrates your soul. After spending time with these animals, I could identify many individuals by their gaze alone. I feel so privileged to be able to spend time photographing and filming these whales, learning their behaviors and personalities firsthand.

this whale several times over the course of our 10 days in the water. With one glance into her eye, I knew it was her. She was unmistakable.

THE WHALES OF DOMINICA have been well studied for decades by a group of scientists making up the Dominica Sperm Whale Project. The scientists have named and identified many of the whales, following their births and deaths. It is a phenomenal data set that has added tremendous knowledge of the behavior and life history of sperm whales. The scientists identify the whales not only by their unique flukes, but also by their language of clicks and codas, which appear to be distinct among families and clans. These sounds help the whales identify one another, and now humans can listen in as well. It is remarkable being in the water, hearing the different patterns of clicks, and knowing that the whales are communicating.

The sperm whales of Dominica are predominantly females, living in matrilineal family units for their entire lives. Grandmothers, mothers, daughters, and aunts all live together, working as a team to take care of their young and protect one another. Like us, the whales learn from and rely on their mothers. Knowledge is passed down from generation to generation, with different family units exhibiting different behaviors.

Since my mother had introduced me to the ocean when I was a toddler, passing on her curiosity and passion for the underwater world to me, I brought her along on my quest to learn more about these mothers. While we have always spent a lot of time on the ocean together, these were our first work expeditions and it was very special for me to have her by my side in the water with the mother and daughter whales. Just like she taught me early on about the ocean, I have now put a camera in her hands to help in the filming of the whales. She has become an excellent underwater camerawoman.

At one point, we were in the water with three generations of whales: a grandmother, named Fruit Salad, the mother, Soursop, and her unnamed one-year-old female calf. It was beyond inspiring to witness how these animals interacted with one another and to see the baby, whom I was lucky enough to name Ariel, copying the behaviors of her mother and grandmother. Many of the whales of Dominica have been named by the scientists who have been studying them and watching them grow up, give birth, and wean their young. These three whales were from Unit A, a well-known group that seems to enjoy interacting with people in the water. The whales in this group all have either fruit-themed names, like Fruit Salad and Soursop, or names that begin with A, for Unit A. Allen and Accra are two other whales from this unit. For this reason, Ariel seemed like a fitting name for this curious young calf. I chose it as a nod to *The Little Mermaid*, but also because Ariel is my middle name and I had fallen in love with her. We interacted with this family of whales throughout our expedition, getting to know them and their behaviors.

From the surface, sperm whales are not very impressive. They look like large logs swimming toward you with a distinctive 45-degree angle spout. However, below the surface is another story. They look like massive submarines with a quirky smile and eyes filled with wisdom. They spend the majority of their lives at depth, only coming up to the surface to breathe and rest. They occupy an area of the ocean only our imaginations can take us to. What could

Three generations of whales swim together—a grandmother named Fruit Salad, a daughter named Soursop, and a granddaughter named Ariel, a one-year-old calf. Female sperm whales stay together their entire lives, passing their knowledge and culture from generation to generation.

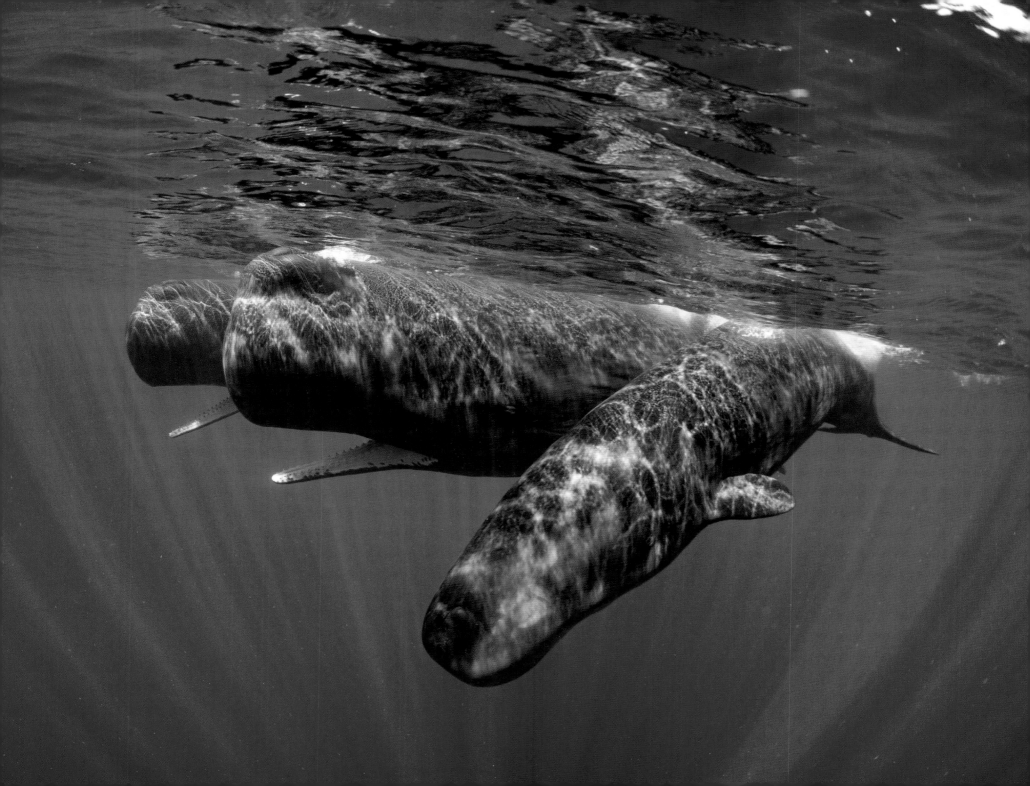

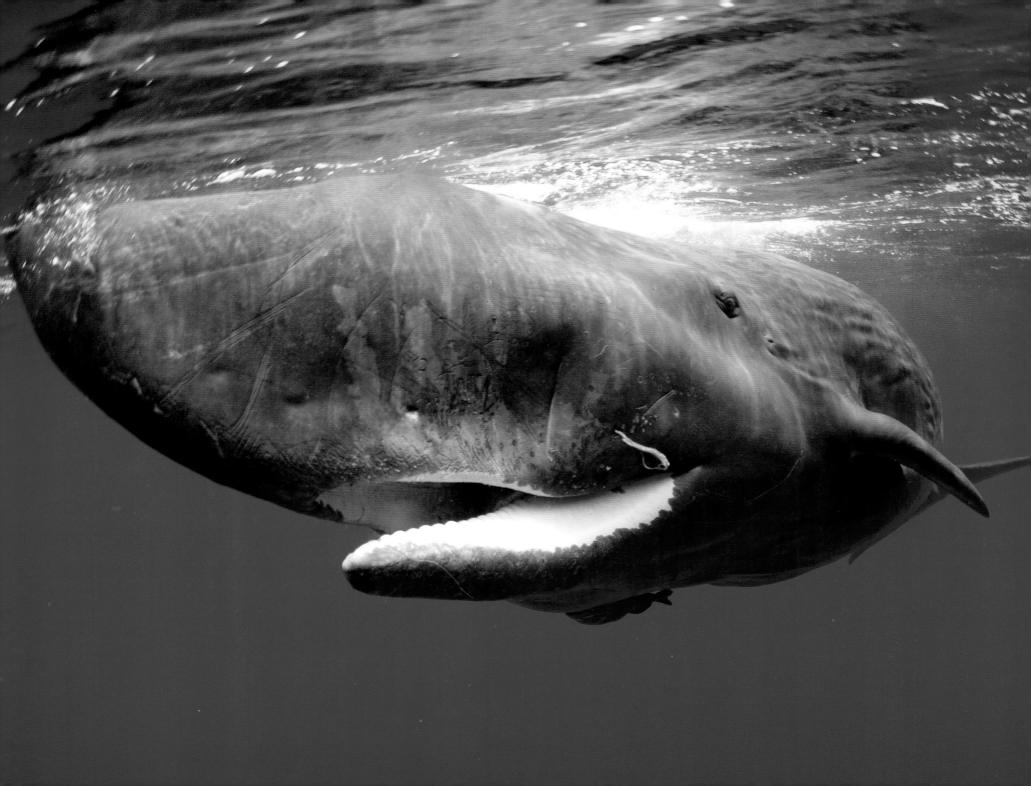

it be like a mile below the surface in a deep canyon filled with squid and mysterious fish?

On our last drop of the trip, I was in the water with five whales. It felt like I was watching a herd of animals frolicking as they swam at a fast pace. I noticed something trailing out of the mouth of one of the whales as I swam alongside them. Initially my heart sank, as I thought it was a piece of rope from one of the many fish-aggregating devices in the area. As we swam along, the whales spun around each other, their codas and clicks getting more and more frequent. I wondered what they were talking about—maybe the weird-looking creature in a wetsuit swimming next to them, making strange noises from the shutter of her camera? Or maybe they were planning when they were going to dive for their next hunt? I'll never know, but after a few minutes, their breathing patterns changed and I knew they were about to dive into the depths. The incredible thing is how they do it in unison.

As I was thinking about all of this, I kept my eye on the whale with the "rope" in its mouth. As four of the five whales sounded, the object fell out of her mouth around 60 feet down, just out of reach of my free-diving ability with my camera in hand. Another young sperm whale named Digit did not dive with her mother and aunts. Instead, when she saw this object fall, she turned and put it in her mouth, brought it up to the surface, and popped it out right in front of me. To my delight and surprise, it was not a piece of rope, but the tentacle of a giant squid! Digit had seemingly gifted it to me, as if she was saying, "Here, you look hungry, have this for dinner." There I was in the middle of the ocean with a 20-foot-long tentacle from a freshly killed (and partially eaten) giant squid. It

was amazing. It was not only long, but also so fresh that the chromatophores (color cells) were still changing color! And its suckers were attaching to me as I wrapped the tentacle around myself like a stole. It was mind-blowing. We brought it on deck and inspected it carefully. I could not believe I was holding a piece of giant squid.

This expedition was remarkable, with so many intimate encounters with mothers, grandmothers, and baby whales. We had interacted with multiple generations and I had reconnected with these animals, but something was still missing. I still wondered where Physty would be

OPPOSITE: A baby sperm whale swims with a piece of squid in its mouth from an earlier meal. Babies start to eat solid food around one year old, but predominantly feed on milk until they are around two.

BELOW: In this photo, I'm holding a freshly caught 20-foot-long giant squid tentacle, a remnant of a deep-sea meal gifted to me by a sperm whale.

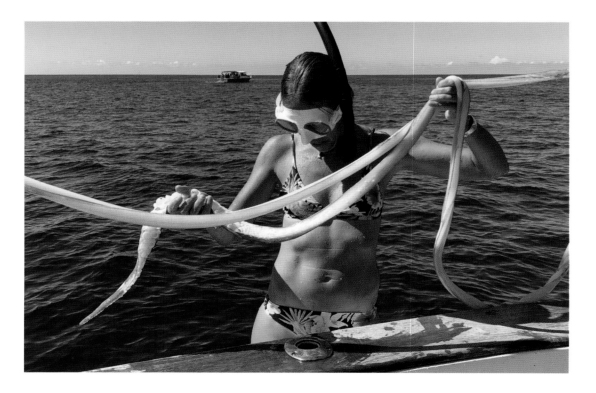

now. We had spent time in the water with a young male named Allen, who was the same size as Physty was when he stranded. Allen was frolicking with his mom and family, and I could only think about how Physty should have still been with his family back then. But today, he would be a large, fully mature whale. We had not seen a full-grown male sperm whale during this trip. I knew I would have to come back.

I BEGAN PLANNING the next expedition to Dominica, knowing that I wanted to go later in the season when my film crew and I would have a better chance of seeing a large male. The males come into the waters of Dominica in the winter months, so we planned to visit the following March. But unfortunately, the global COVID-19 pandemic hit and the trip was postponed. It was very disappointing to be sitting at home knowing that the large males were still heading to the azure waters of Dominica to visit the females but we would have to wait. However, it was reassuring to know that, while our lives had largely been put on hold, the whales' lives were unlikely to be disrupted by the pandemic. If anything, perhaps the global pause in the oceans would be a good thing for the whales.

Sperm whales have very few natural predators. Killer whales and pilot whales will attack them and account for many of the scars on their flukes, but the largest threat to sperm whales is people. They were hunted to near extinction during the whaling days, when their oil helped fuel the Industrial Revolution, and then the greediness of industrialized whaling in the 1960s nearly annihilated all of the whales for use in fertilizers and cat food. The whaling moratorium that was finally put into place in the

1980s helped stop the hunting of whales, but humans and human activity still pose the largest threats to their populations. Cruise ships, high-speed ferries, cargo ships, plastic pollution, entanglements in fishing gear, and pesticides are just some of the human-caused threats to sperm whales. During the pandemic, however, the ships and ferries around the islands stopped, much of the boat noise and shipping traffic slowed, and the whales were given a much-needed break from the threats around them. They could frolic and live in a quieter ocean while the human world battled the virus.

We had to wait a full year before we attempted to get back to Dominica and the whales. The following March—with vaccines having been rolled out in the United States and Dominica doing a great job of controlling the virus—we were able to travel back to the island. We hoped to encounter a full-grown male coming in to visit and breed with the females.

The expedition got off to a slow start, with no whale sightings on the first day. It was hard for me to be optimistic remembering the outcome of our first trip, but I knew it was only the beginning and we had many more days to find the whales. Plus, since no boats had been looking for them for months, it was a much quieter ocean. Would we find the whales? Would their behavior be different after this pause?

Fortunately, on the second day, we heard clicking on the hydrophone and shortly thereafter spotted the whales on the surface. Once again, I had the nervous anticipation of seeing them for the first time after being away. I thought to myself that I should have some kind of fear, but I didn't, only complete excitement at seeing the whales that had

A pod of pilot whales patrols the waters of Dominica. Part of a larger pod consisting of hundreds of whales, these three adults swim with a baby alongside. Pilot whales are one of the only known predators of sperm whales. Due to their presence in the area, I was concerned that the sperm whales might head into deeper waters where we would not be able to find them.

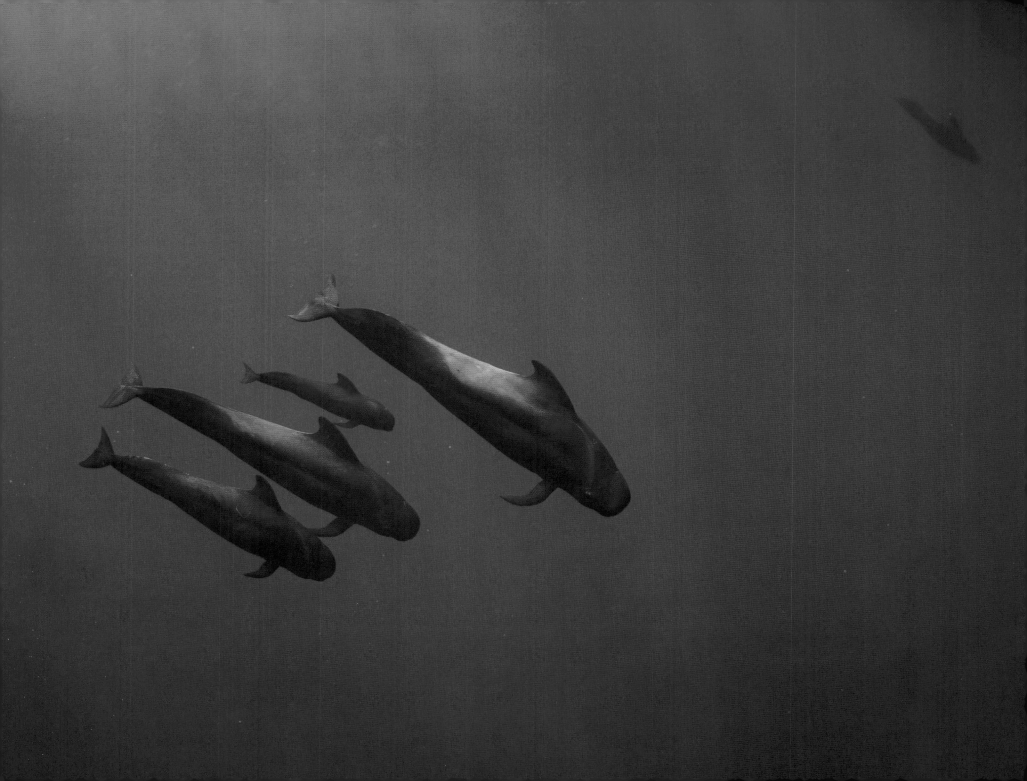

captured my heart. I slipped into the water and waited for the silhouette to come into view. The whales were behaving differently than in years past. Instead of coming at me on the surface, when they saw me and began clicking, they submerged, turned over, and swam directly below me, belly up. It was an interesting behavior because sperm whales can only see in stereo this way, so essentially they were getting a full view of me. One paused directly below me and winked; another did the same but then came up next to me right after. The whales seemed to be reacquainting themselves with us in the water and trying to figure out who these creatures in wetsuits were. We made sure to give them space and let them dictate our interactions. We had a few beautiful moments that day, and it was reassuring to know that the whales were in the area.

The next day we encountered one of the sperm whales' natural predators, a huge pod of pilot whales. Pilot whales hunt in packs and will target baby whales, so we knew the sperm whales would act differently in their presence. Sure enough, while we heard the clicks of sperm whales, they were mostly elusive, and we could only hope the pilot whales would move out. They stuck around for another day, but it turned out to be a blessing in disguise for us. I jumped in the water with them. They have a completely different vibe than sperm whales, a little more sinister in their gaze. They are smaller in size, but they are voracious predators. There was a baby swimming alongside its mom, a larger male that paused to look at me for a bit, and many others—there were likely hundreds of whales in the pod. While I was in the water, my thoughts turned to the baby sperm whales. I was concerned for their safety and hoped the pilot whales would not drive them into deeper waters.

This baby whale was very curious. It spent about 45 minutes with us, playing like a puppy. It tried to view us from every angle. It would spin, go upside down, and then go vertical. We essentially were babysitting while the mom hunted below. After a while, it must have heard its mom calling, as it quickly swam away. Shortly thereafter, we saw the two of them on the surface together.

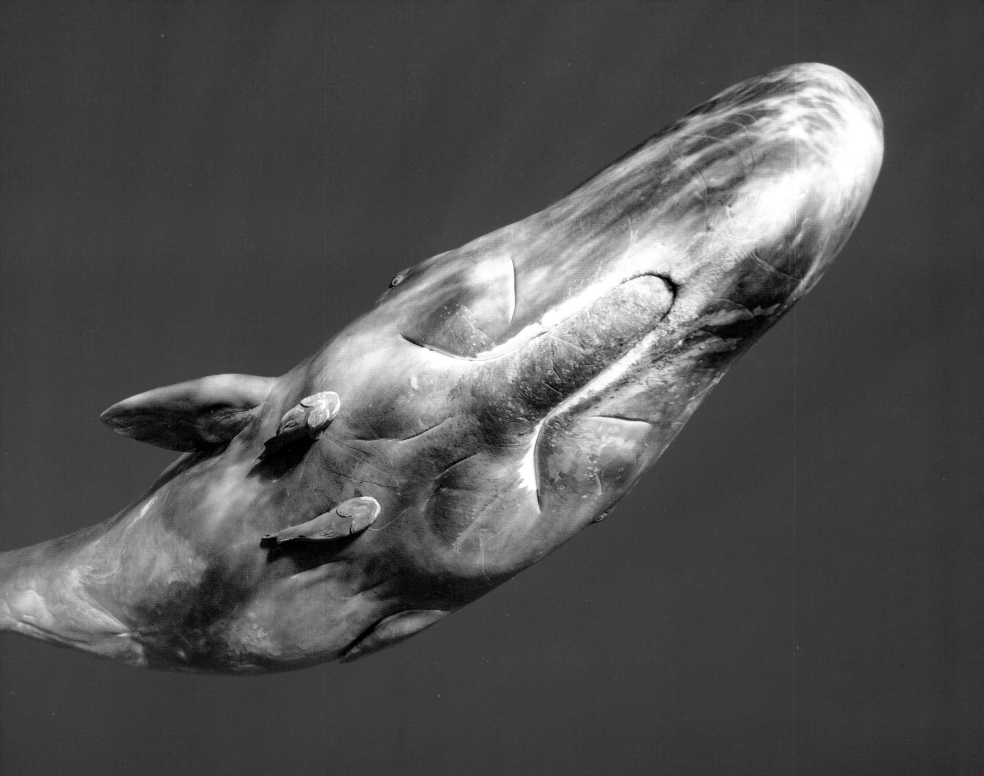

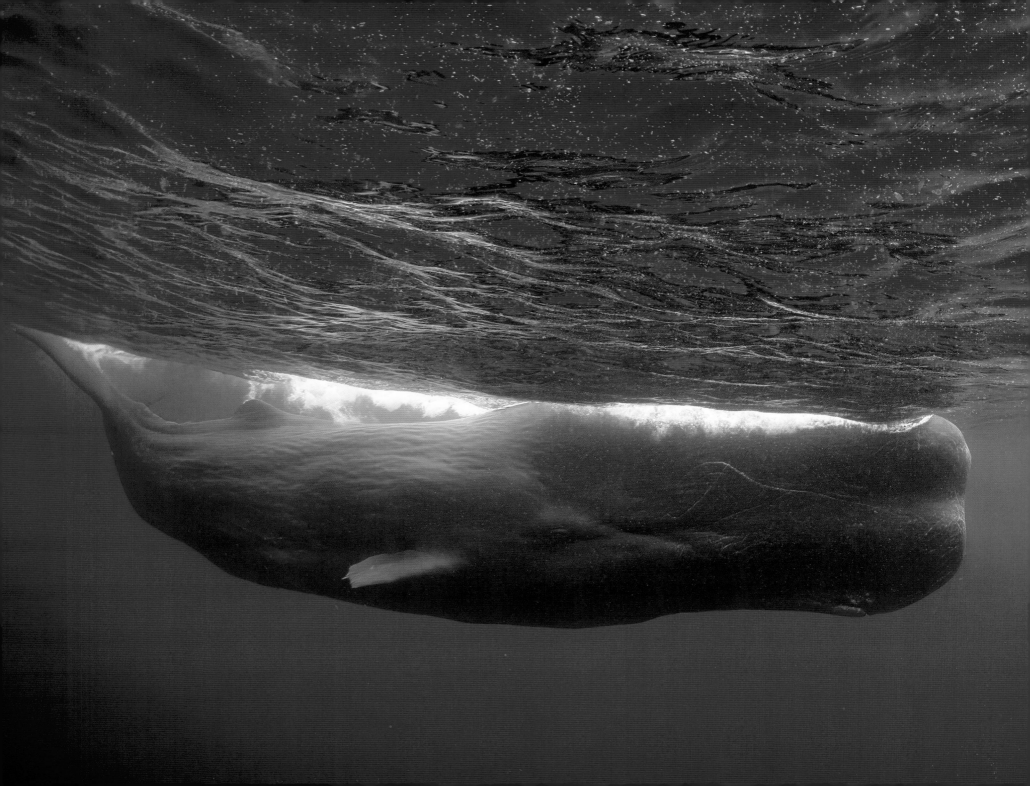

We stopped to listen for the sperm whales again and heard them in the north so we headed that direction. They were acting skittish, but then we saw a mother and calf in the distance. We slowly approached and turned off the boat engines. I got in the water alongside my mother and swam toward the whales. I could only see their shadows, but as I approached it looked like the mom "said" something to the baby and then swam off. Just as my heart began to sink thinking I had disturbed them, the baby turned toward us and swam right up to us playfully. It seemed like the mom had decided that, in the presence of pilot whales and the absence of a sperm whale aunt or grandmother, we were charged with babysitting her child. For the length of the mother's dive, the whale played with us like a puppy, a little aggressive at times, but also getting very close, spinning around, and trying to nudge into us. I was blown away that the mother would entrust us with the care of her baby, but she seemed to know it would be in good hands. After 45 minutes, and two camera changes for me, the baby must have heard its mom and swam off. Shortly thereafter, we saw the two of them reunited on the surface. It was a magical moment and I was honored to be charged with watching over the baby for that brief moment in time.

The following day, when we lowered the hydrophone into the water, we heard it! The loud clangs of a male sperm whale who had come in from his vast ocean wanderings to gather his ladies and hopefully breed. Would we get to see him, or only hear him on the hydrophone? I was excited. Could it be Physty? If it was, would we be able to tell him apart from another whale? Would the scar he had at the base of his tail still be visible after all these years? I knew that was wishful thinking, but the possibility of seeing any full-grown male whale was exciting. Males are much larger than females, and I could only dream about what being in the water with one would be like.

Those dreams quickly became a reality. The next afternoon, the clanging on the hydrophone was quite loud, and out of the depths appeared a full-grown, 65-foot male sperm whale in all his glory. He was massive! As he swam through the water, his body kicked off a wake like a boat going at high speed. It was raining and windy, and the sea state was rough, but I knew I had to try to see him underwater and look for the scar. I entered the water and immediately felt the enormity of his size. The females had all seemed big, but this whale dwarfed them. I felt tiny next to him. His head was shaped differently than the females, and he was covered in scars—or rather battle wounds from a life lived in the open ocean. He was clanging as he swam next to me. It sounded like metal hitting metal, the call sign for females to know he was there. His swimming emitted so much energy and force that I could feel the water move. He was so powerful. He let me get two drops with him as he circled the boat before sounding. The water quality and light were not ideal. I tried to get a good look at the base of his fluke. I kept my distance and did not see a scar near his tail, but Physty would be around the size of this male. To think that he would be this strong thanks to the caring community of people all those years ago nearly had me break down.

AFTER SPENDING SO MUCH TIME in the water with these whales and seeing the large male, I knew I needed to dive further into their behaviors and social interactions. Every expedition, every drop, every moment revealed something new about the whales and I was eager to learn more.

We went back to Dominica in March knowing that it was the prime time for large males to come to see the females and breed. Midway through the expedition, we heard the clanging of a male. Out of the depths appeared this Leviathan, at least 60 feet in length, dwarfing the females. It was incredibly powerful to be in the water with such a massive animal, and I could feel his clanging reverberating through my body. His many scars told stories of a harsh life in the open ocean. I wondered if this could be Physty. He certainly was the correct size!

I had fallen in love with the whales of Dominica. When I returned home from our trip, my mind kept wandering and wondering what Soursop, Fruit Salad, and Ariel were up to. I knew I needed to go back and check in on them.

I planned yet another expedition to Dominica, an island that has become a second home to me. This time, my team and I went in late October. This was about 15 months after the males would have visited the waters back in 2020 during the pandemic. Not so coincidentally, 15 months is the gestation period for sperm whales. Would there be more babies born because of the quiet of the pandemic? What would the whales' behavior be like now that cruise ships and shipping traffic had started back up? I wanted answers to these questions, but mostly, I just missed the whales. The deep-blue waters and the sirens of the deep keep calling me back year after year.

On our first listening stop, we heard clicking! There were whales everywhere. I could not contain my excitement as I put my wetsuit on, checked my camera settings, and began scanning the horizon for their blow. Shortly thereafter, two whales surfaced, and within an hour of venturing out I was in the water with four whales swimming toward me. Sure enough, my suspicions were right and we found two mothers with two newborn calves. One of the calves was more curious than the other. The mothers ushered them away, but not after I had a beautiful encounter with the babies and their moms. Once we were out of the water, we saw whales breaching in the distance, their full bodies out of the water, and their enormous splashes. It was an incredible morning, and I was so happy to be back.

This family unit stuck around for the next few days. The moms and babies got to know us well. Our patience and distance on the first day paid off, and the whales approached us with curiosity. The babies became bolder and peeked out from under their mothers more frequently. At one point another baby joined, and we were with three newborns who were playing together while one of their moms was babysitting. Every interaction with the whales was different. Toward the end of the day, they headed offshore. Could they have heard a male in the distance calling to them, or was it time to move on to the next spot? I certainly hoped they decided to stick around for us.

The ocean was silent the next day and the morning after. Where had the whales gone? Would they come back? We traversed the waters up and down the island and heard nothing but a few distant boat engines and whistles of dolphins. Just as I was losing hope, I heard the wonderful words "There she blows!" as a small spout was spotted in the distance. The ocean was like glass that day and we headed about 12 miles offshore, where we found a baby on the surface and mysterious shadows below.

What we found when we got in the water was one of the most incredible sights I have ever seen: the two adult females we had seen two days prior were sleeping vertically, and their two babies were twisting, turning, and playing directly above them. They were nestling into their sleeping moms, copying them, trying to stay vertical next to them. Swimming next to the sleeping whales, I had never felt so small and humbled to be in their presence. Something about being able to pause and truly examine the whales made me appreciate the magnitude of their size. I was awestruck. Then the moms woke up, turned on their sides, and started swimming away. At that moment, one of the babies began nursing. Sperm whale babies suckle for around two

Two females sleep with their calves frolicking around them. These whales are part of the same matrilineal family unit. Families of sperm whales consist of up to 10 individual whales. Sometimes, however, families will socialize with each other and form clans. These clans may have shared behaviors, but they have unique codas to identify themselves.

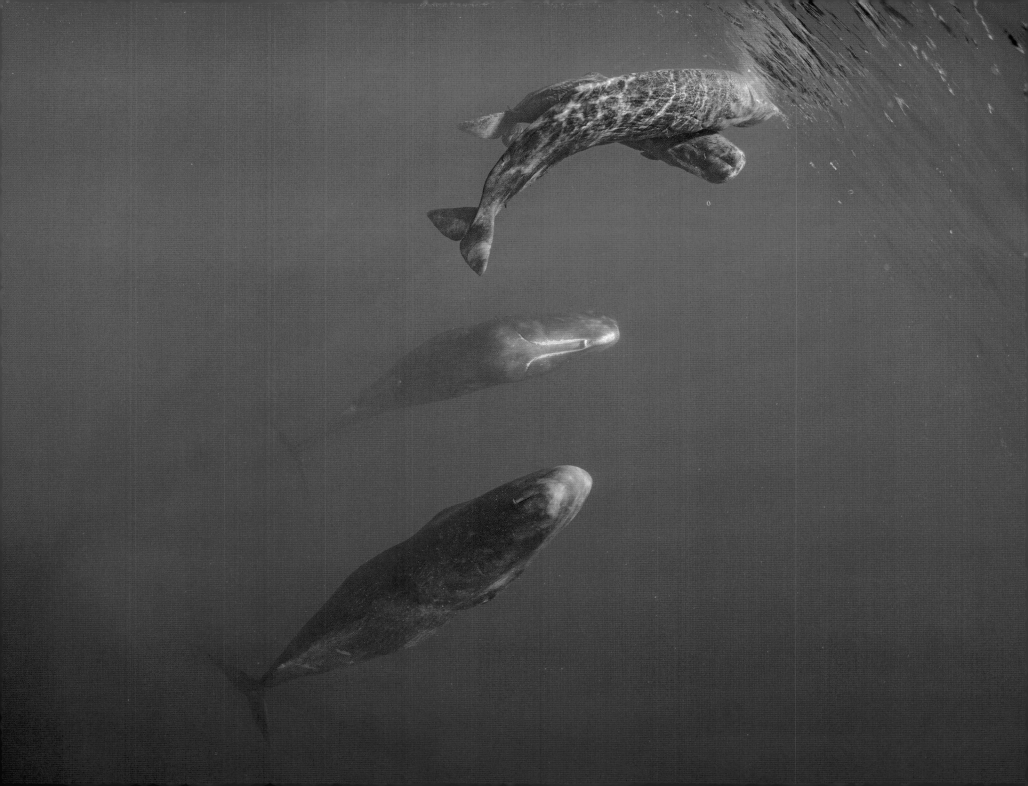

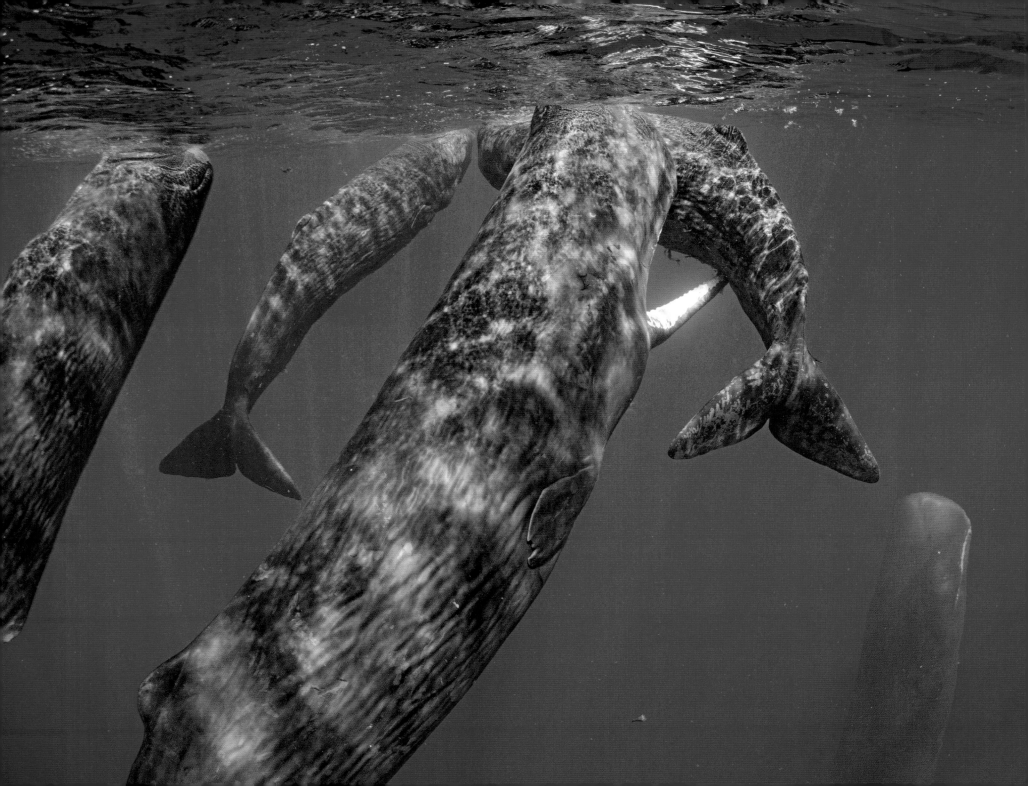

years, and this baby, clearly a newborn, was hungry after letting her mom rest for a little while. The intimacy of the mother and baby among the whales was truly remarkable.

One thing about sperm whales that is unlike any other animal I have ever interacted with in the wild is that they bring you into the moment. More often than not, I do not feel like an observer to a situation or encounter. I feel like they are having a conversation with me, and at every moment they are looking at me and making sure I am present. Some might question if we are interfering in their lives, but my feeling is that it is very easy for them to leave, and more often than not, they swim toward me and bring me into their narrative.

The encounters continued on this expedition and the whales formed a large group in the next few days. They were socializing and playing; seldom did you see one whale at a time. We had not identified the family unit yet, but on one of our next drops, I immediately knew I was eye to eye with one of my favorite whales: Soursop. It was amazing to me that I could recognize her just by looking into her eye, and I wondered if she could do the same. With Soursop was her now much older calf and my favorite baby, Ariel. We were with Unit A, a well-known group to both me and science. It was wonderful to see Ariel again and it felt like we were having a reunion in the water.

The next day, we saw a whale slapping the water violently with her tail. I hadn't seen this behavior before, but it seemed like it was a call to the other whales that it was time to gather. As we approached, we saw five whales on the surface socializing. We quietly dropped into the water and, as we neared them, saw that the action on the surface was only telling a part of the story. Below the five whales, there were at least three more that were sleeping vertically at various depths below. The sight took my breath away. As I looked around, side to side and up and down, there were whales everywhere. On the surface, two adult females were nurturing and watching over three babies. They were rolling and spiraling around each other. To say this was epic would be an understatement. At one point, one of the adults began grooming a baby, using her mouth to remove the excess dead skin that was sloughing off. She had the baby gently in her mouth as she nudged and caressed it. It was such a tender moment. I was in the midst of the whales, and it felt like they were taking me into their family. They were checking me out as they frolicked. I put down my camera at a few different points just to take it all in.

The final days of the expedition were spent in the water with this group of whales. They continued to welcome us into their world. The number of babies was awesome and made me hopeful for the future of sperm whales, who had seen diminishing numbers in the past few years. I only hope that this trend in growth continues.

Spending time in the water with sperm whales, getting to know both individuals and families, has been a tremendous privilege. When I'm in Dominica, I can't help but wonder if Physty has been in these waters at some point during in his lifetime—perhaps he is even the father of some of the babies we have seen and come to know.

During one of the most spectacular moments I have ever spent underwater, I witnessed this large group of whales socializing, with some interacting on the surface and others sleeping below. I watched as a female groomed her baby, a behavior I had never seen before. With an open mouth, she gently removed dead skin from the baby. It was an incredibly tender moment.

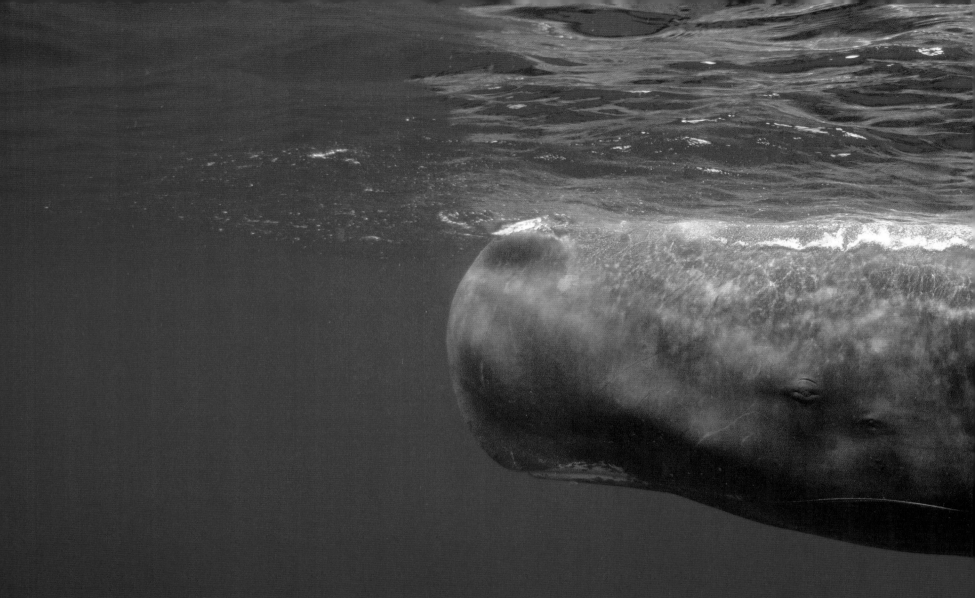

GENTLE GOLIATHS

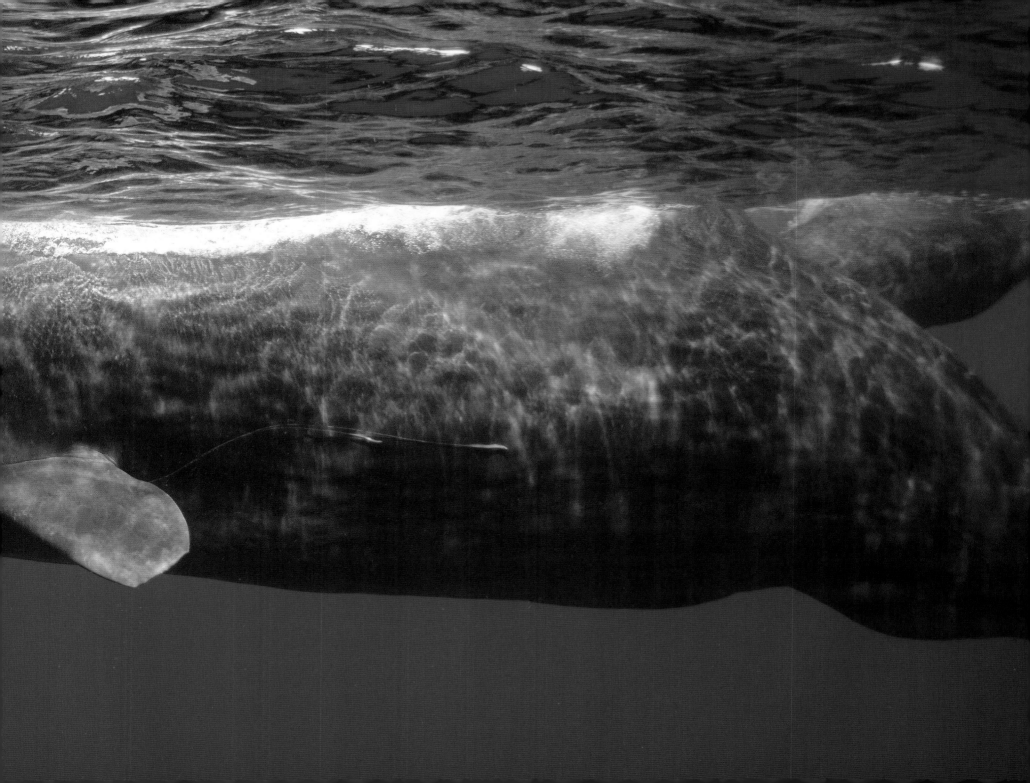

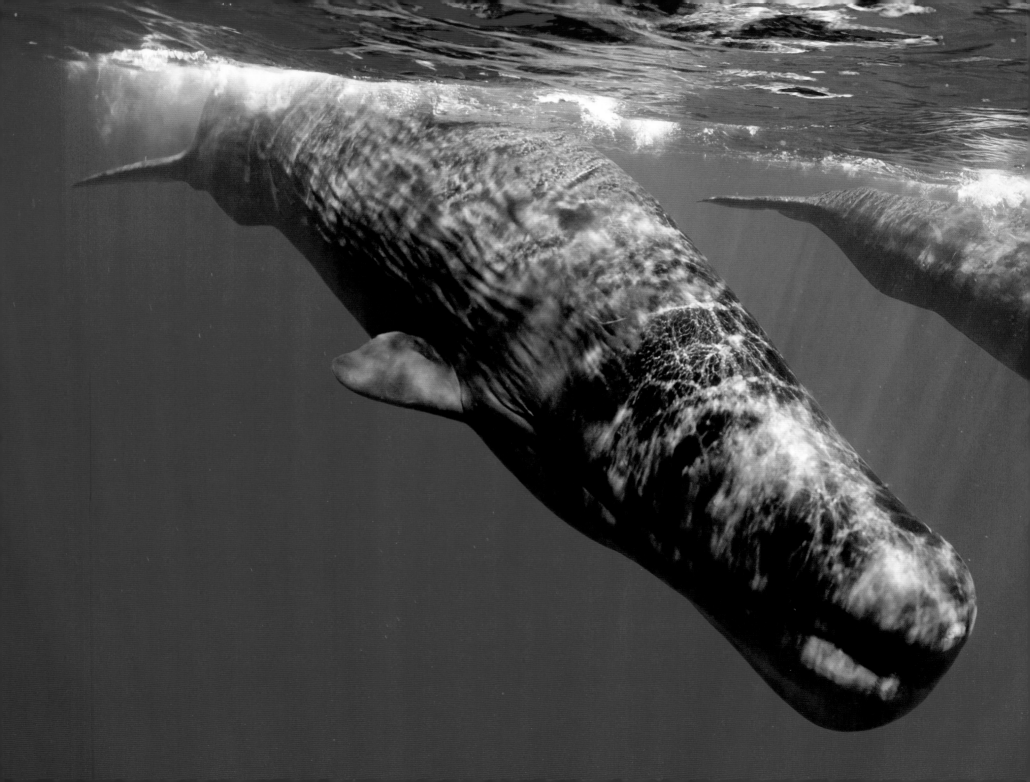

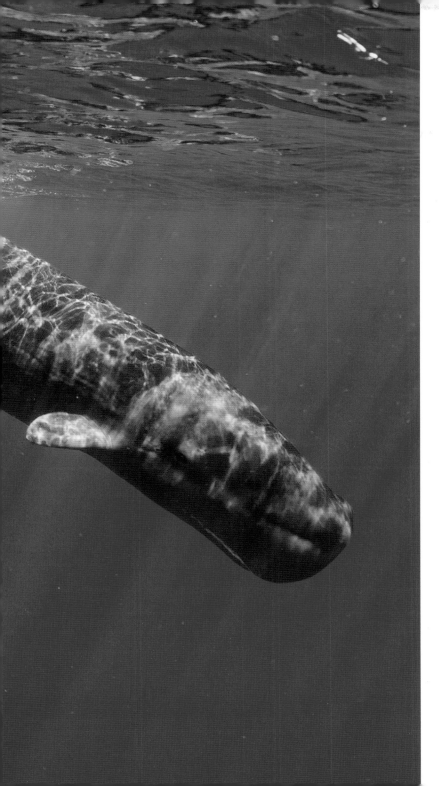

A young whale dives next to an adult in perfect synchronicity, as if it were planned. And perhaps it was—by communicating through clicks and codas.

OVERLEAF: An egg mass from a diamondback squid (*Thysanoteuthis rhombus*), a favorite prey species of sperm whales, floats under the sargassum while a whale swims off into the distance. These large squid, weighing more than 53 pounds and averaging 39 inches in body length, are widely distributed in tropical and subtropical waters and are abundant in the deepwater canyons of Dominica. One of these egg masses can hold anywhere from 35,000 to 75,000 eggs.

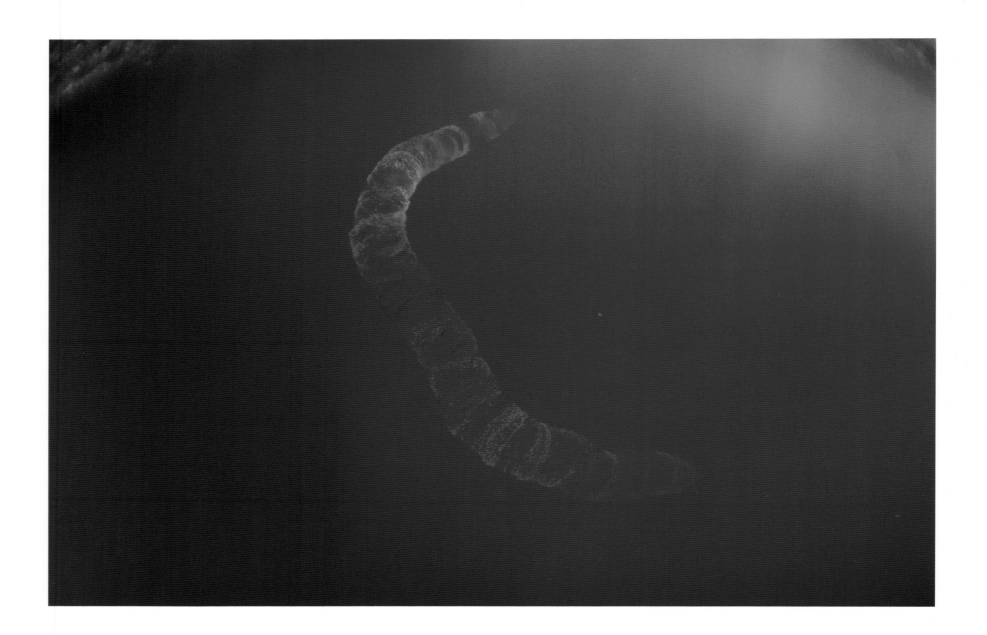

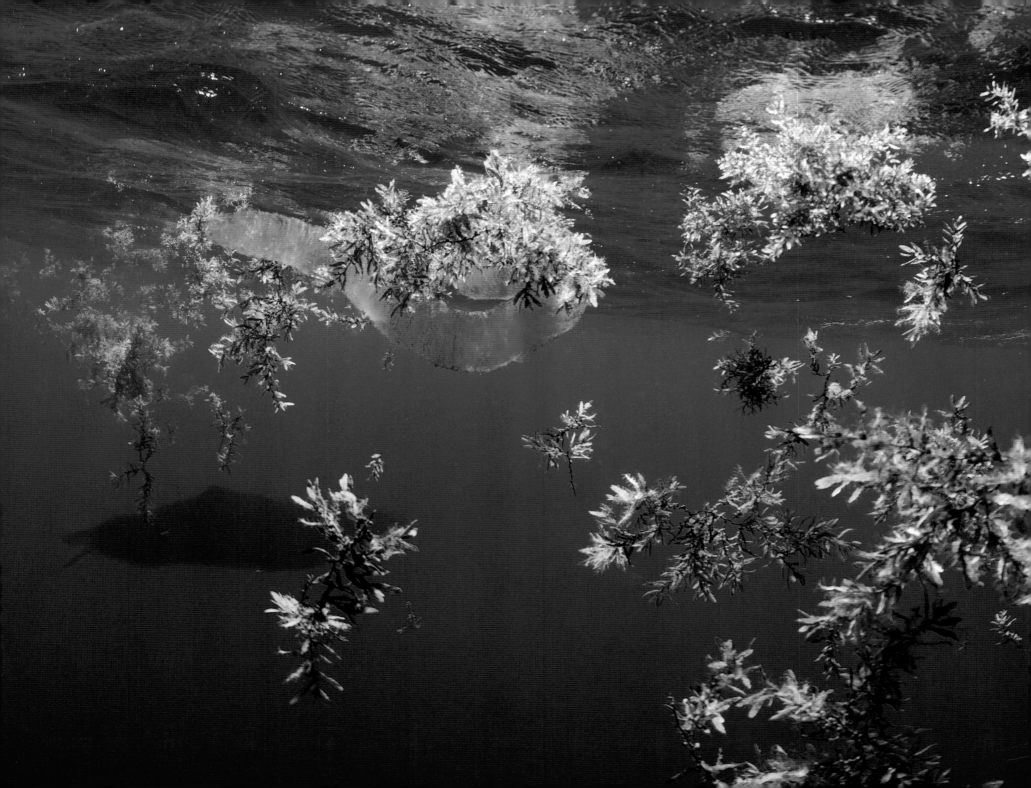

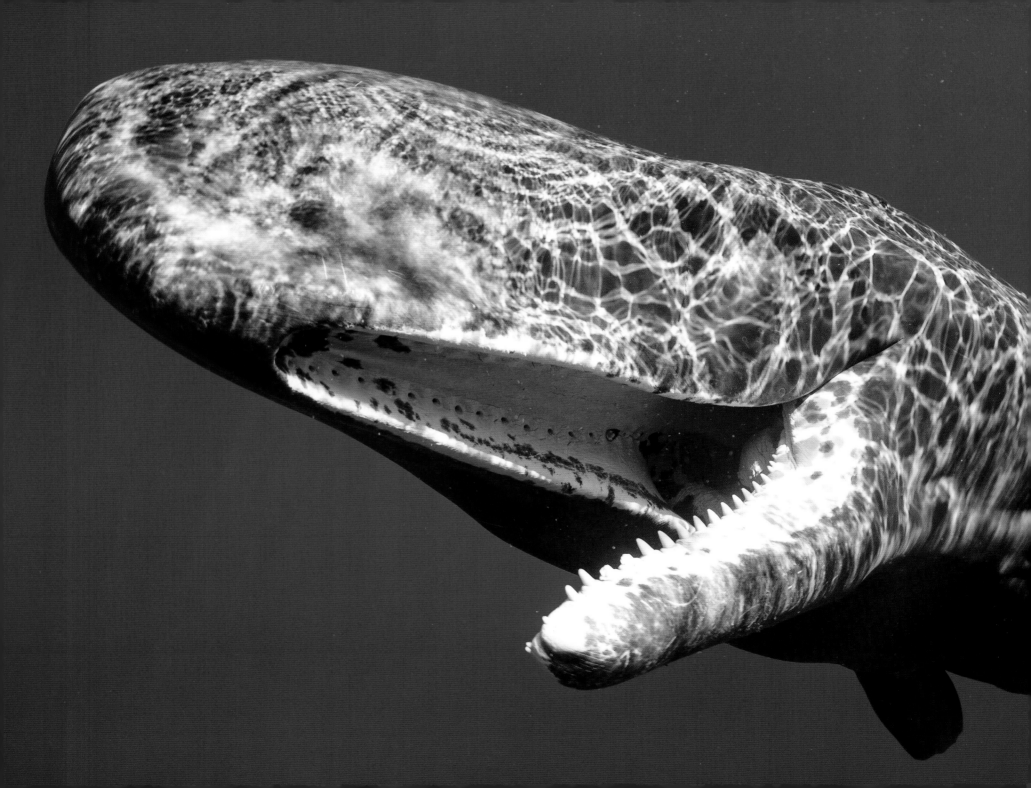

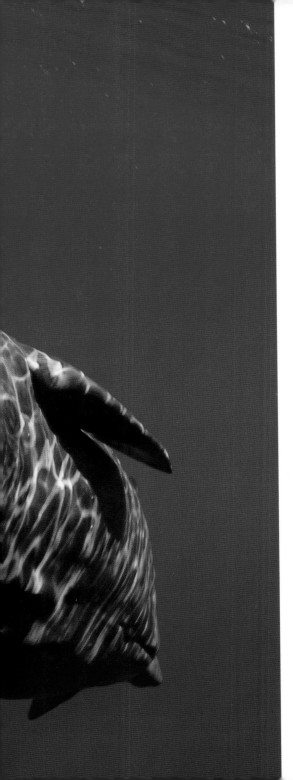

When you are welcomed into the world of sperm whales, it feels like you are having a conversation with them as opposed to watching them. They interact in a way I have never experienced with any other wild animal either on land or in the ocean. This whale, a pregnant female, kept me locked in her gaze for 30 minutes while she pirouetted around me, giving me a close-up look at her teeth and mouth. Sperm whales only have teeth on their bottom jaw. Their upper jaw has sockets for the teeth to fit into.

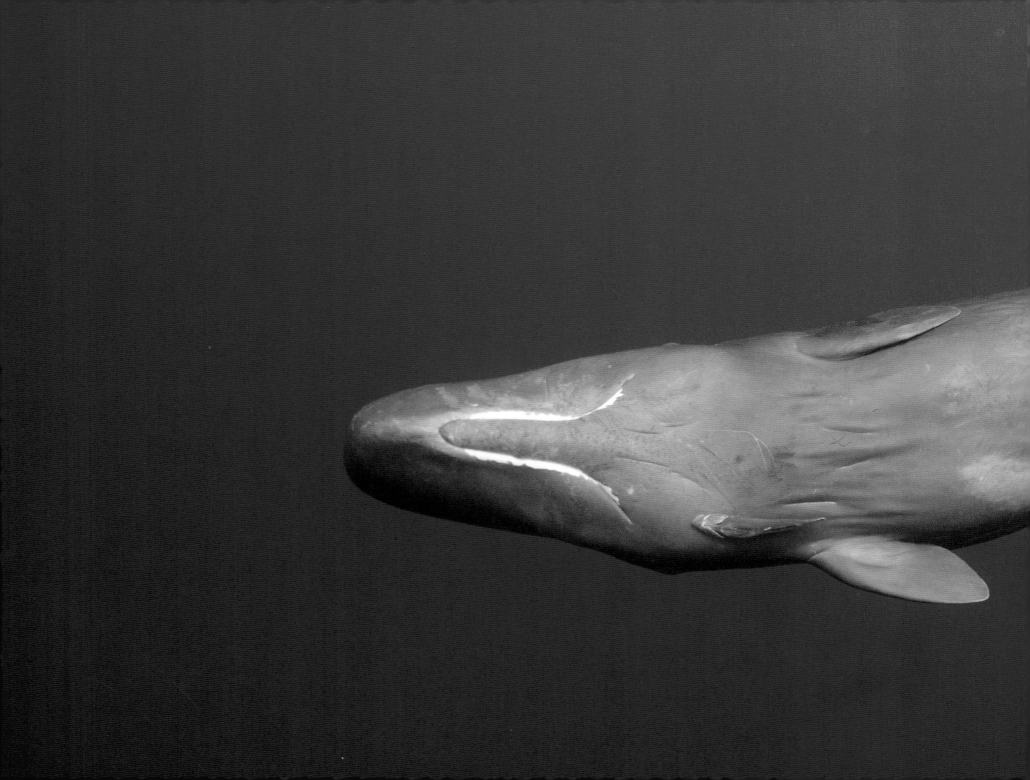

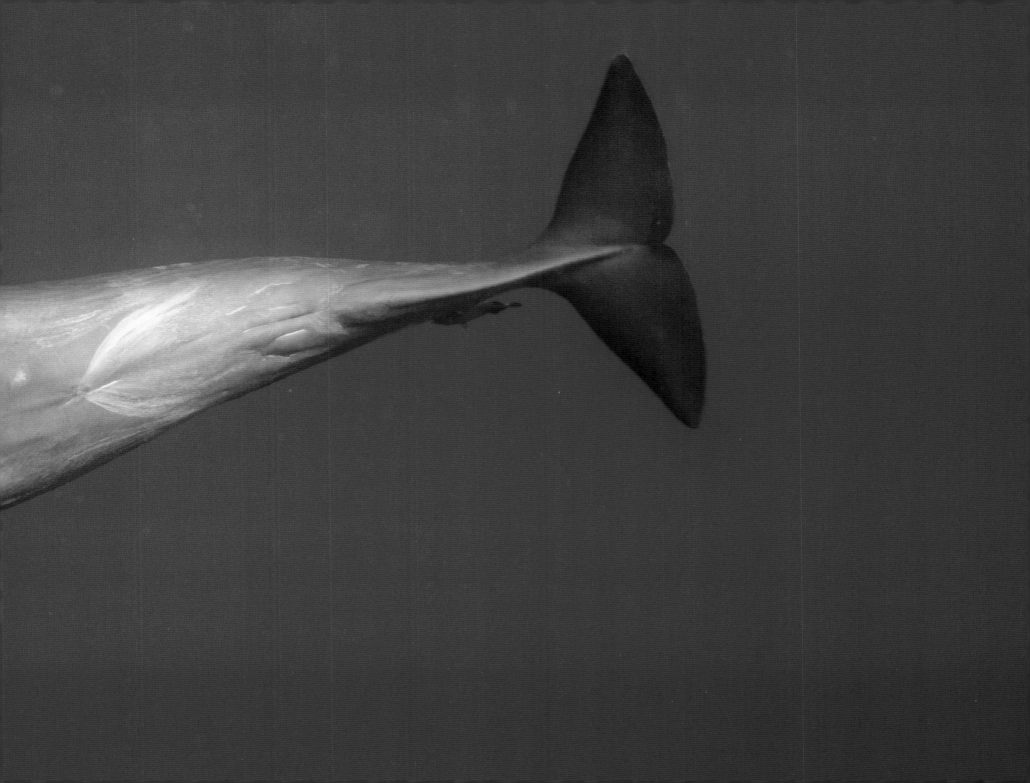

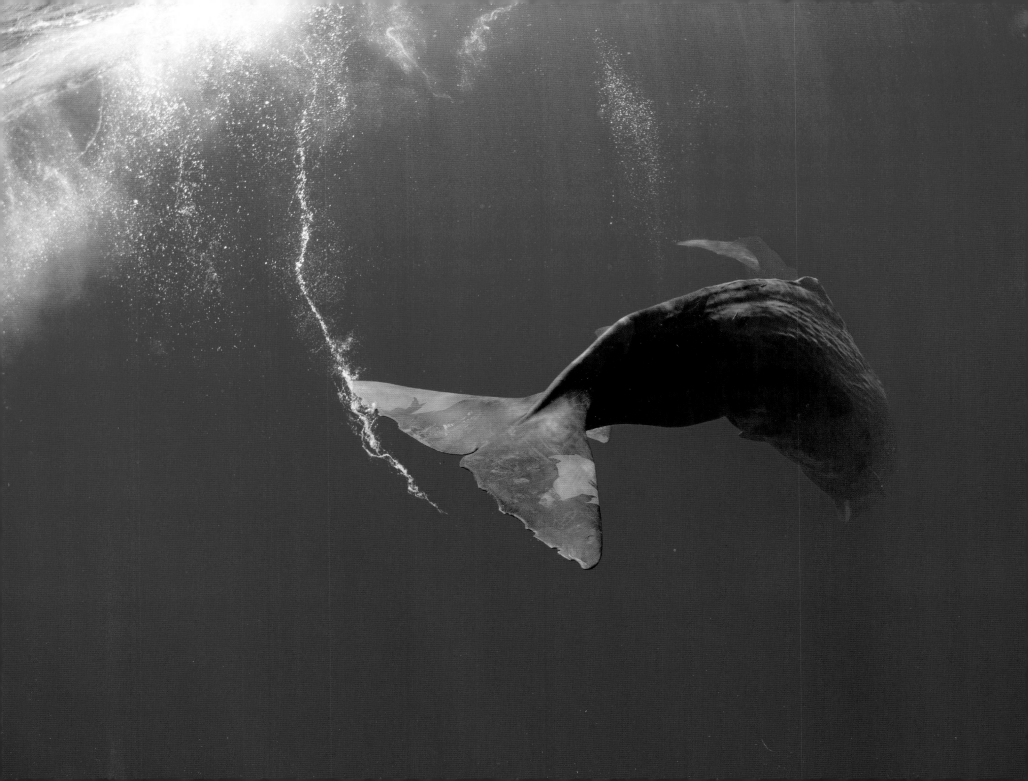

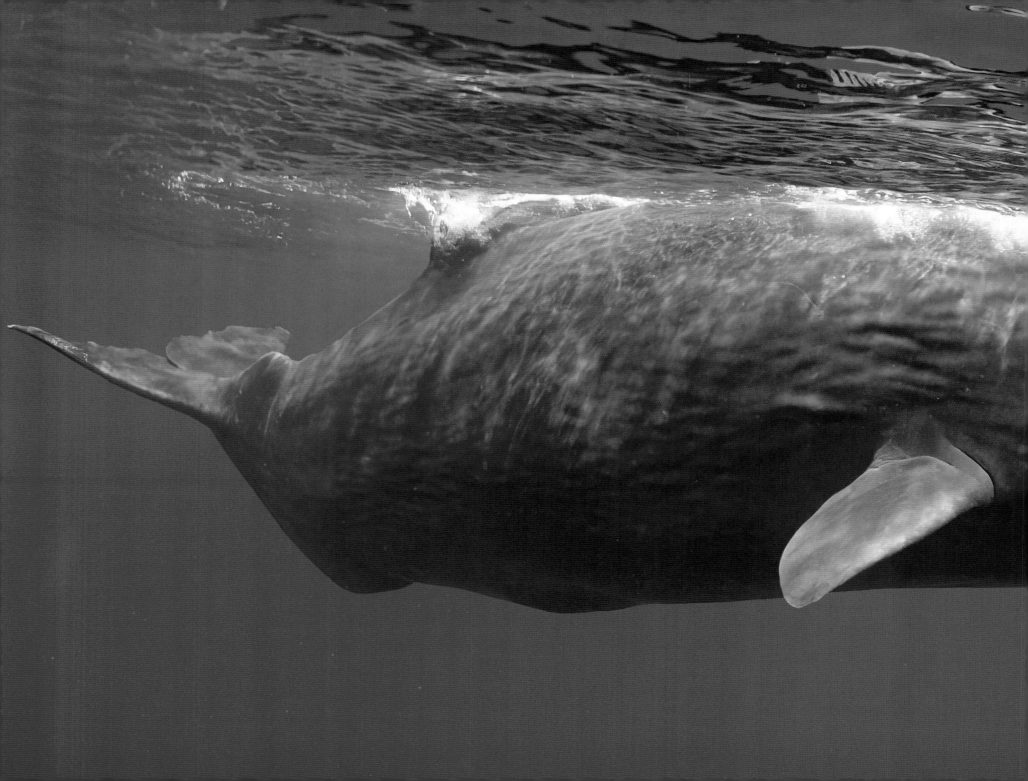

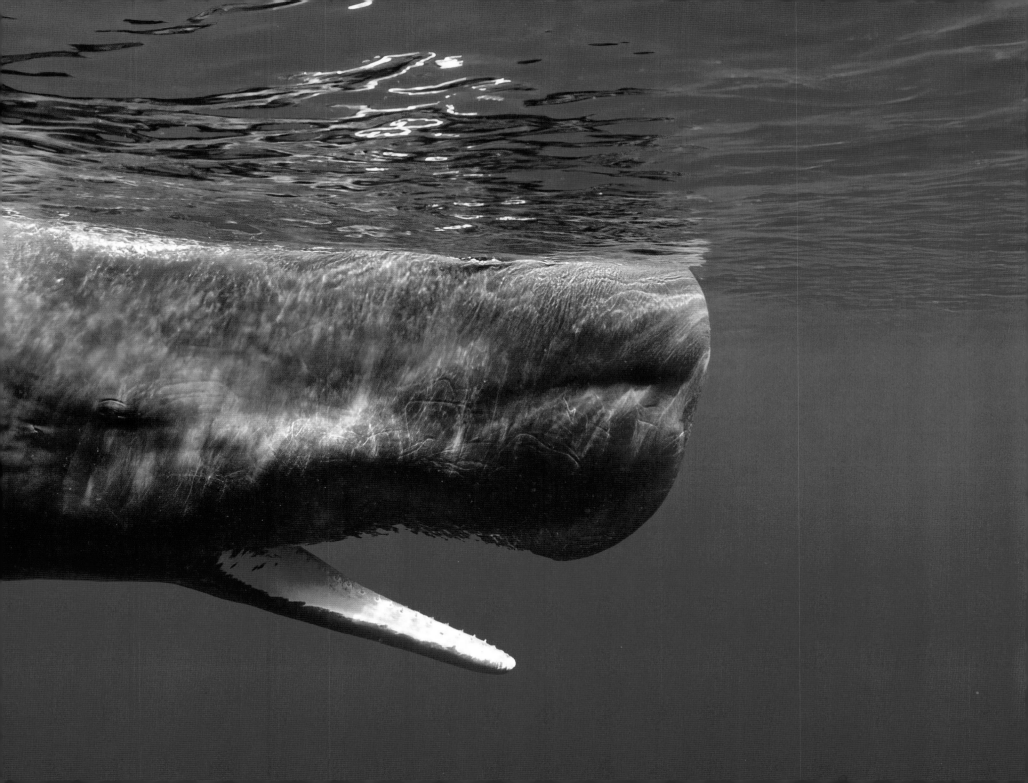

While swimming near the surface and not missing a beat, a newborn nurses from its mother, or possibly another female in its family. Sperm whales practice alloparenting, with many of the adult females sharing the responsibility of taking care of their young. The babies will nurse for approximately two years, but sometimes longer; juveniles up to 13 years old have been found with milk in their stomachs.

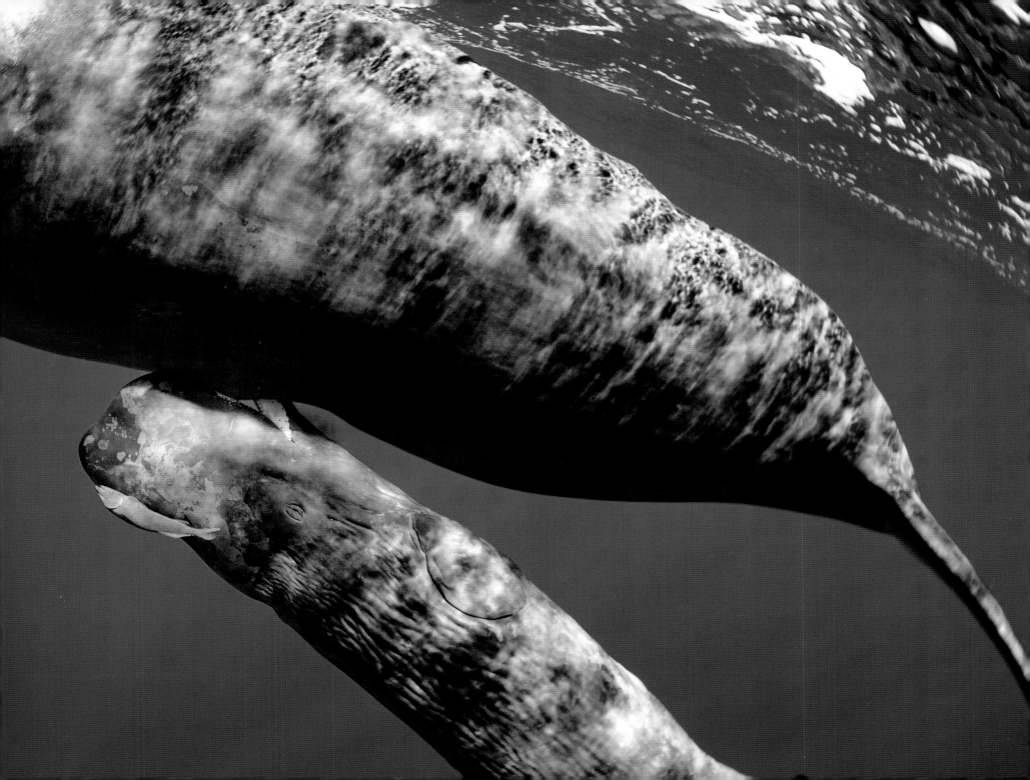

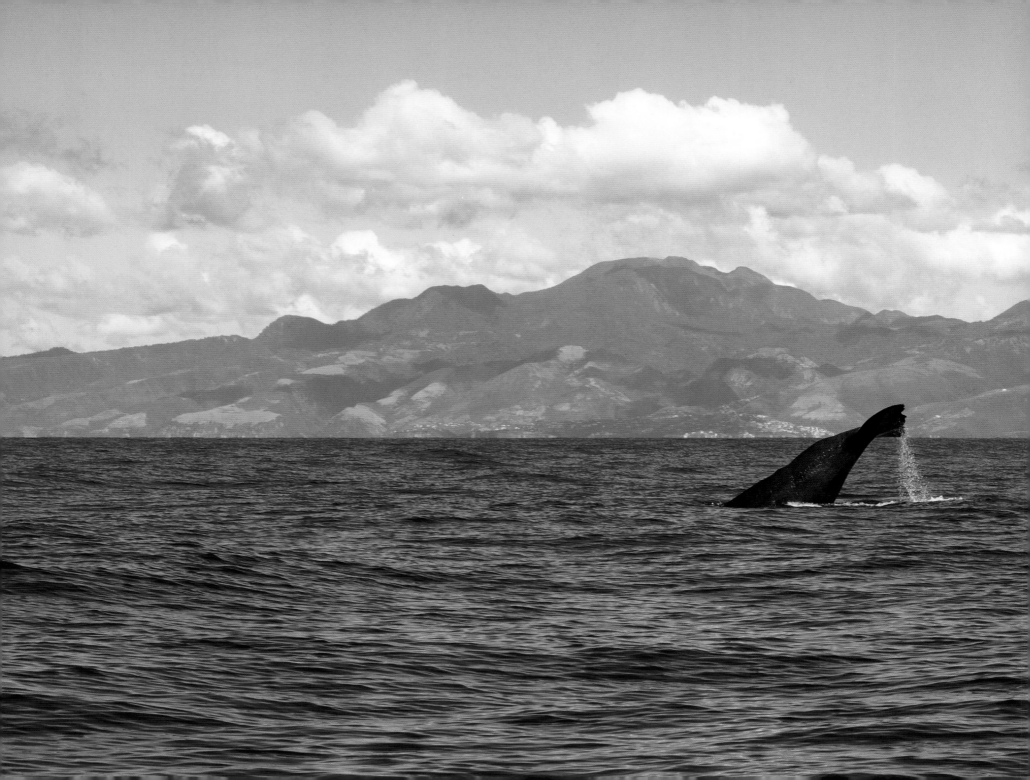

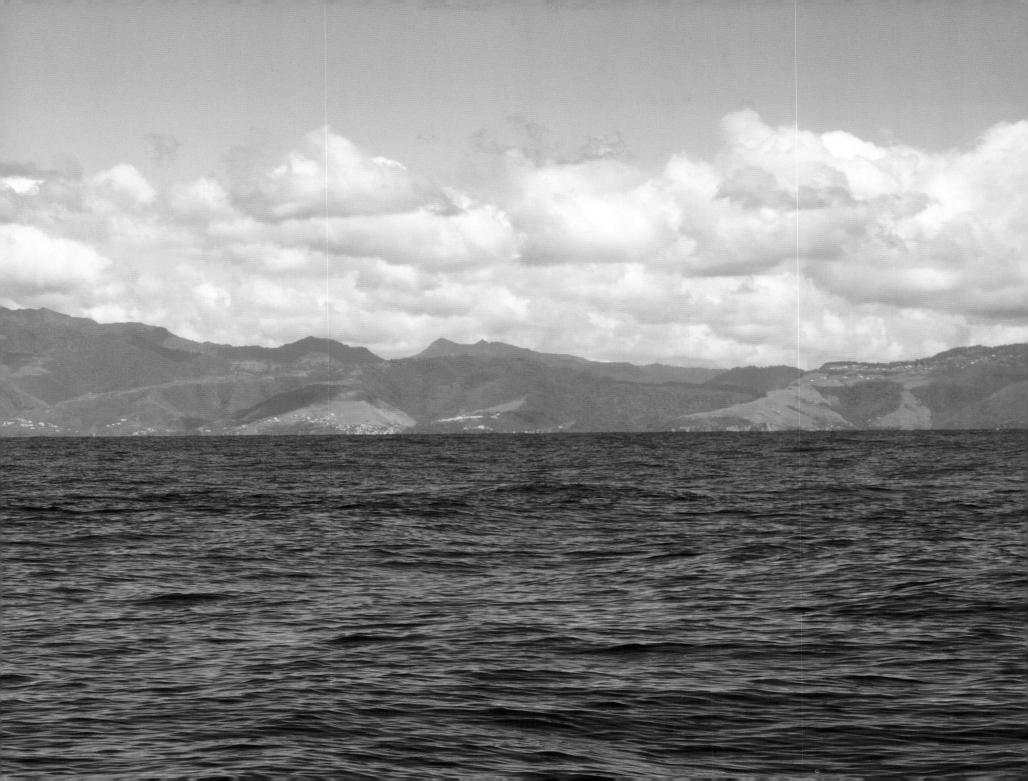

PREVIOUS SPREAD AND OPPOSITE: It was getting late in the afternoon, and we knew that we didn't have much more time on the water after an already amazing day, but in the distance we saw a whale tail slapping the water. Was it a call to gather? Often whales will breach and tail slap to get the attention of other whales. We slowly moved toward the whale on the surface. As we approached, we saw blows of a few whales socializing, meaning they were playing on the surface, but not moving much. I gently slipped into the water, and I couldn't believe what I saw. There were not only whales on the surface, but also at least five whales sleeping vertically below! They were both head up and head down, at depths from just below the surface to 60 feet and beyond. I am sure there were more whales that I could not see. On the surface, an adult female was taking care of the newborns, frolicking and grooming them. One of the females kept looking at me and then back at the babies. Everywhere I looked, there were whales. Babies and adults swam up to me and then back to their family. This was socializing like I never could have imagined.

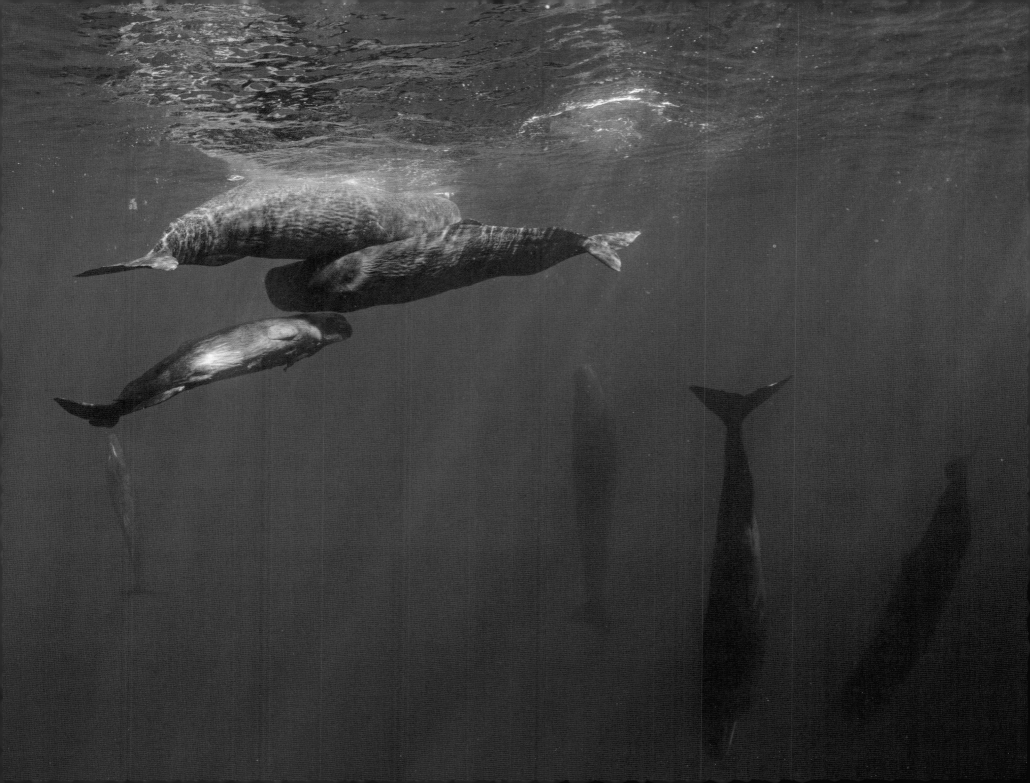

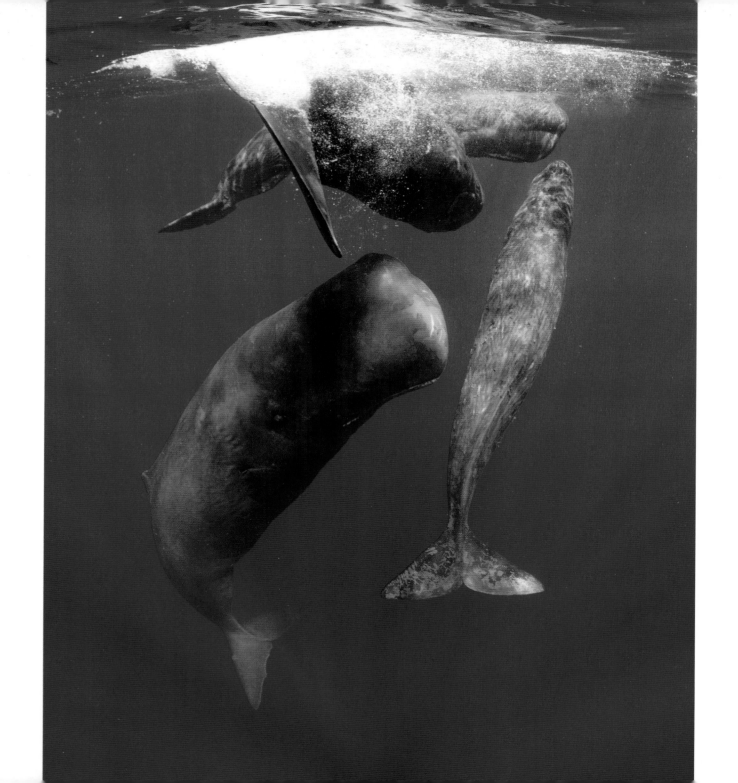

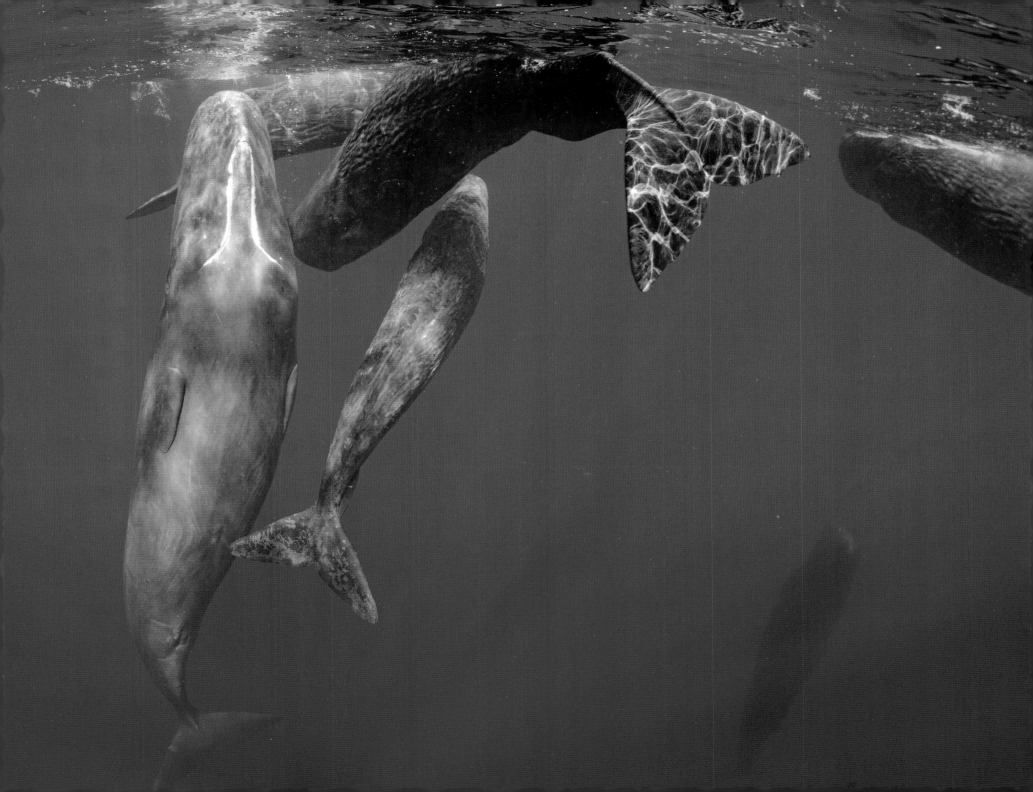

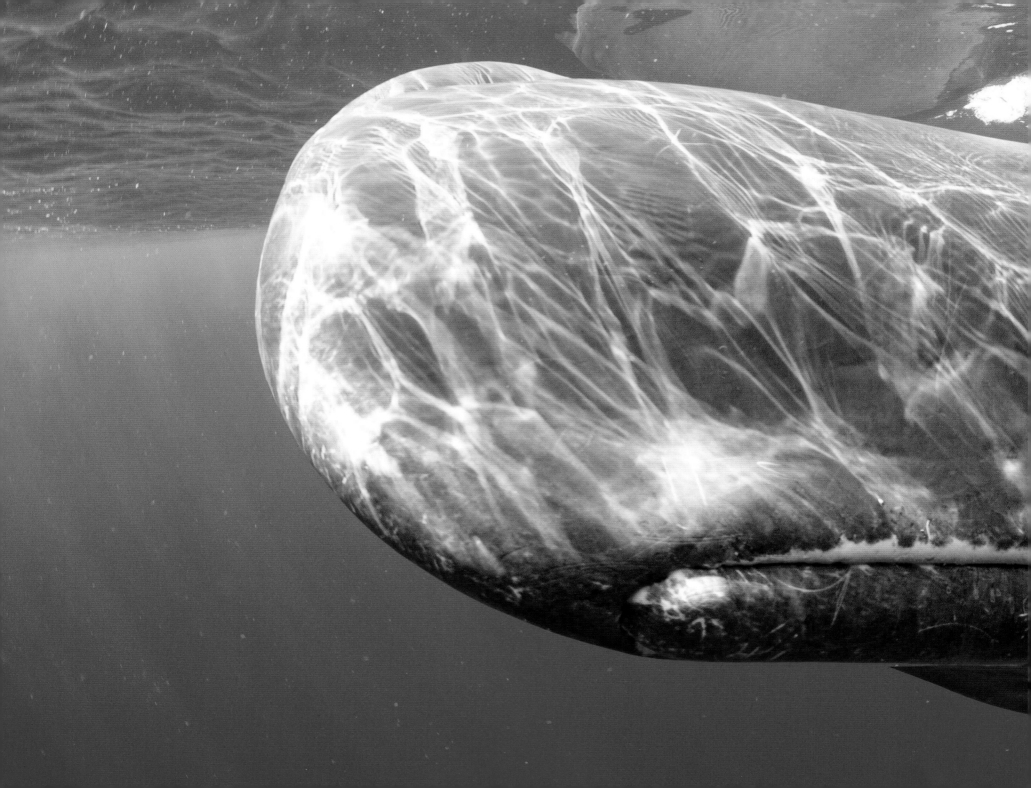

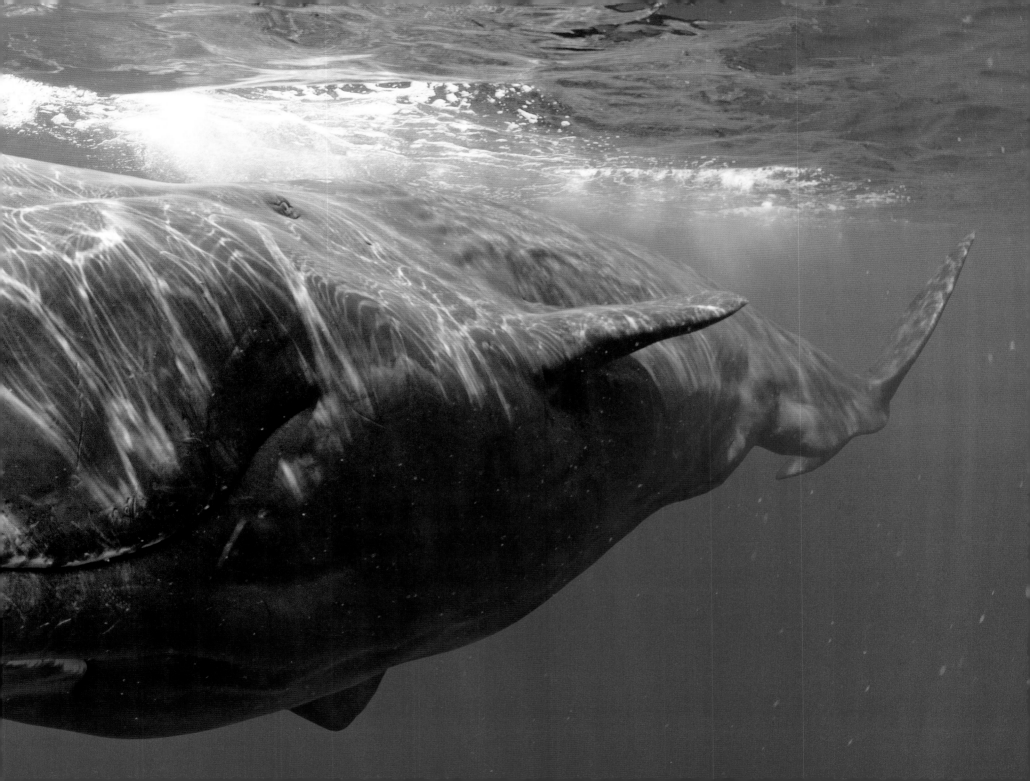

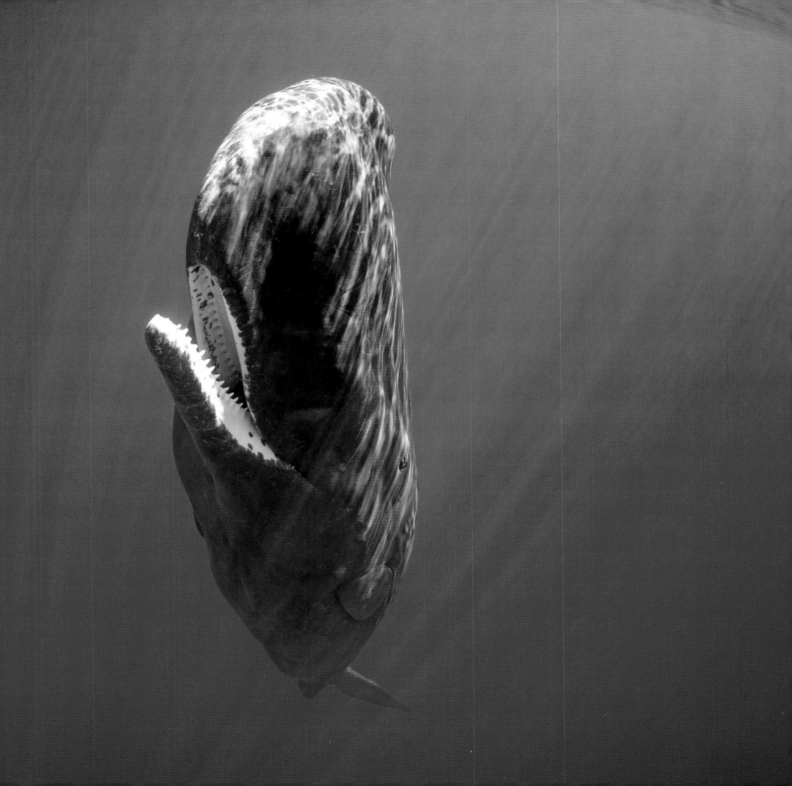

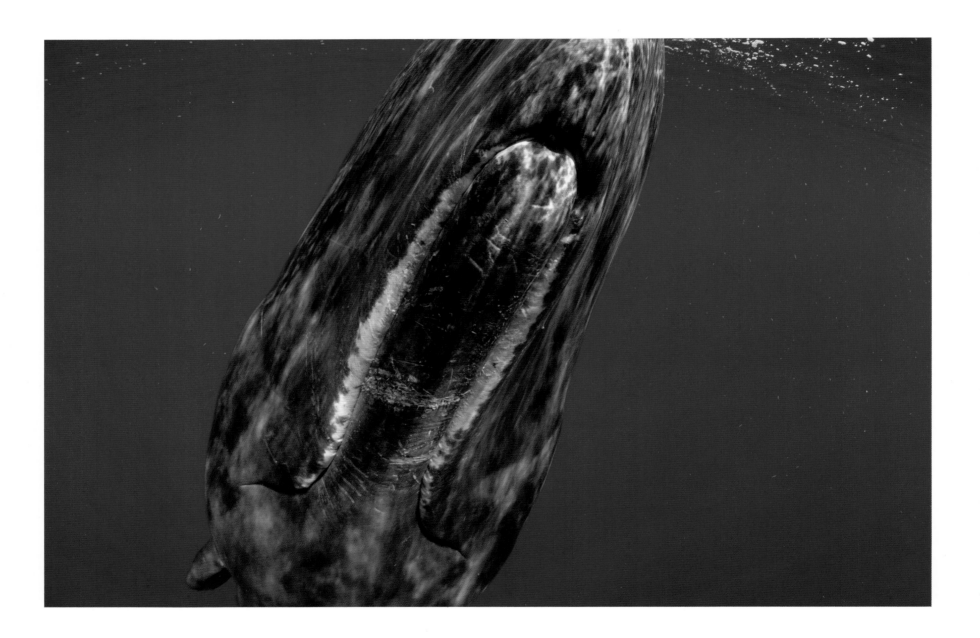

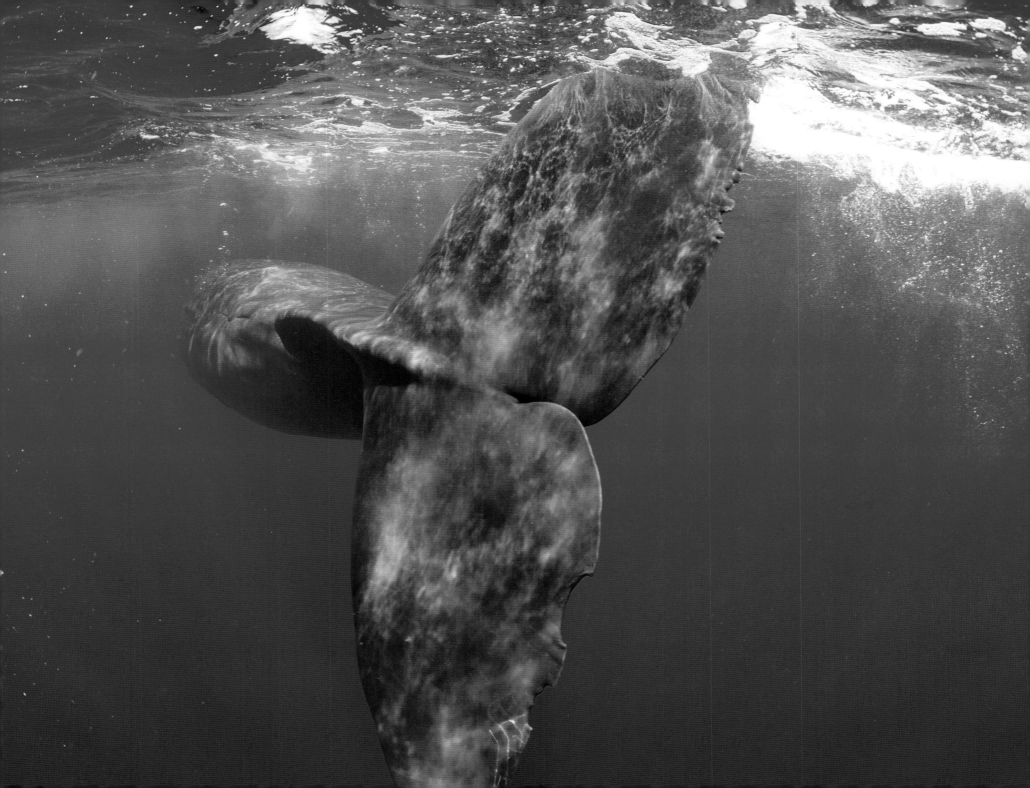

Three generations of whales—Fruit Salad, Soursop, and Ariel—swim together in formation, with Ariel copying her mother and grandmother clicking on me with open mouths. I could feel their sonar clicks as they sized me up. It was adorable to watch this one-year-old whale interacting with her elders, copying their every movement and learning from them.

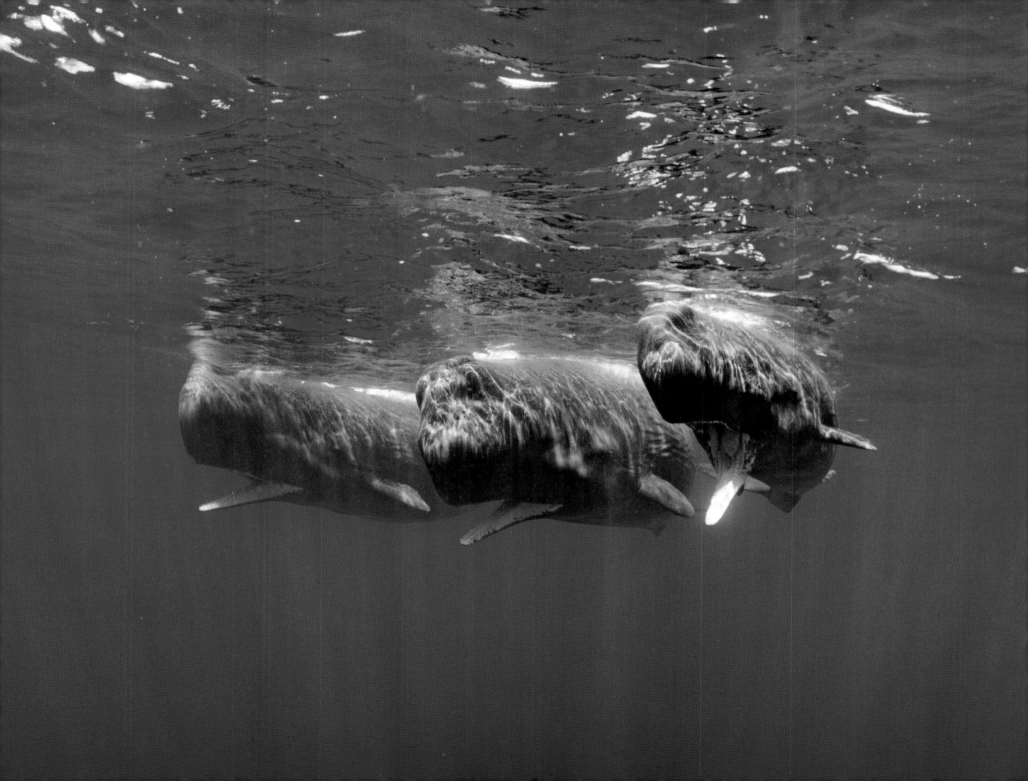

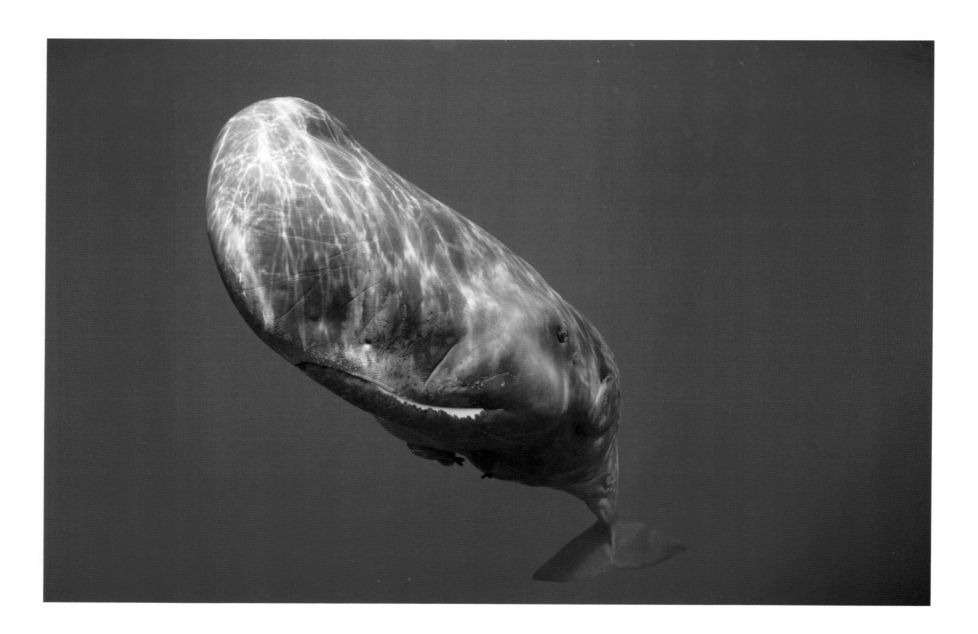

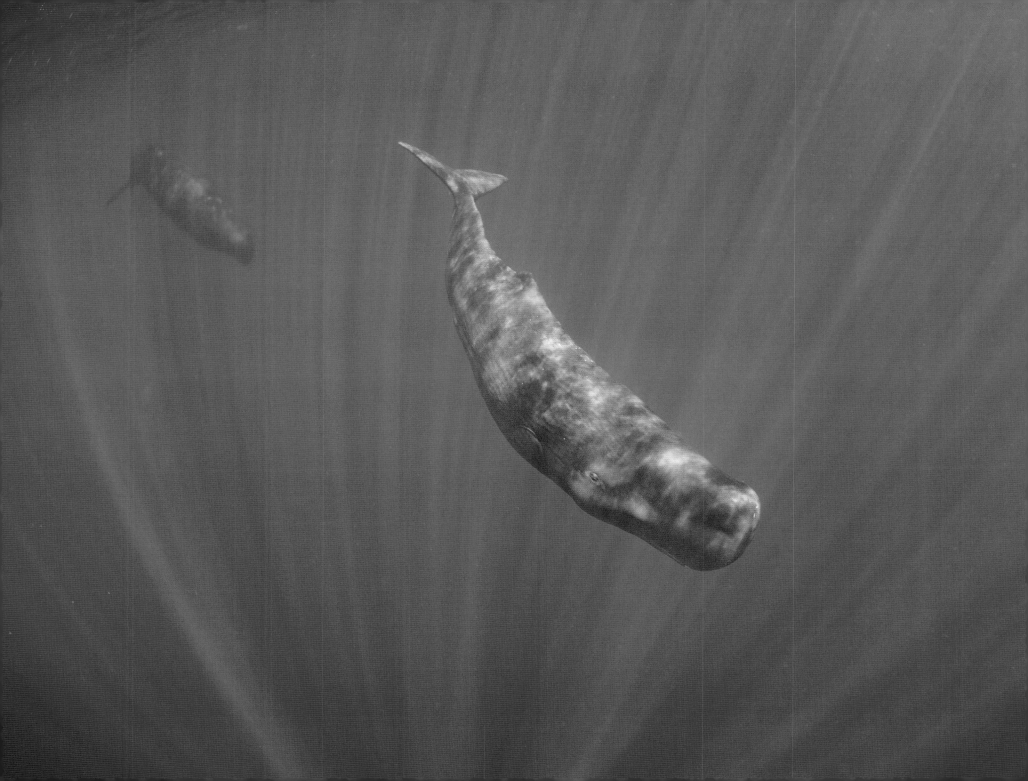

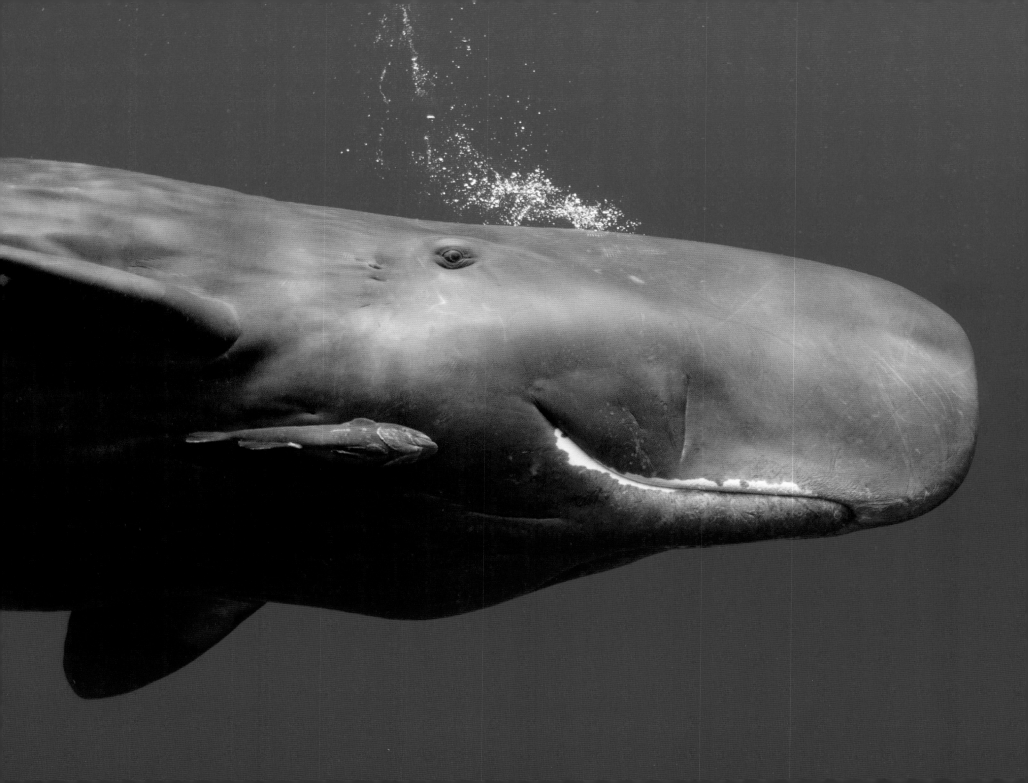

The tenderness between mother and babies among sperm whales is something that amazes me and is so humanlike. They frequently touch and keep an eye on one another. The stable and complex matrilineal society of sperm whales is similar to that of elephants.

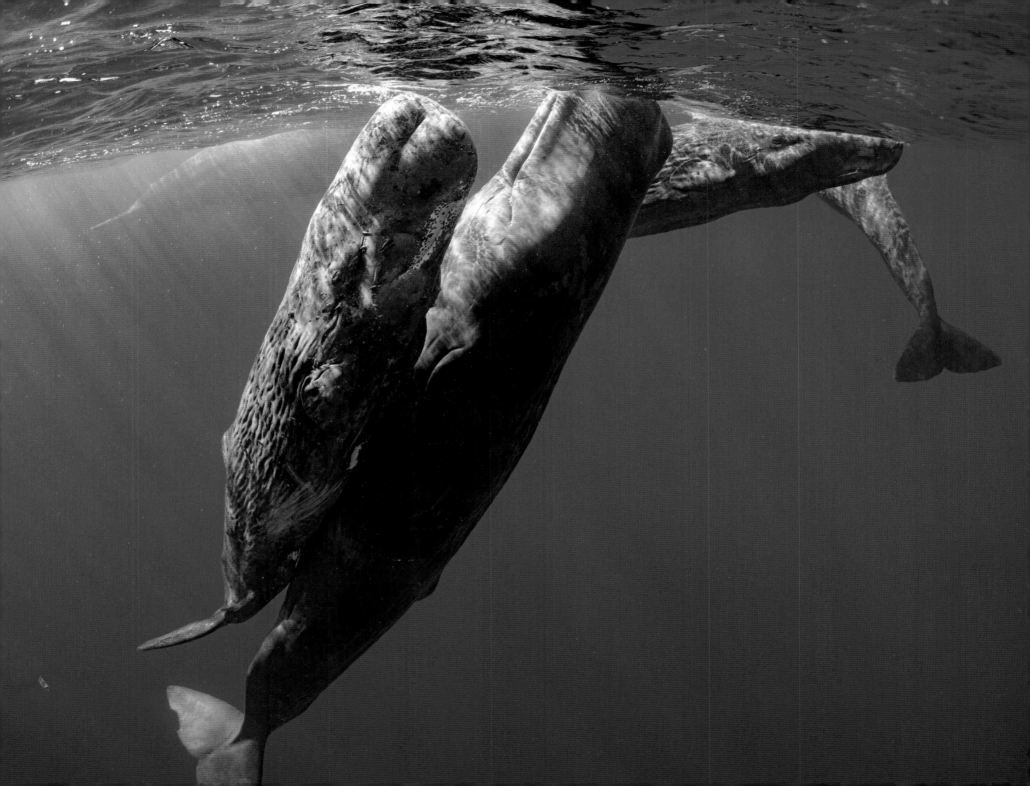

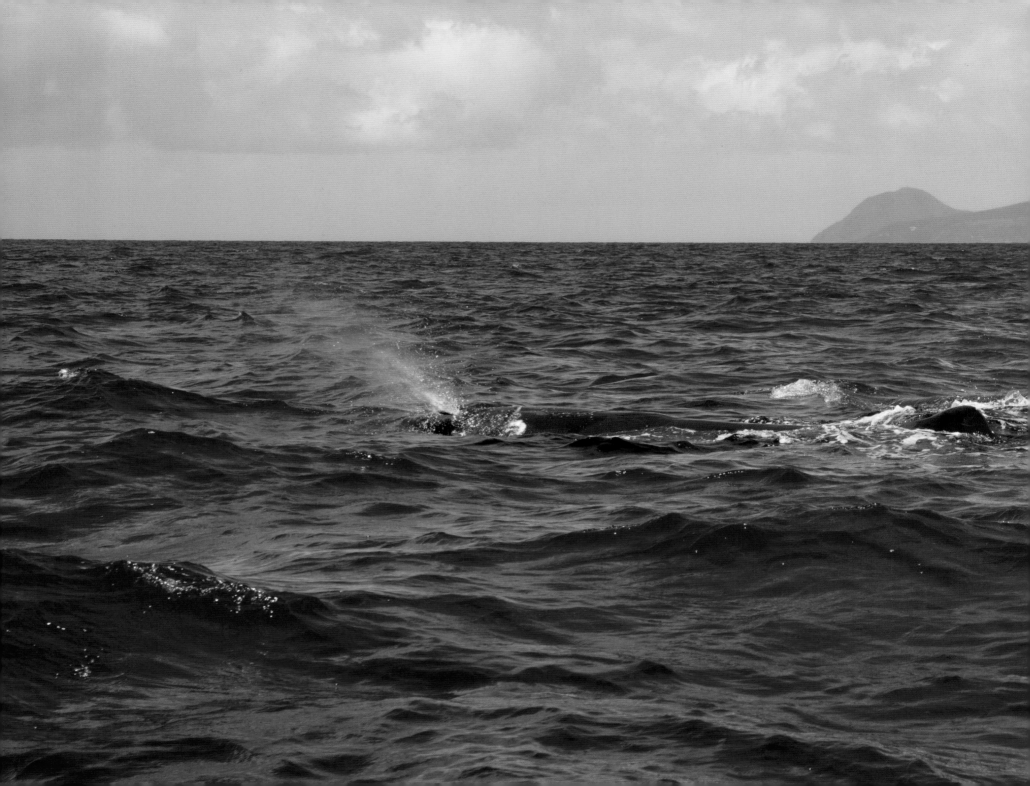

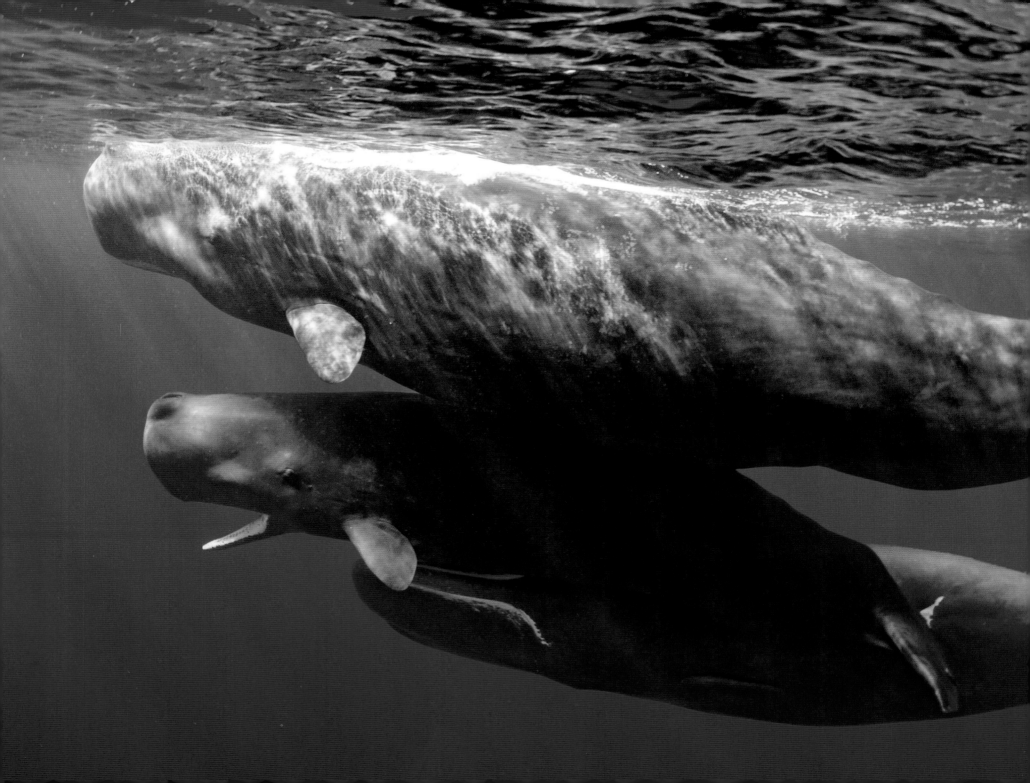

OPPOSITE: A newborn peeks out from underneath its older cousin's belly. While the adults teach their young, it is clear that babies also learn from their older siblings and cousins.

OVERLEAF, LEFT: A whale louse, a small parasitic amphipod, clings onto the pectoral fin of a whale. These parasites are common and have specialized features, such as hooked appendages and a flattened, leaflike body to help them deal with the high pressures they experience when whales dive to extreme depths.

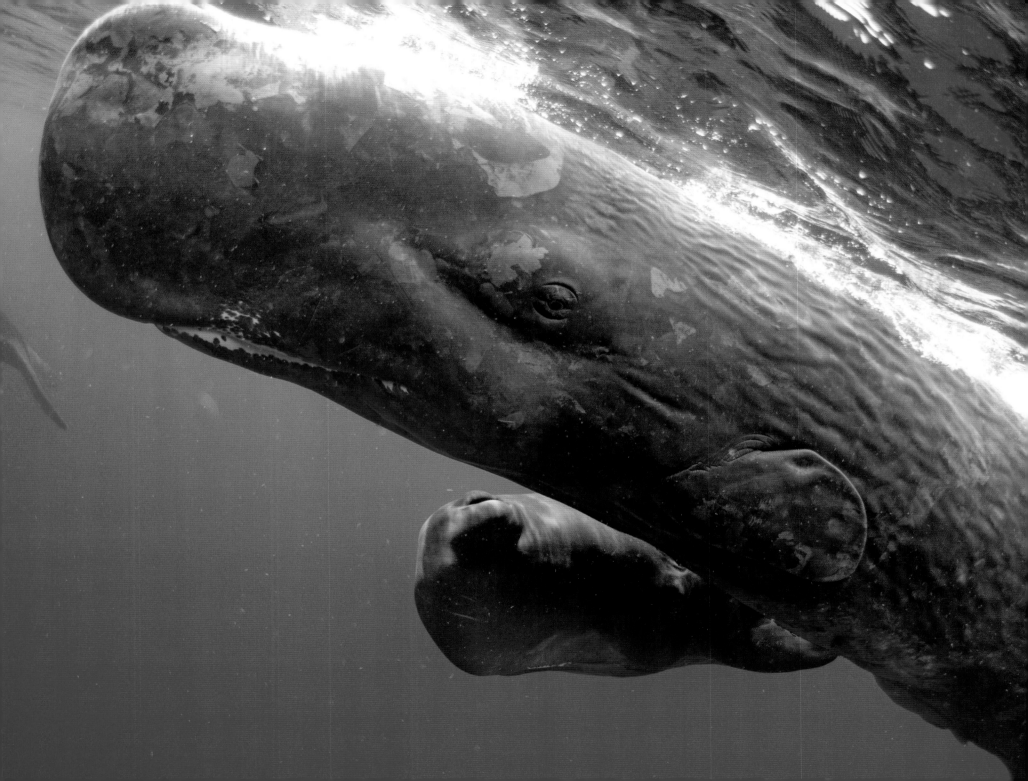

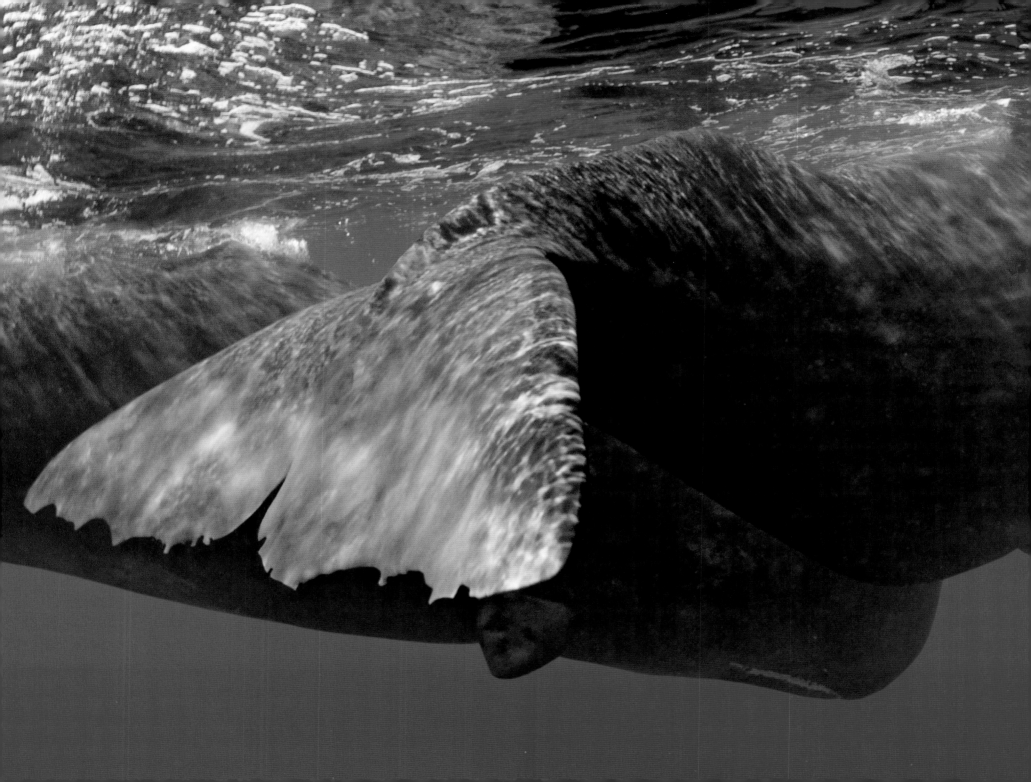

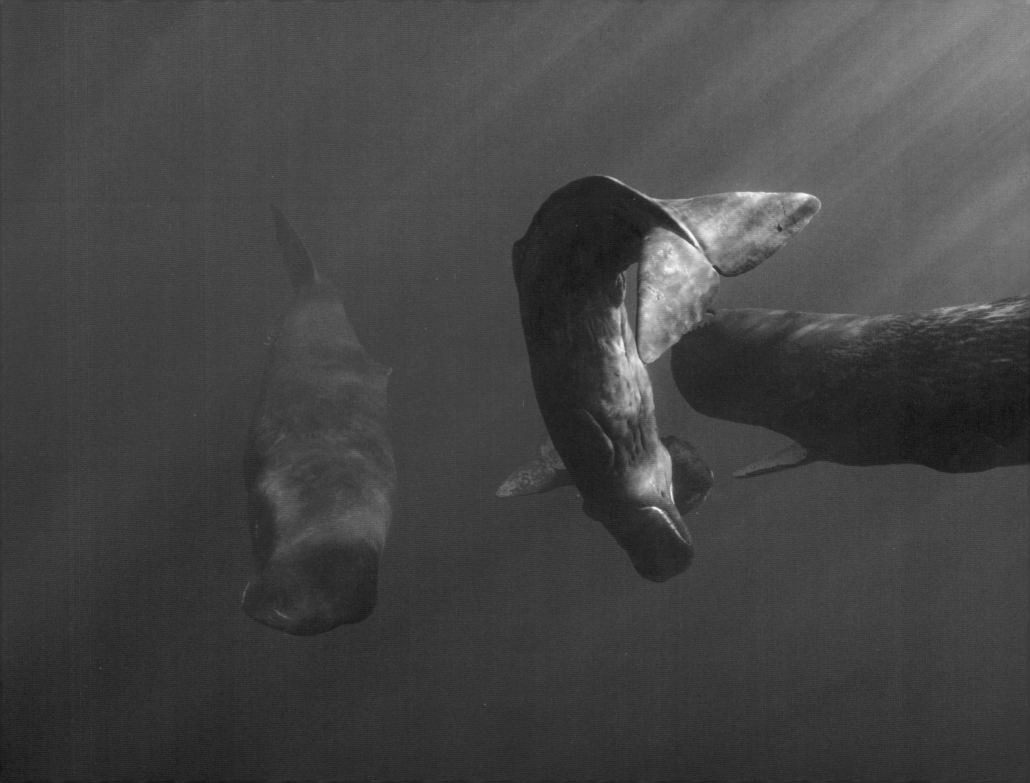

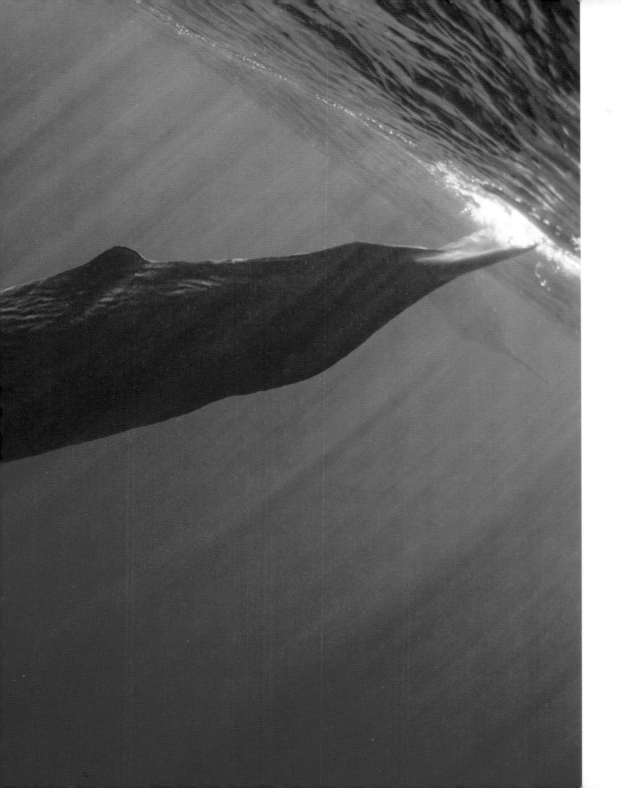

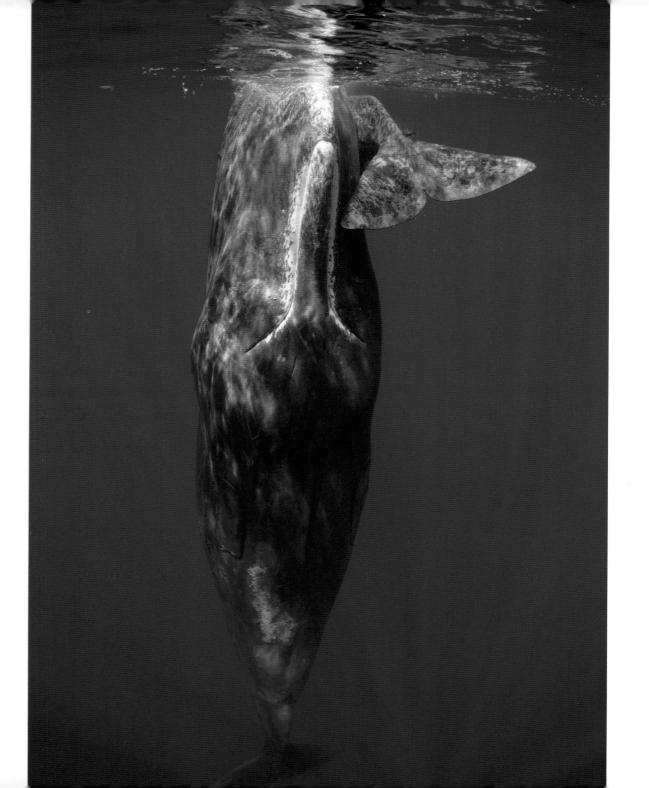

As this mother slept, her baby swam around her, staying nearby for protection and comfort. Unlike any other species of whale, sperm whales sleep vertically, either at depth or bobbing near the surface. It is rare to observe sleeping whales, but the baby breathing at the surface helped us find this individual. As I swam next to the sleeping whale, I was struck by the sheer size of her head, which makes up one-third of her total body length and mass. Inside this enormous head is the largest brain of any animal on the planet. One can easily see how the species got its scientific name, *Physeter macrocephalus*, which comes from the Greek word for "bigheaded."

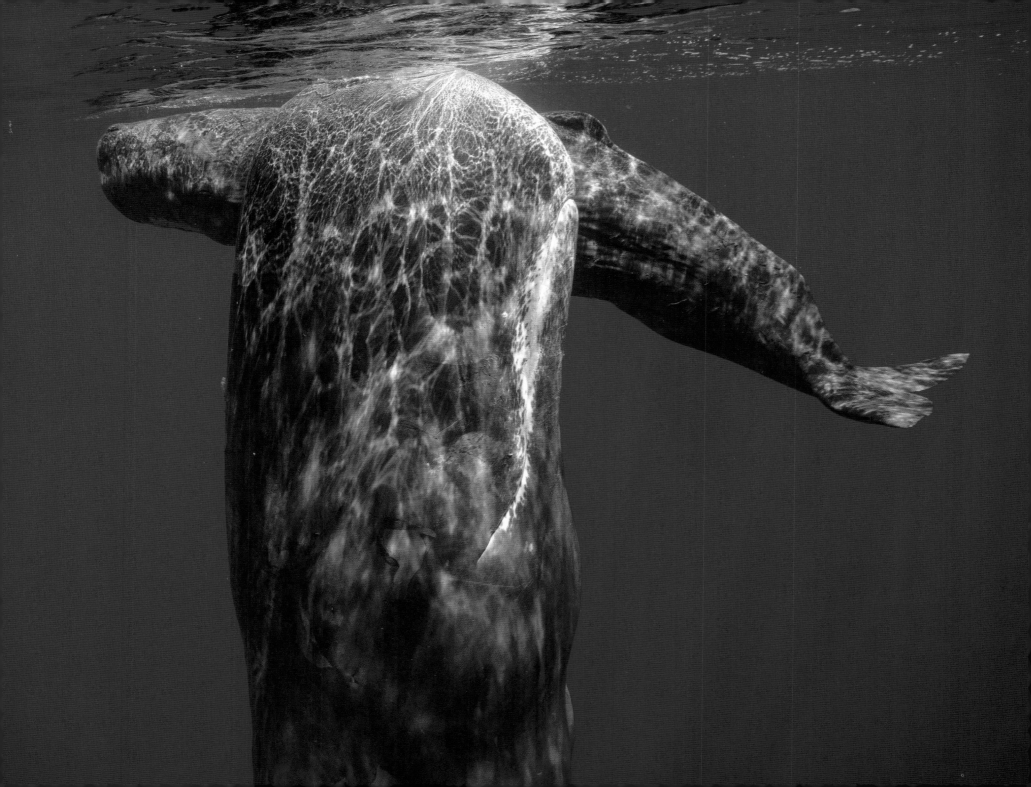

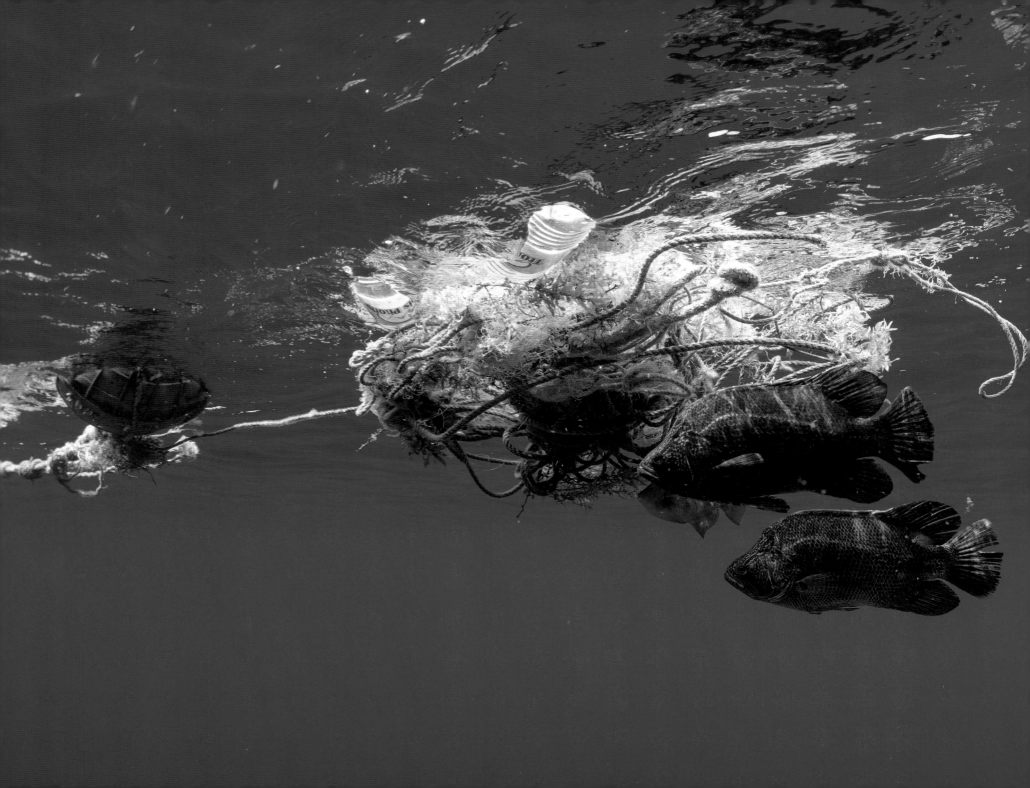

A school of tripletail swim near a fish-aggregating device (FAD). FADs—essentially a hodgepodge of old fishing gear, plastic, and buoys—are put out by local fishermen to attract the fish that they're targeting. In the vast open ocean, FADs are a refuge for fish, providing shelter and a potential hiding place from predators. They pose a threat to sperm whales, as the animals can become entangled in the hundreds of feet of line and netting. Once entangled, it is very difficult to get free and can often lead to starvation and lack of mobility for the whale. We jumped in the water near some of the FADs and found an abundance of fish and, fortunately, no entangled whales. In addition to FADs and other marine debris, sperm whales face even more anthropogenic threats, like ship strikes and pollution, as they swim through these waters.

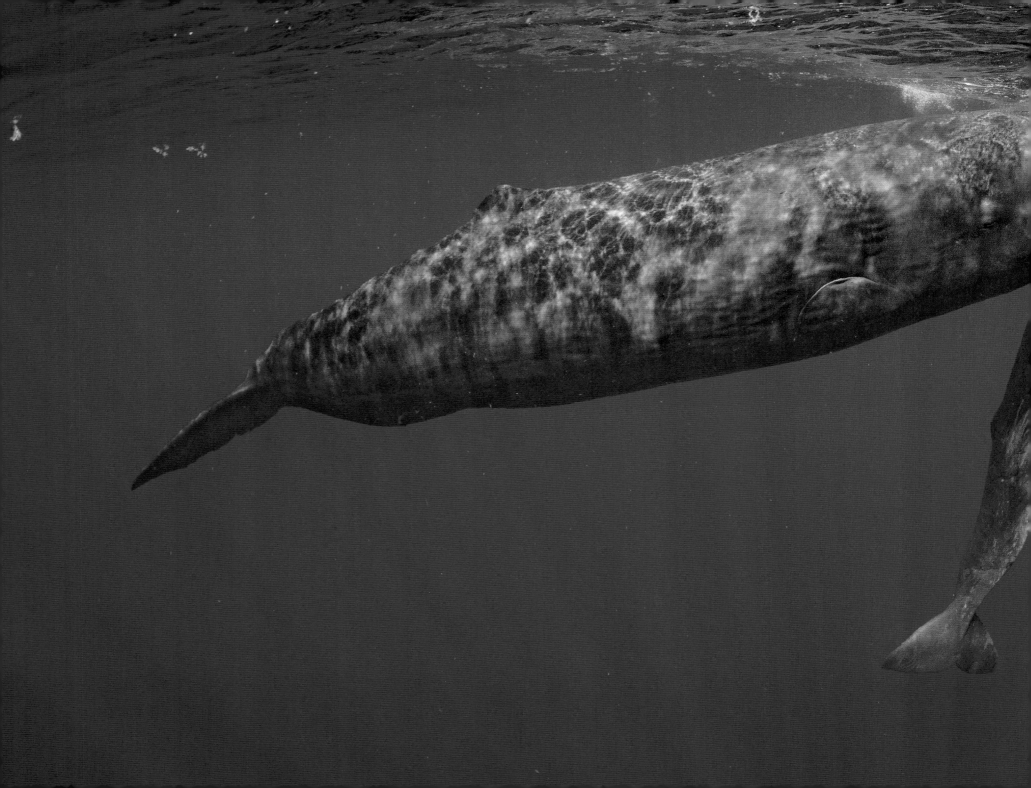

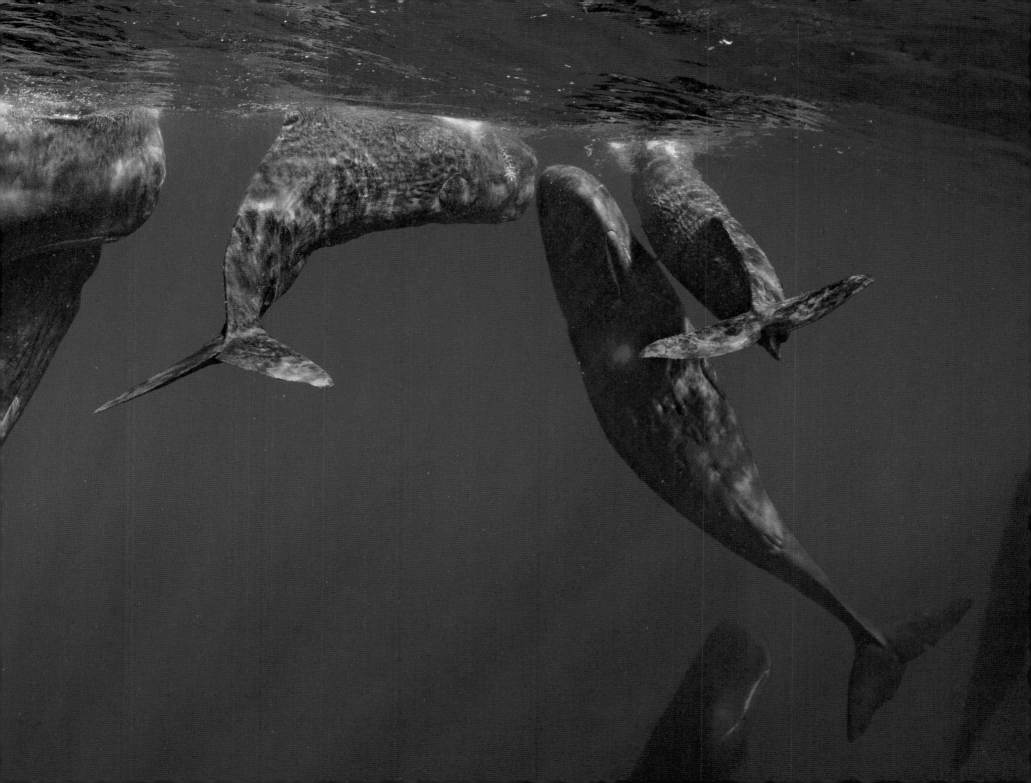

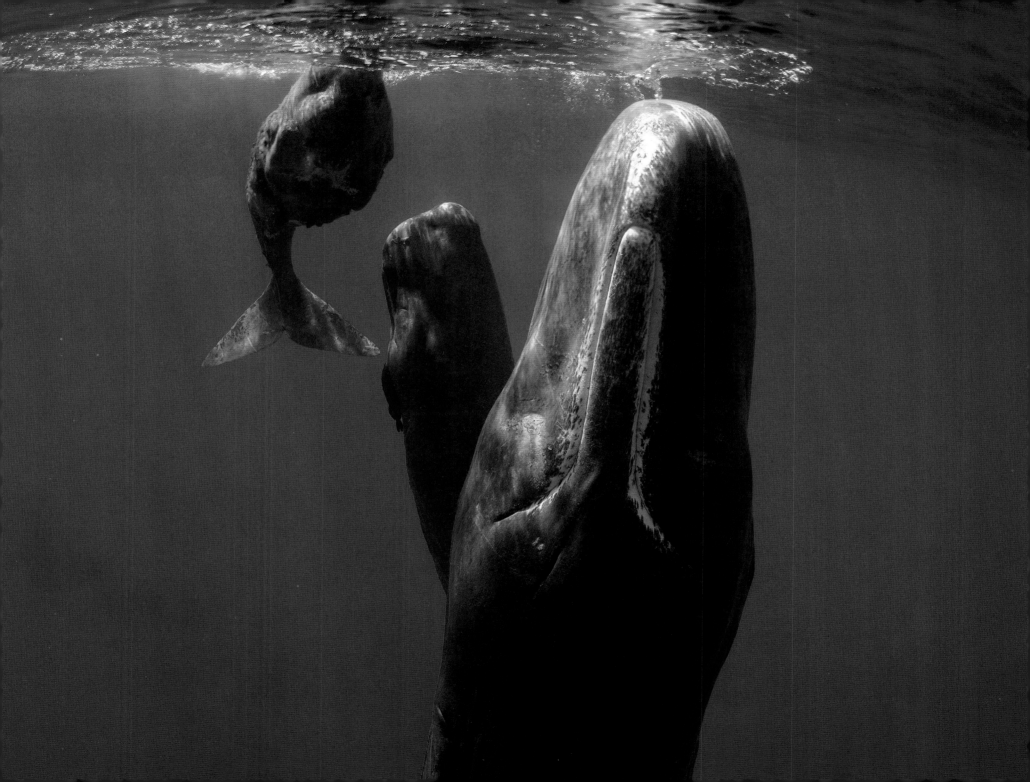

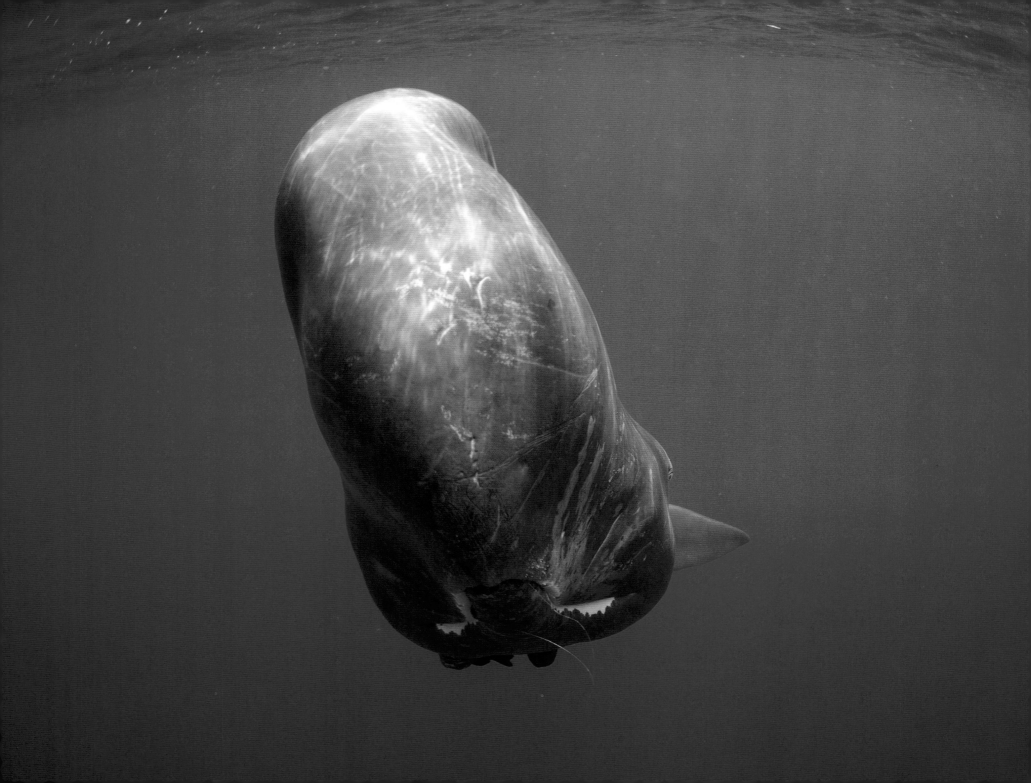

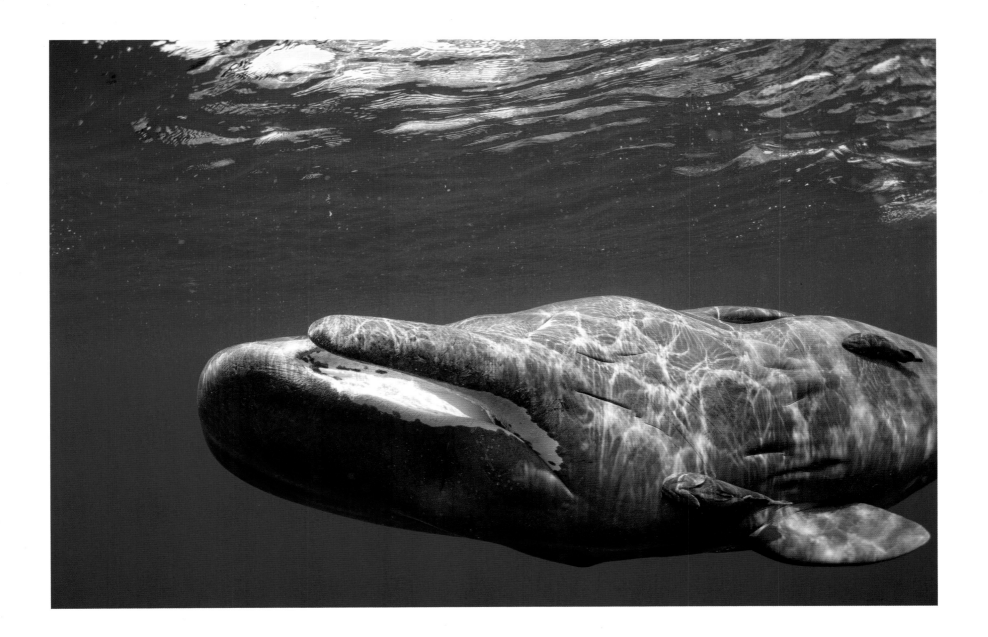

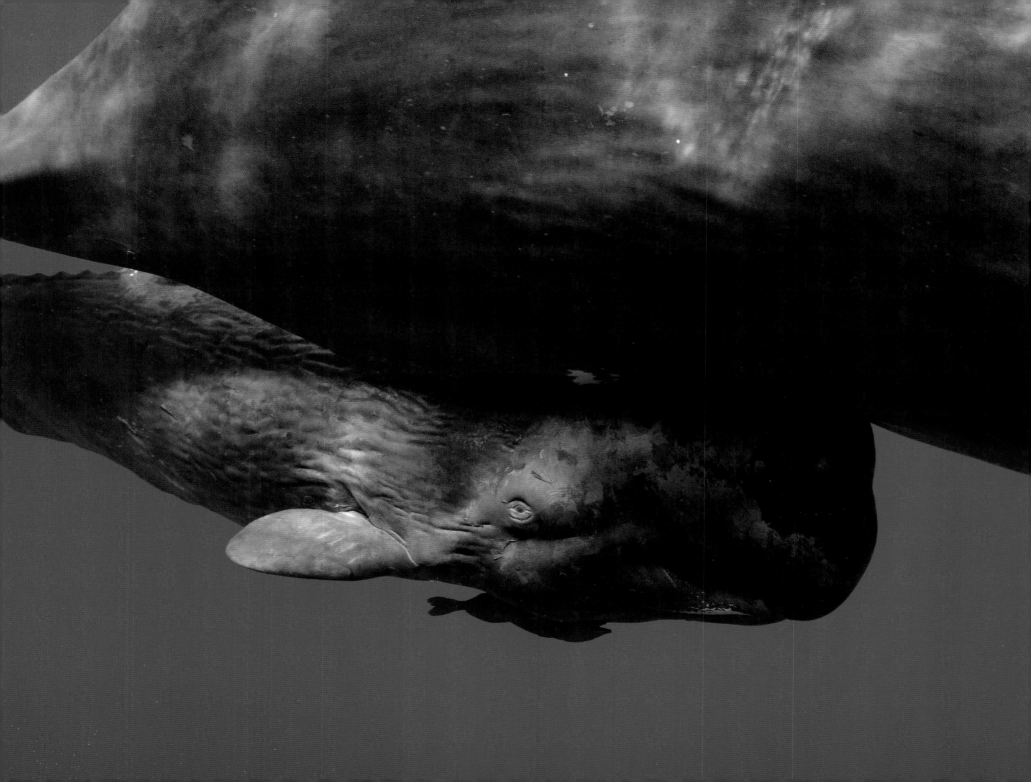

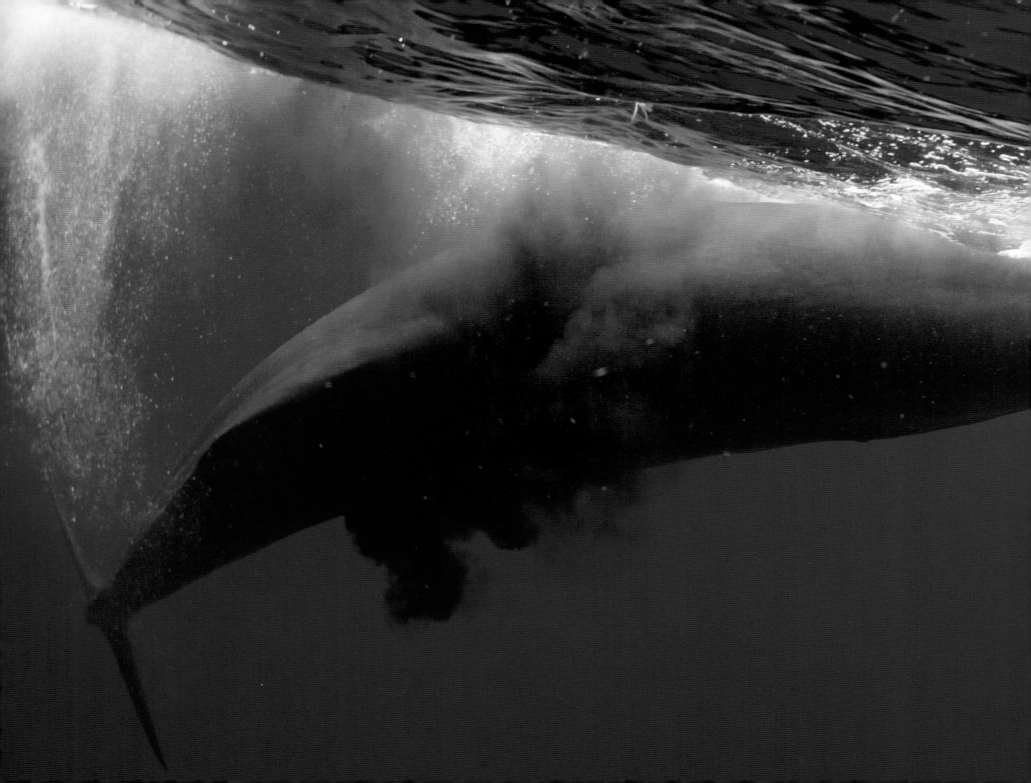

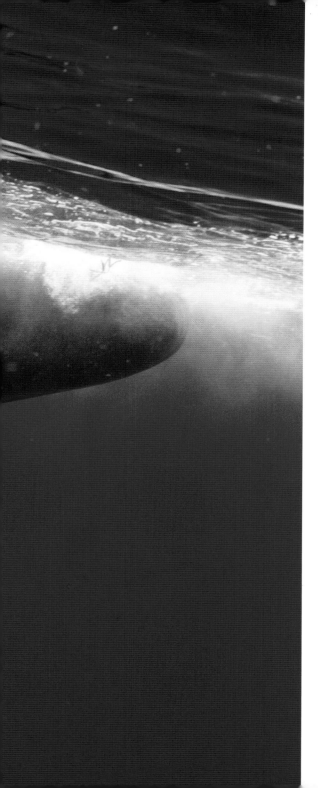

On our second expedition to Dominica, we got pooped on a lot! There was always a moment you knew it was coming. The whale would slow down, pause, start rolling, and then suddenly we would be in a cloud of poop. Then the whale would dive to hunt. Whale poop plays an extremely important role in the nutrient cycle of the ocean. Because sperm whales feed at great depths, they bring nutrients from the deep sea up to the surface waters to fertilize the phytoplankton, which are the building blocks of the food chain. They are one of the most ecologically significant animals in the ocean.

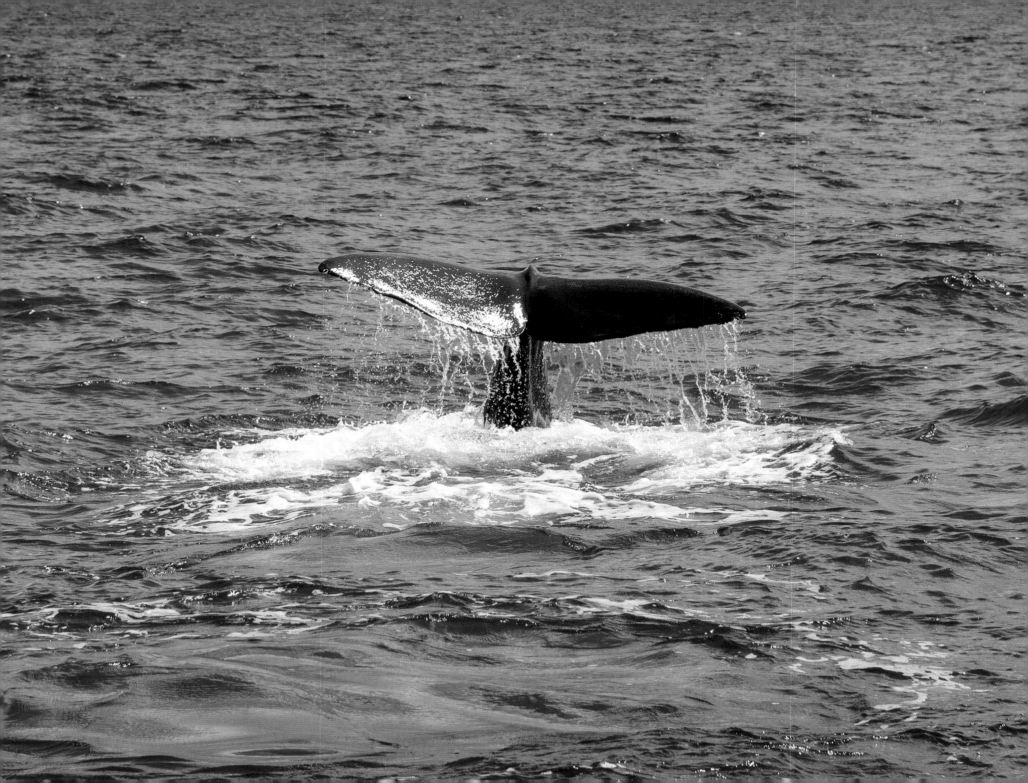

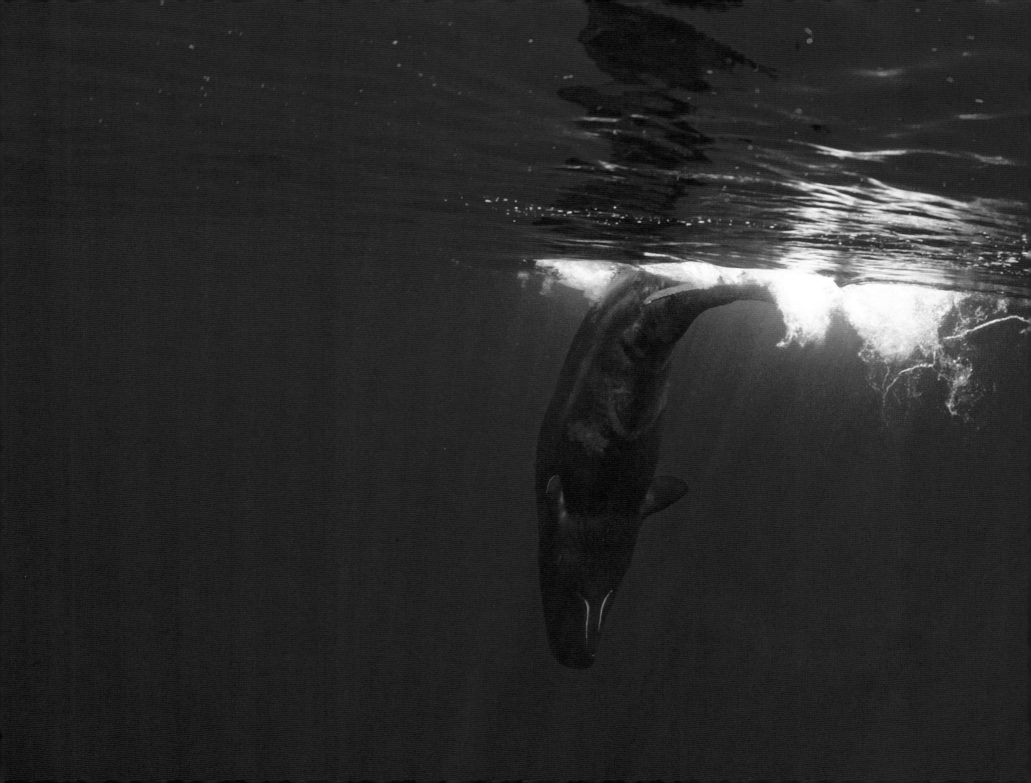

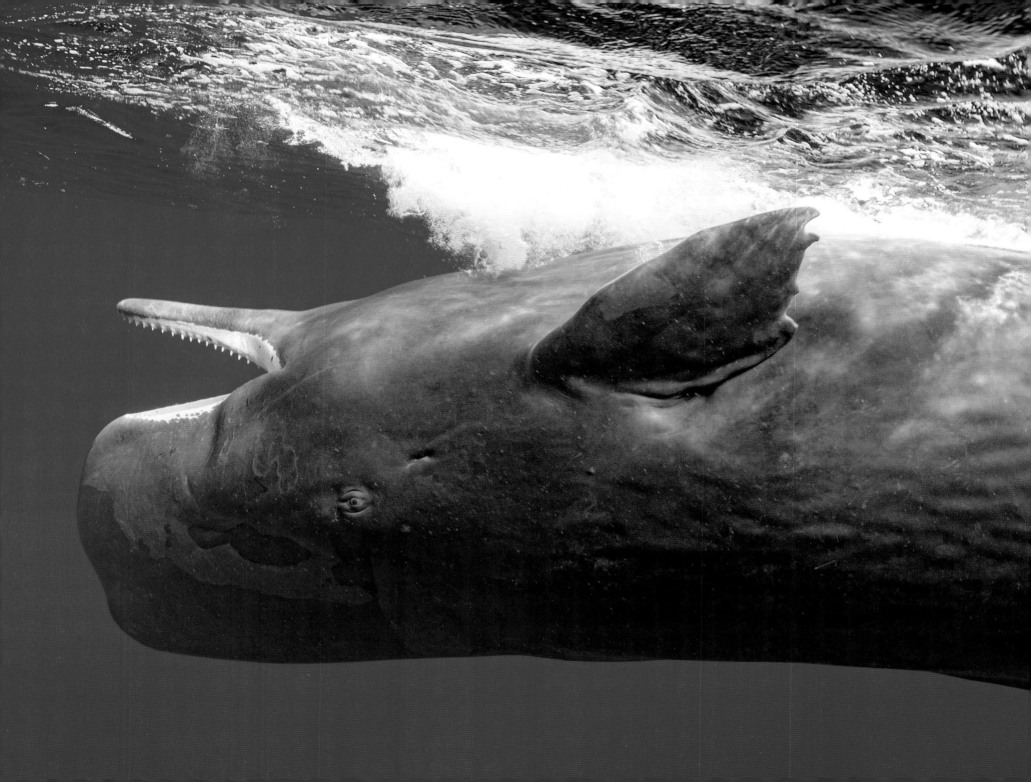

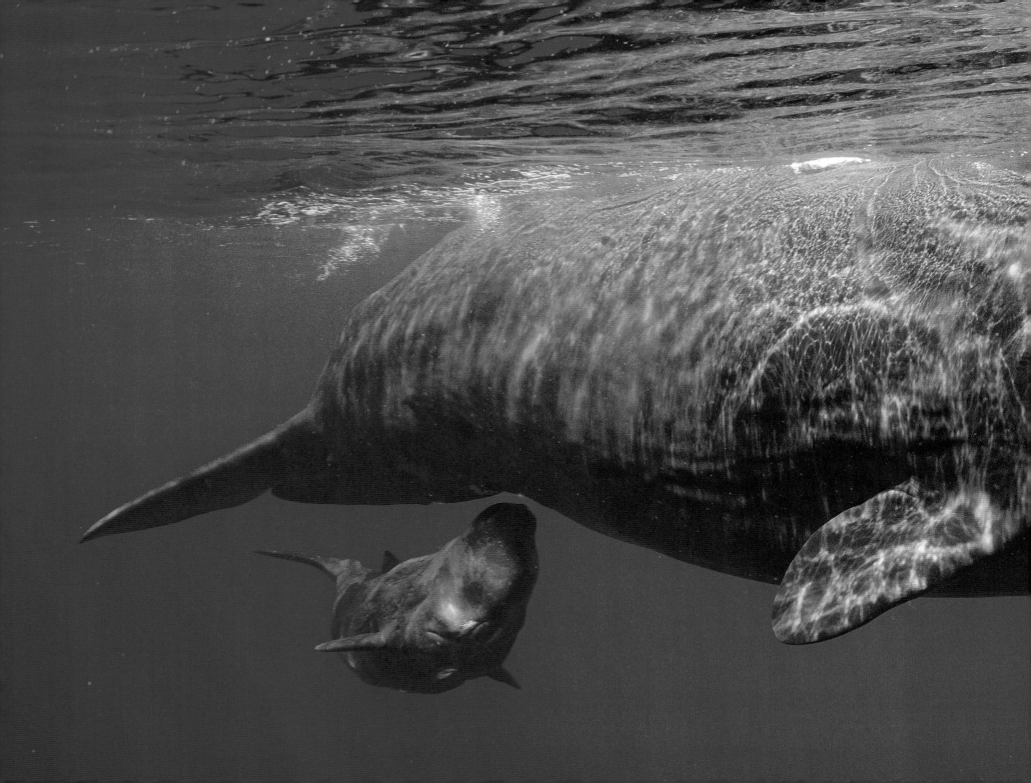

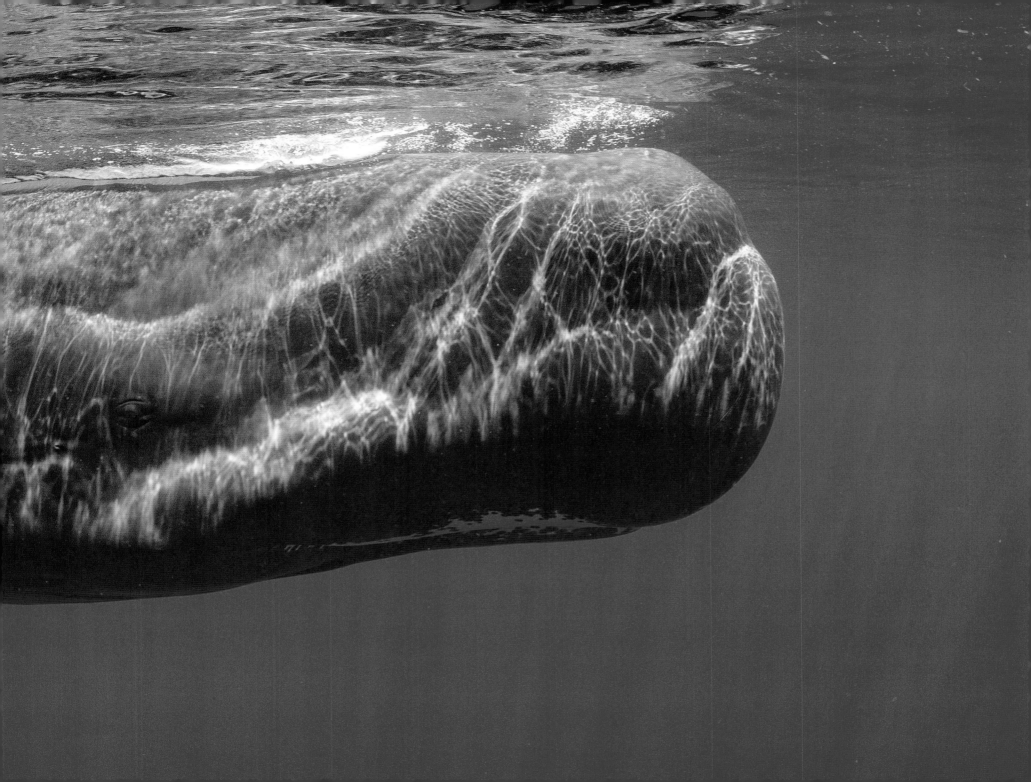

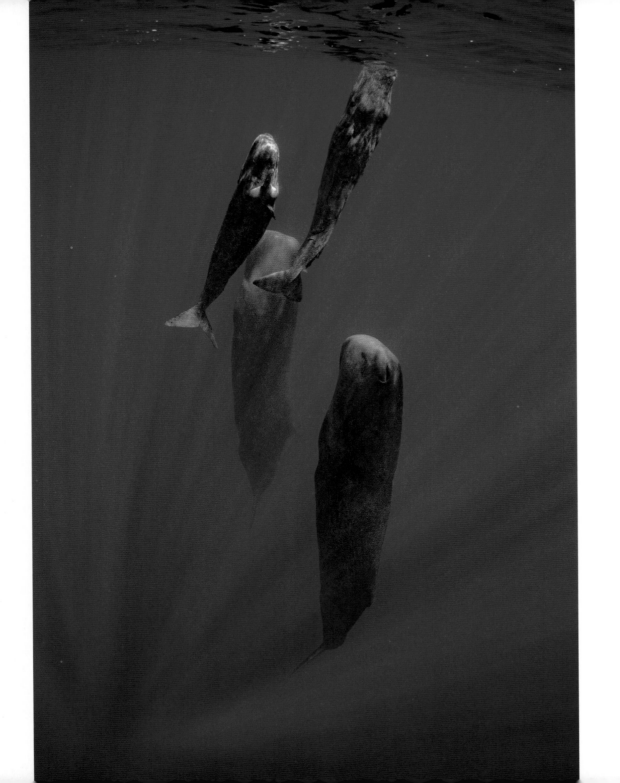

LEFT: Baby whales mimic their moms in an attempt to sleep vertically. For the babies, this position lasts only a few seconds, but the mothers remain sleeping for many minutes until the babies start to nudge them awake.

OPPOSITE: Just after a rest, this family of whales does a shallow dive, giving me a glance and then disappearing into the depths. The young calves do not dive deep. They may start a dive with their mothers, but they stay shallower or on the surface as the adults hunt.

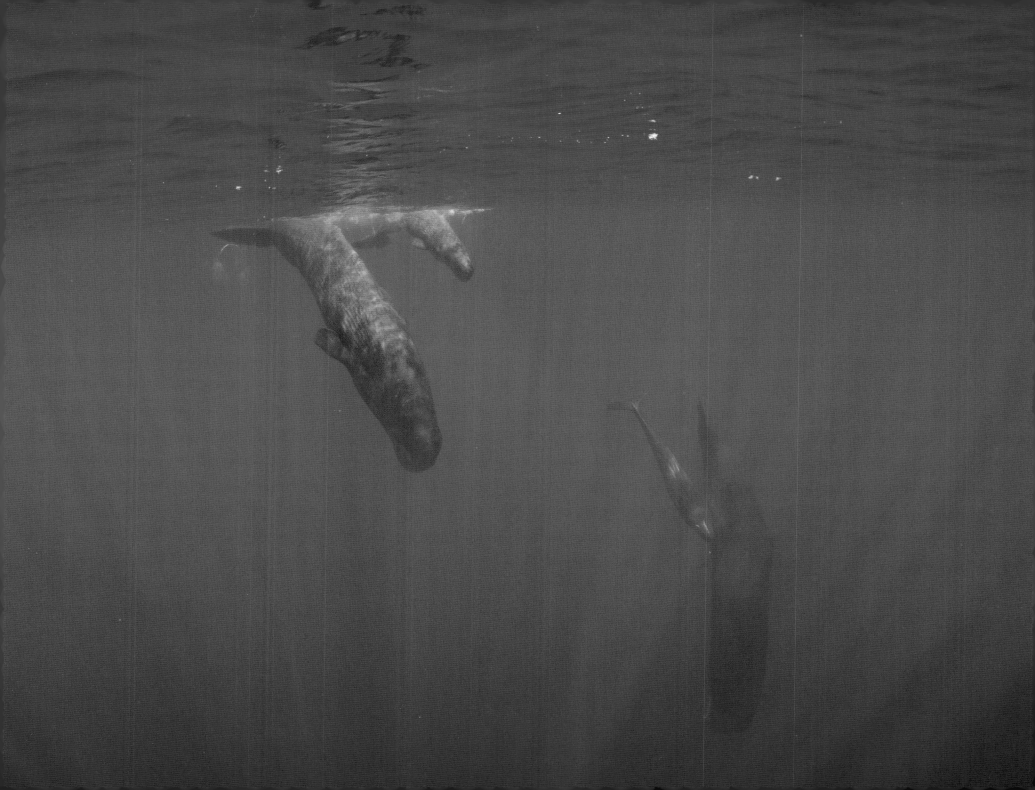

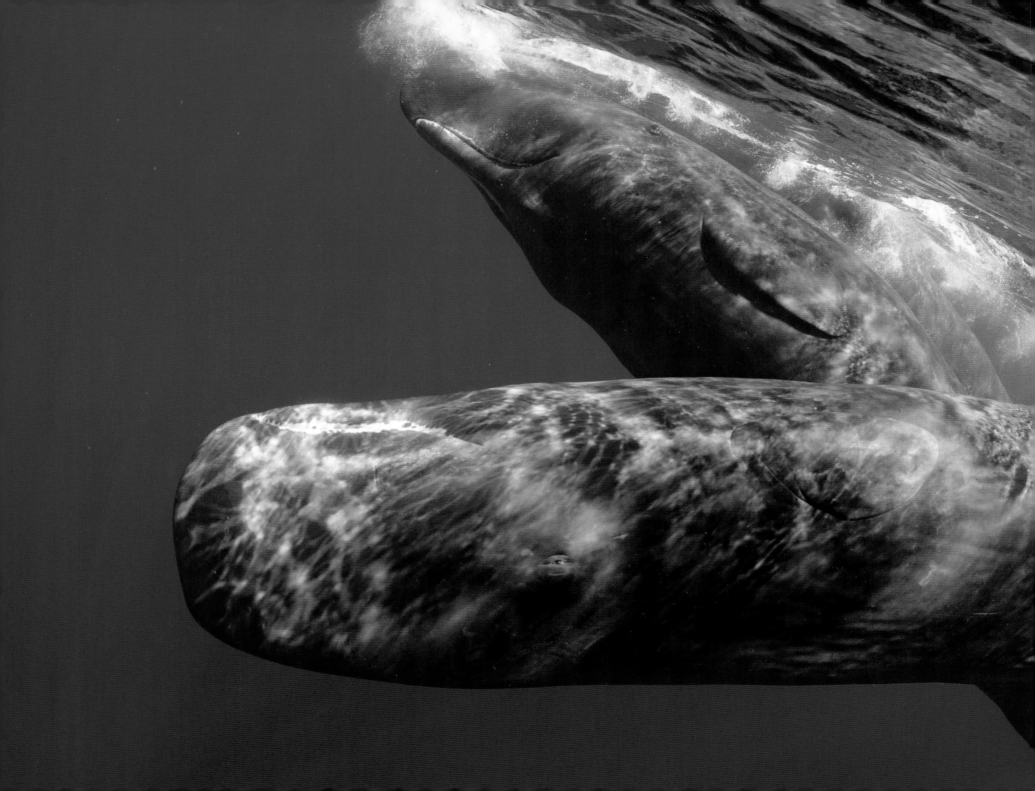

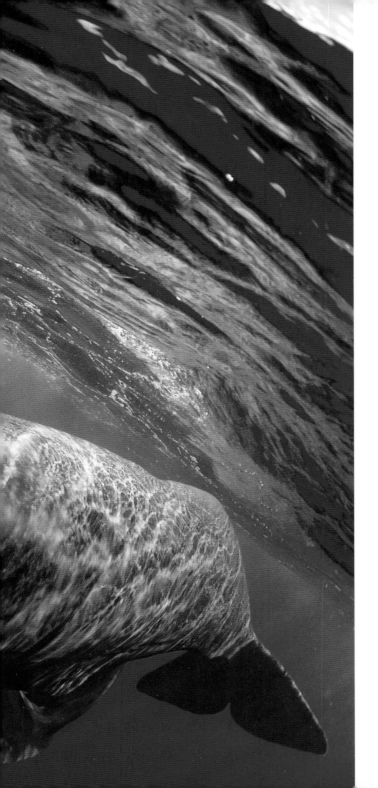

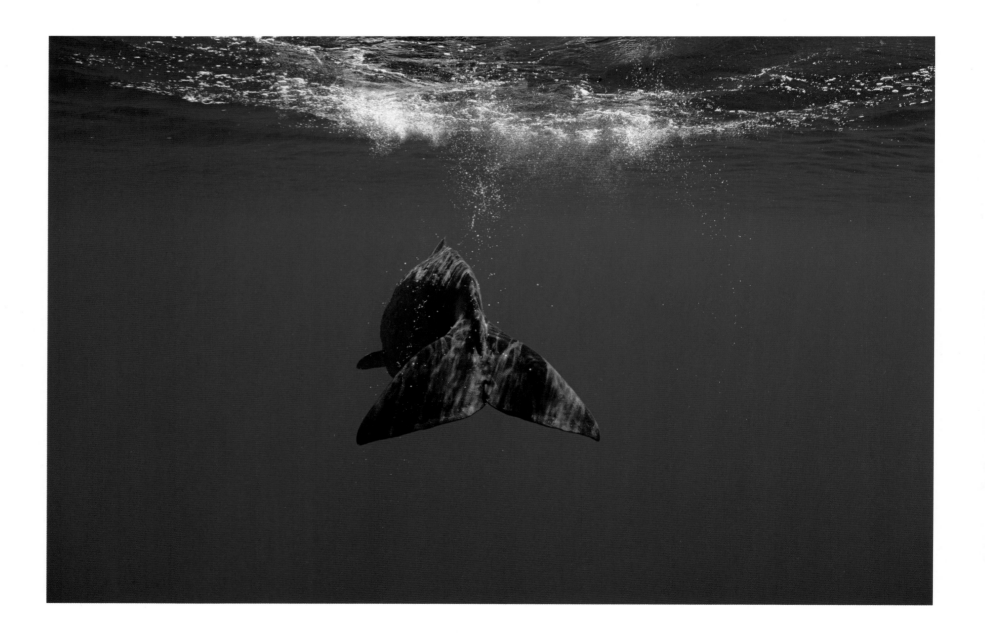

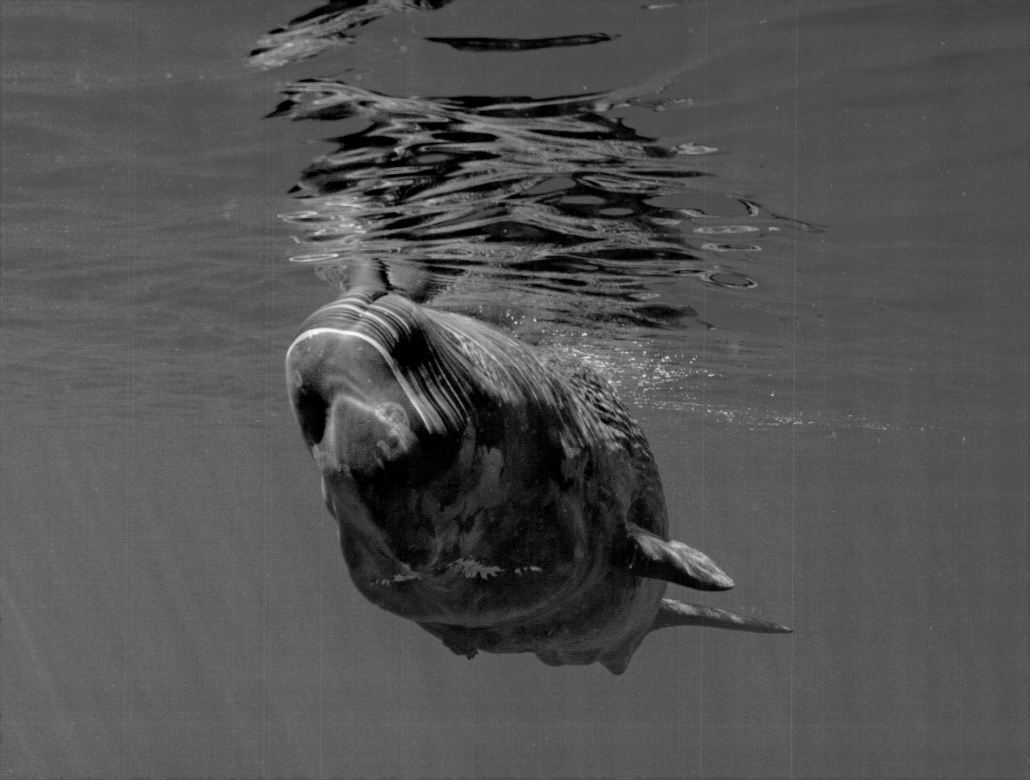

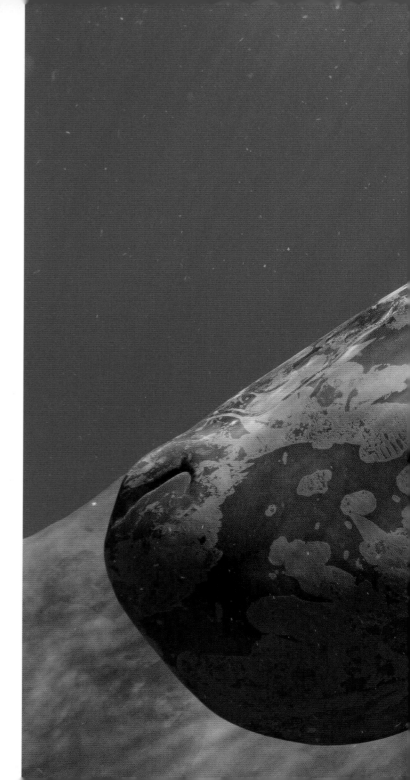

OPPOSITE: Compared to adults, a newborn whale has very wrinkled skin, and it is constantly sloughing off, giving it a mottled appearance. With a gestation of about 15 months, sperm whale babies weigh around 2,000 pounds when they are born, and are between 11 and 16 feet long. They are able to swim and breathe on their own as soon as they are born.

OVERLEAF: Three newborn calves swim side by side. It was awesome to see the abundance of newborns on our postpandemic expedition.

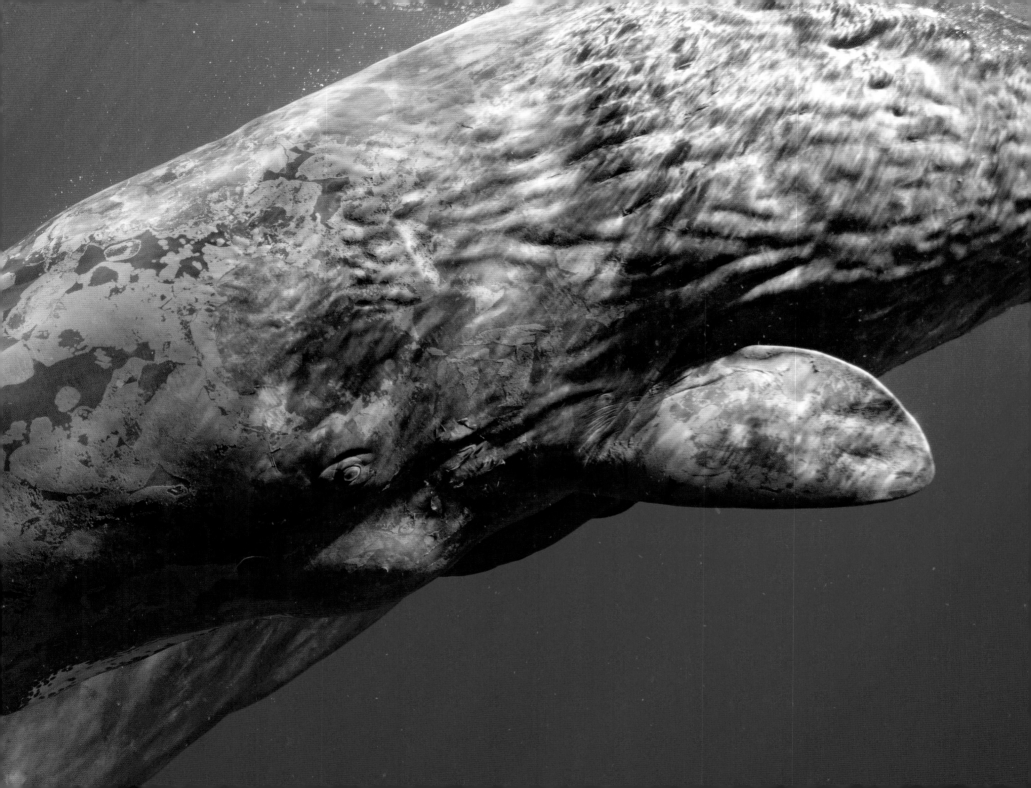

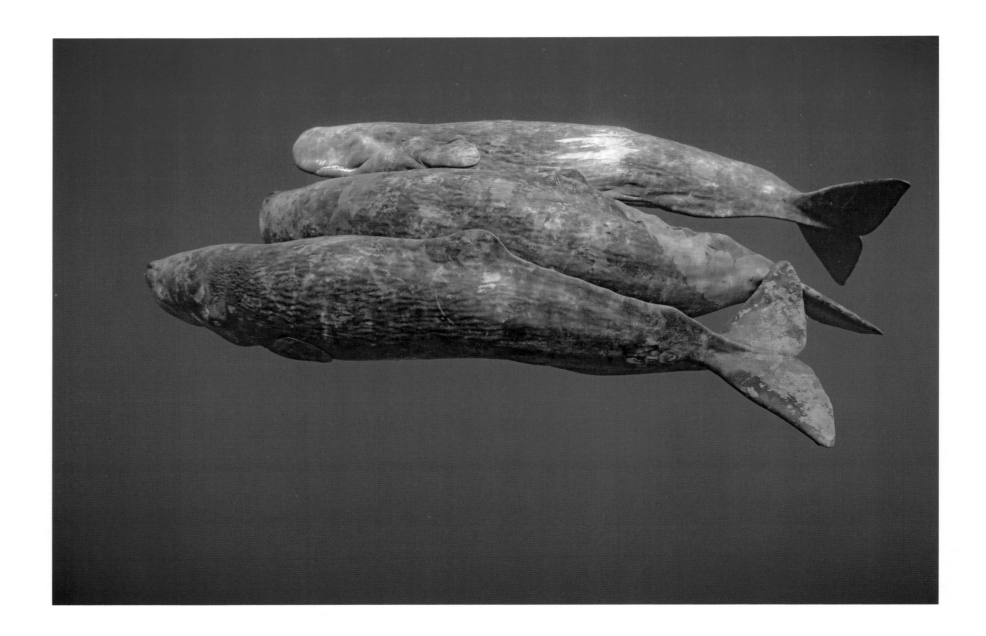

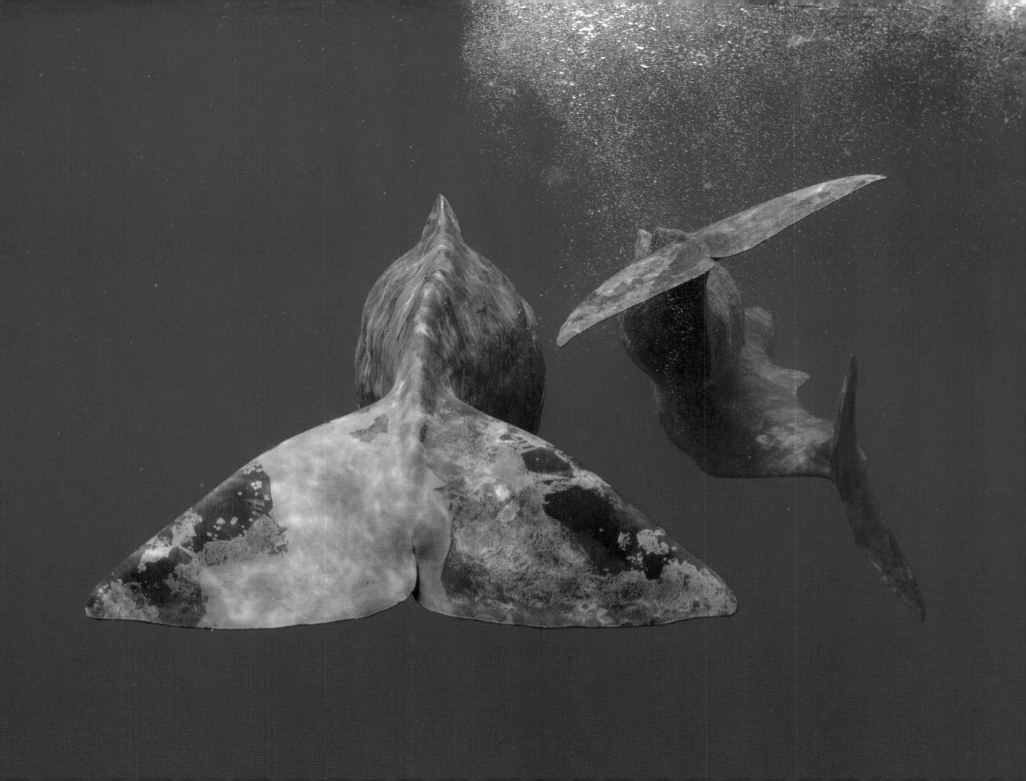

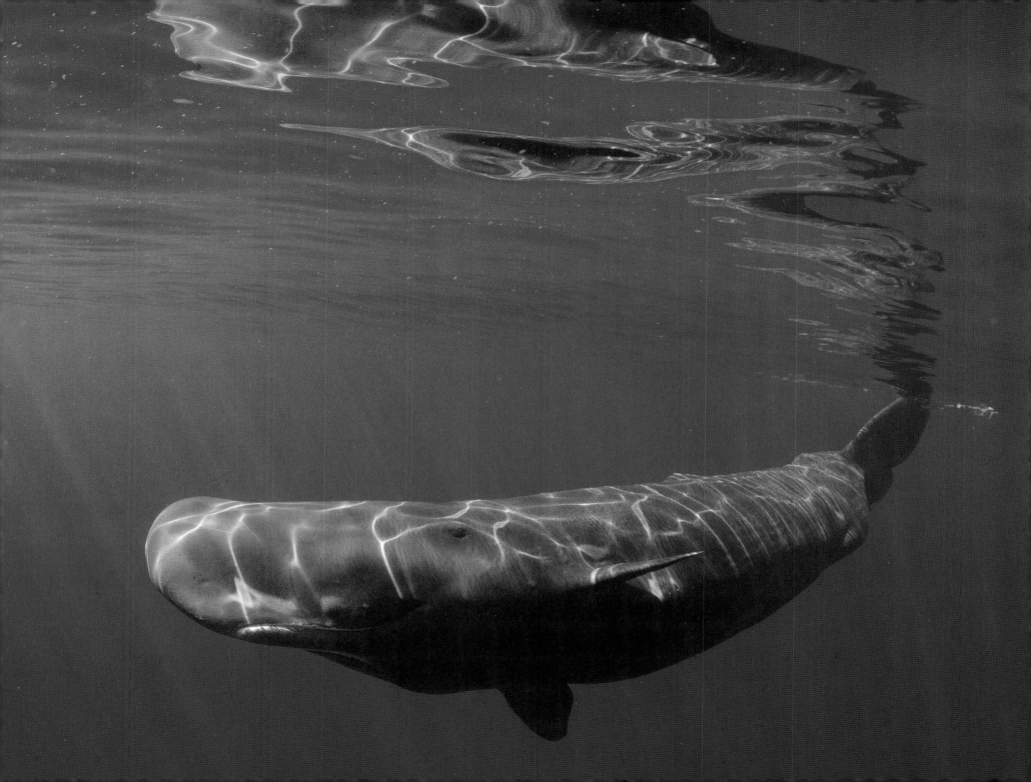

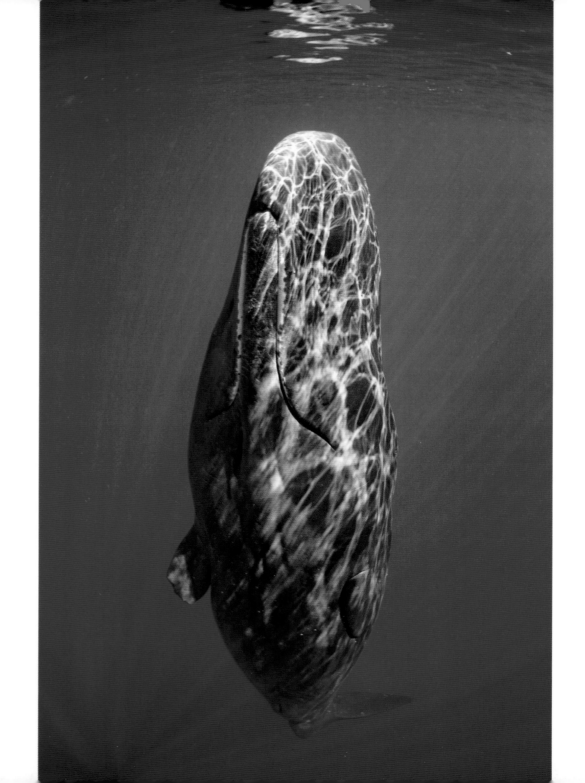

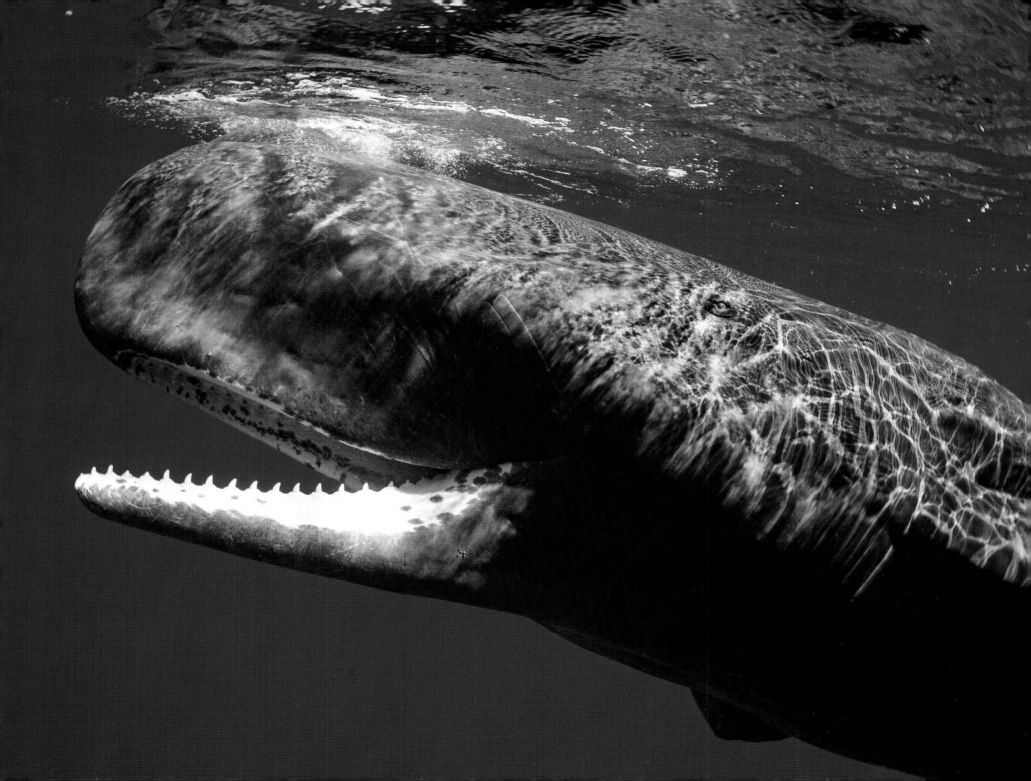

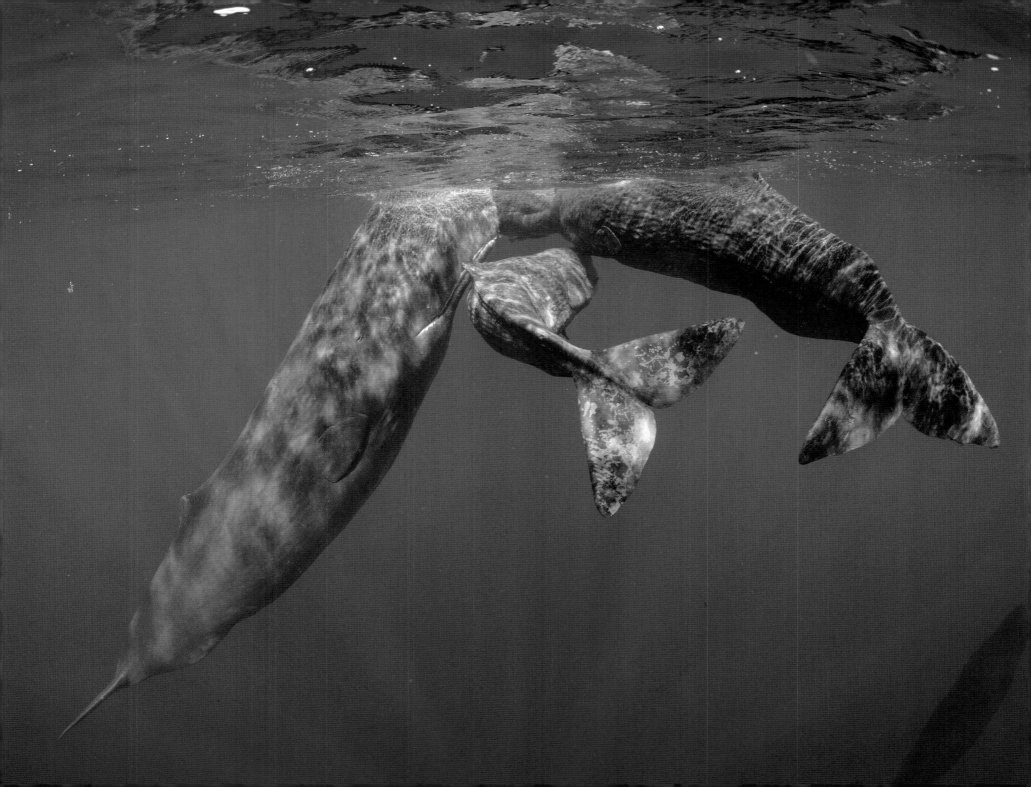

I saw this female whale with a half-moon scar on her head throughout our expedition. I had seen her grooming a baby when we observed the large group of socializing whales, but on this drop she was alone and curious about me. She would swim slowly, then stop, twirl around, go vertical, and look at me before swimming off. I swam alongside her, and when she allowed me to keep up, she repeated the same behaviors.

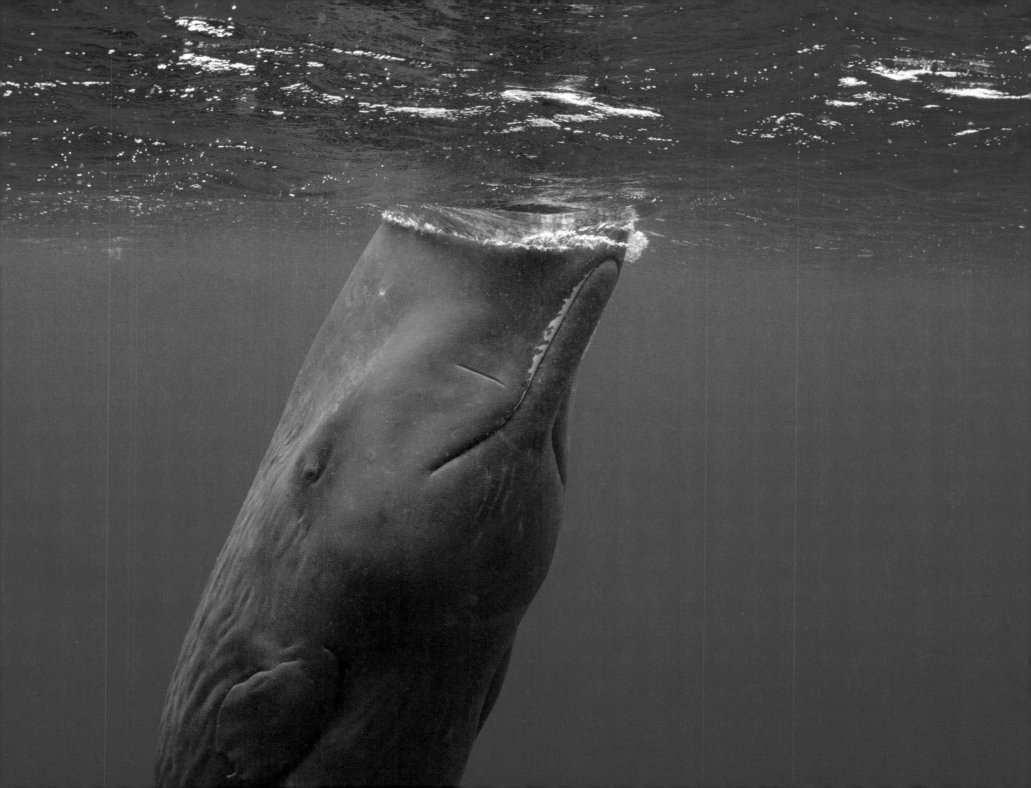

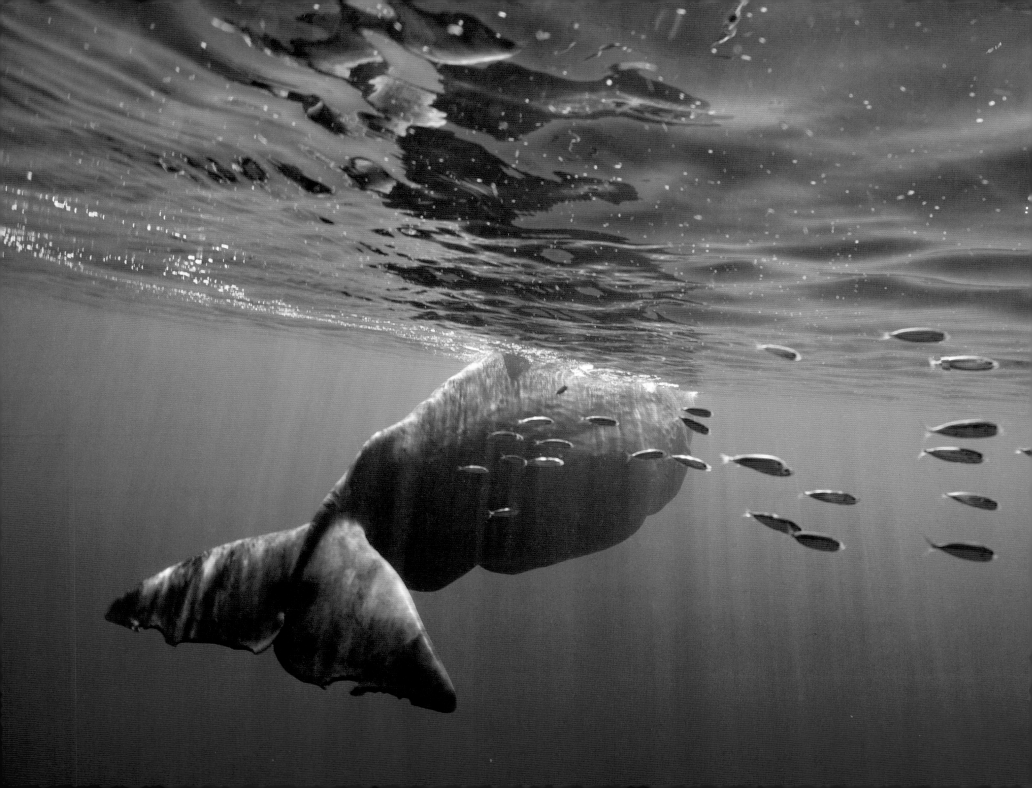

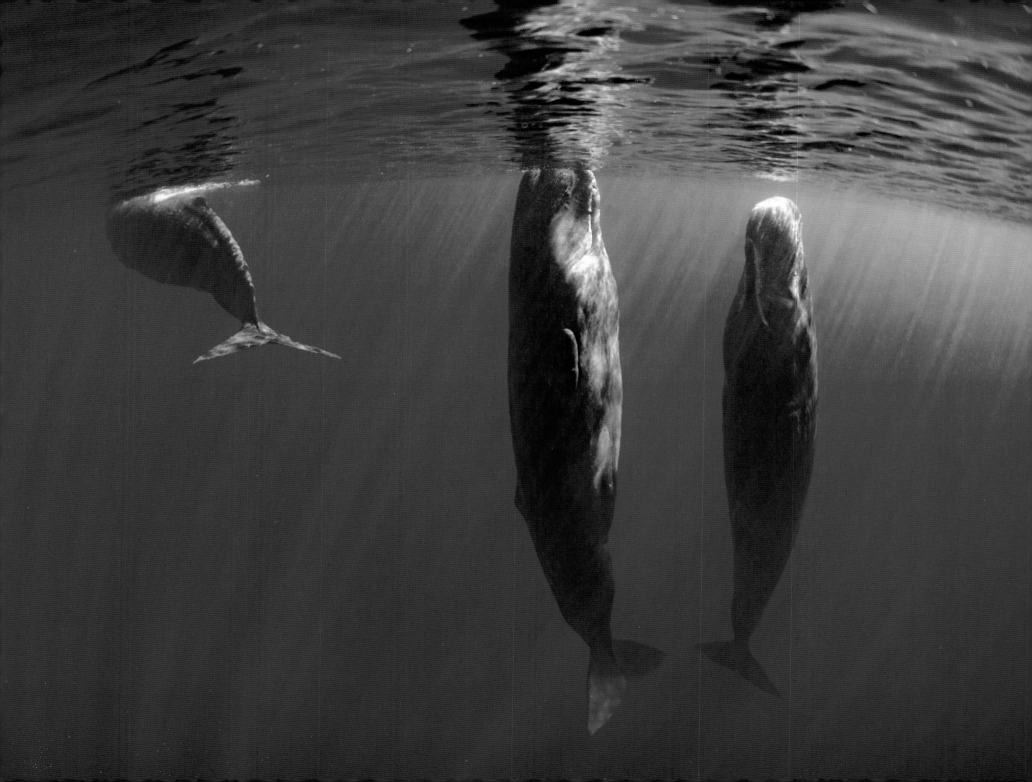

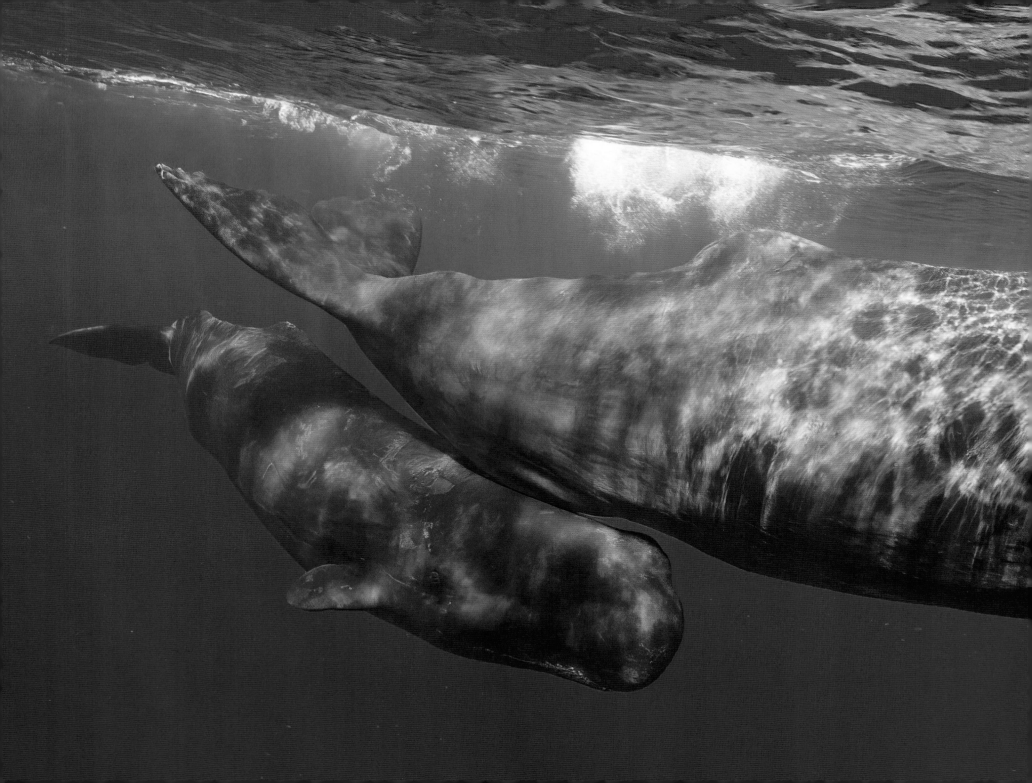

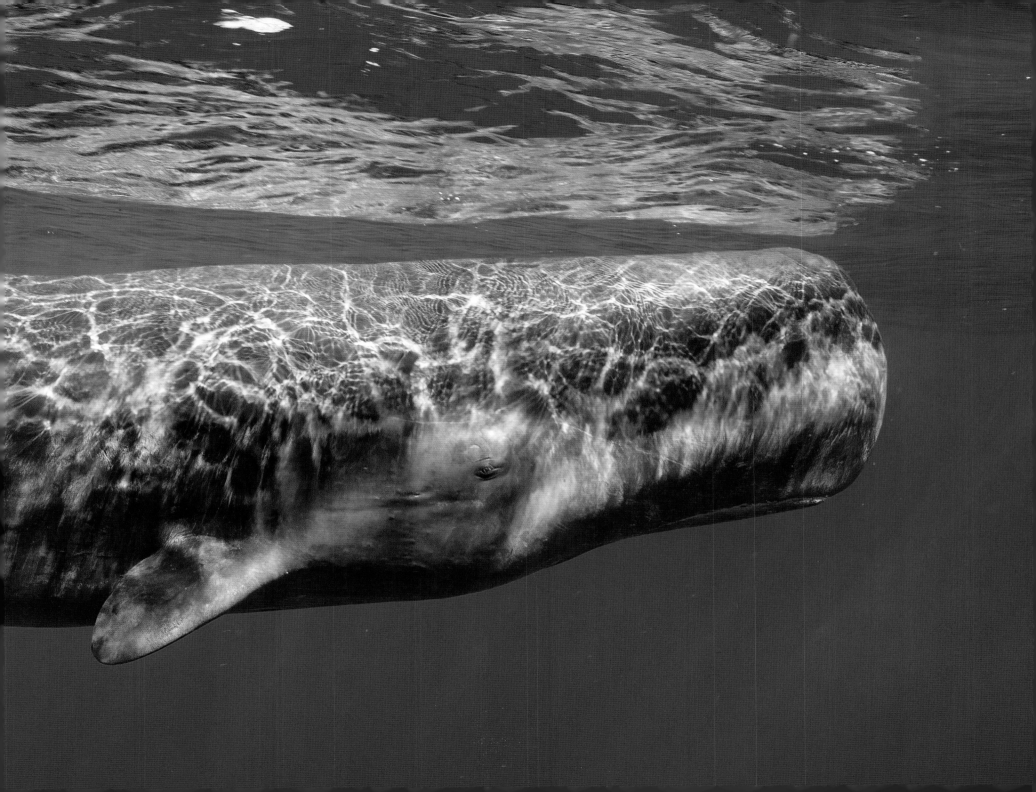

OPPOSITE: Two young whales swim playfully, their flukes near pristine at this young age.

OVERLEAF: Remoras, also known as suckerfish, are often seen clinging to young whales in hopes of getting remnants of food, a good strategy for living in the open ocean. Remoras are not seen on adults, as they cannot withstand the pressure from the depths where the adults go to hunt. Most of the calves have these companions. With a feast like this piece of giant squid tentacle, it's easy to see why remoras hitch a ride on baby sperm whales.

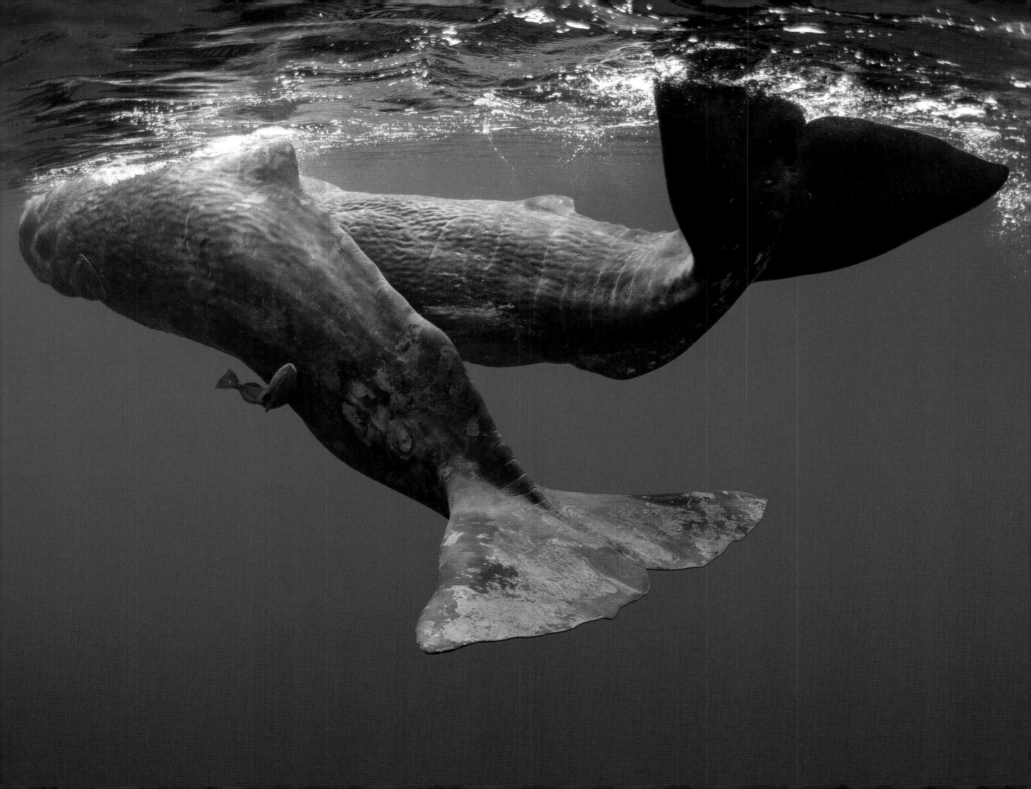

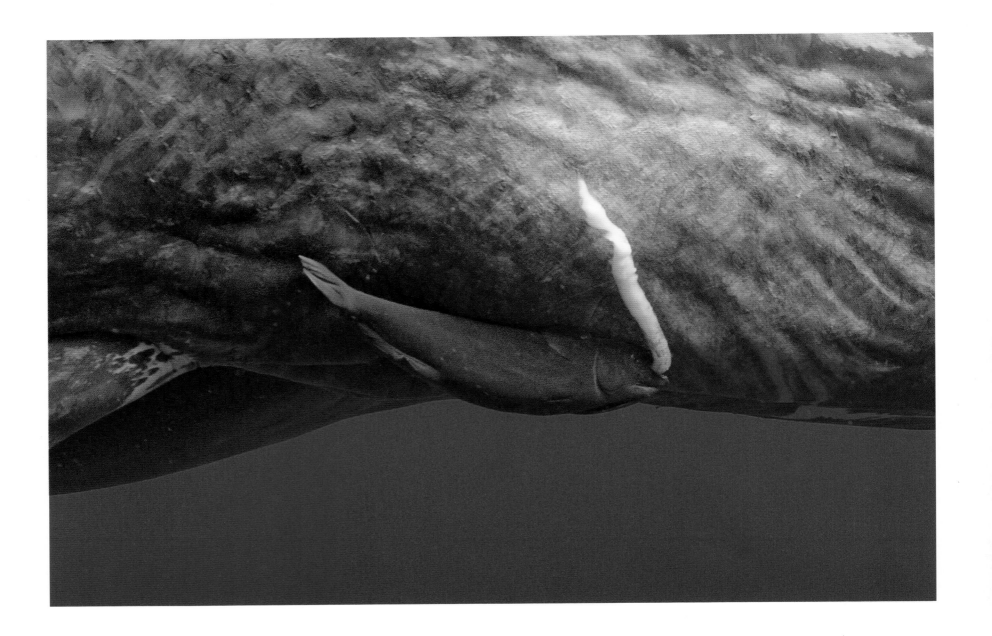

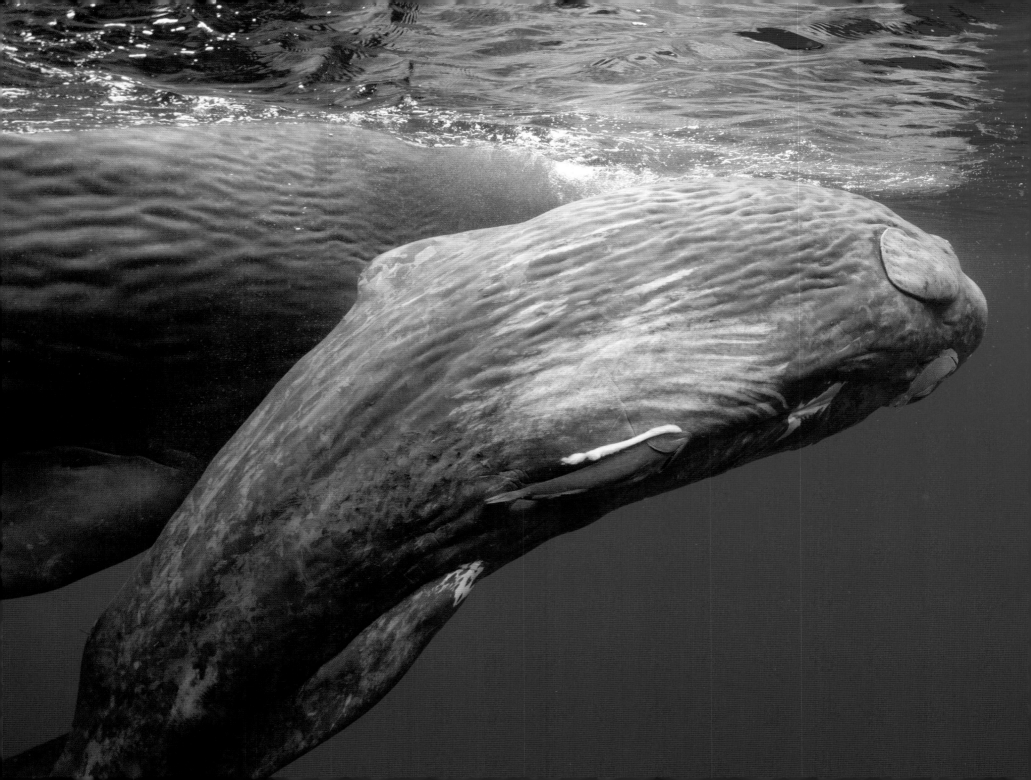

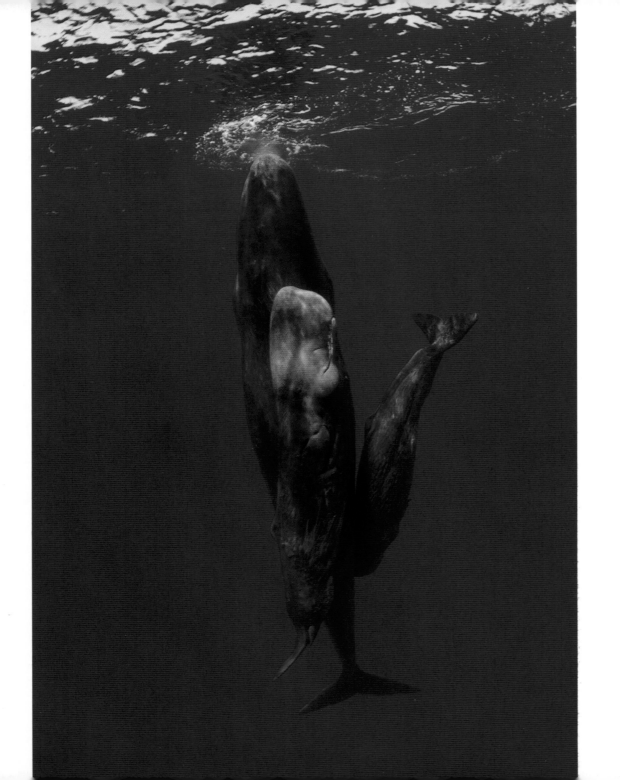

LEFT: A mother sperm whale swims with two young whales, one a newborn.

OPPOSITE: Two calves stick close to a sleeping adult. In the background, my mom watches from a distance. It was a privilege to share these moments with sperm whale families with my mom.

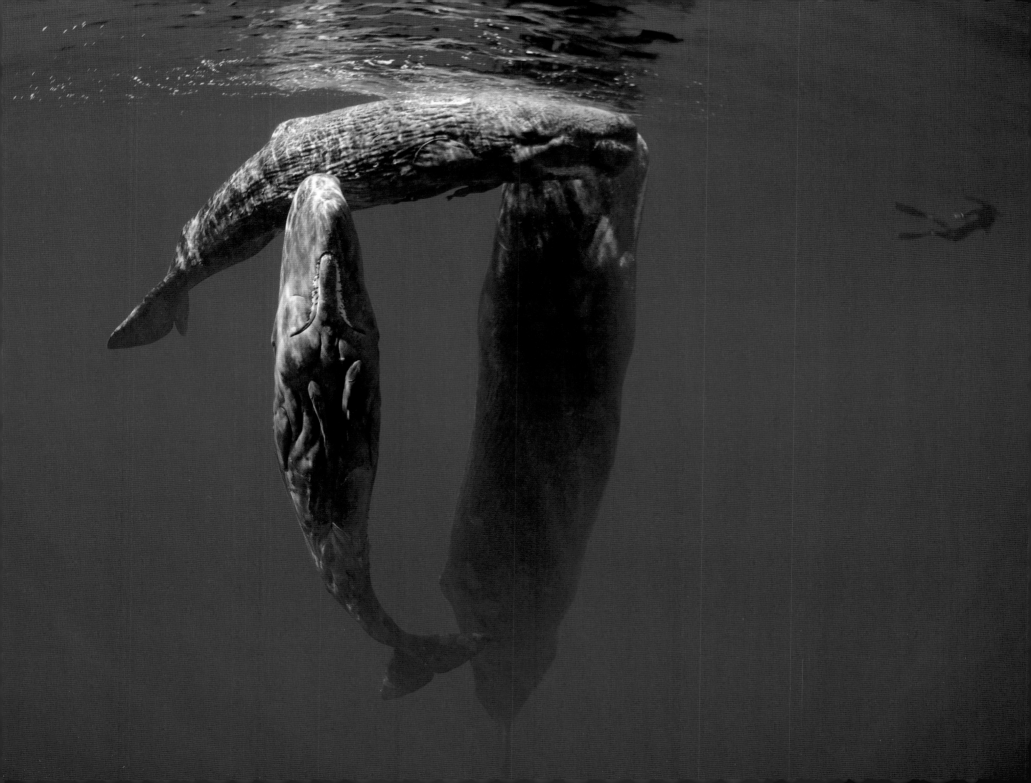

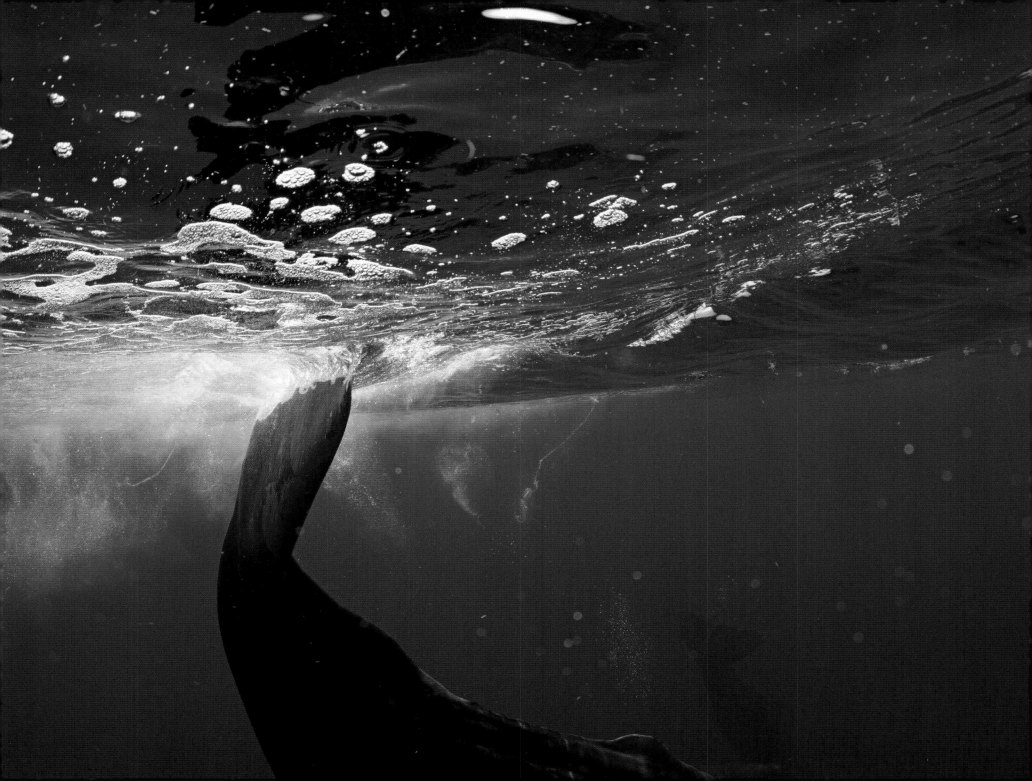

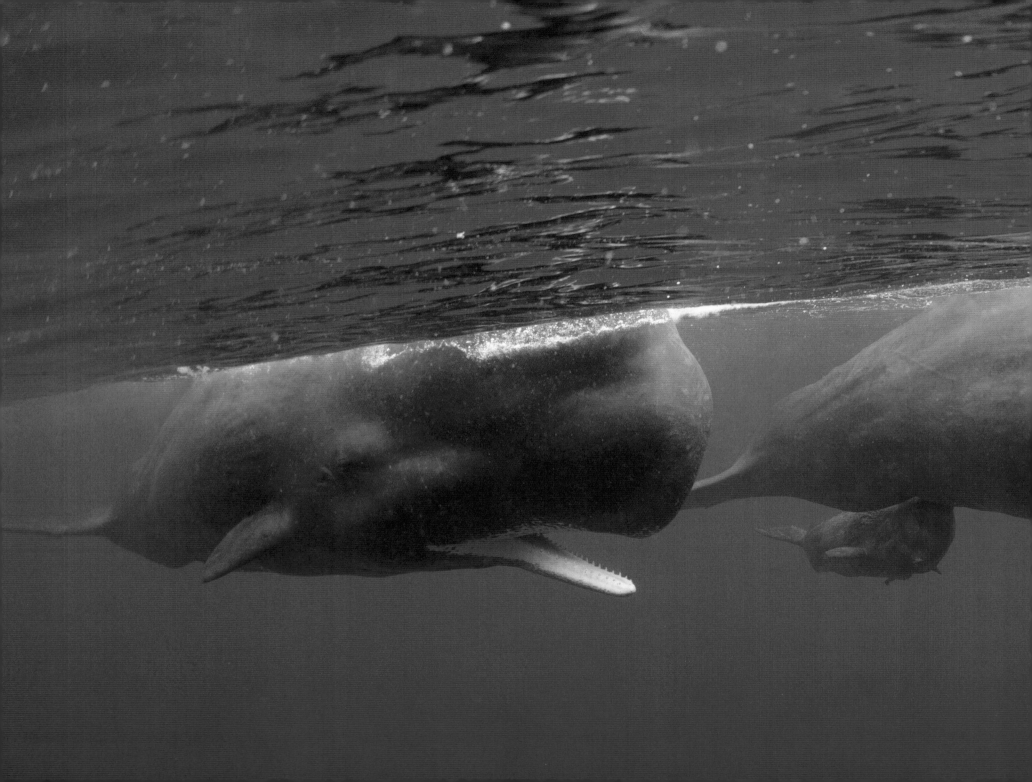

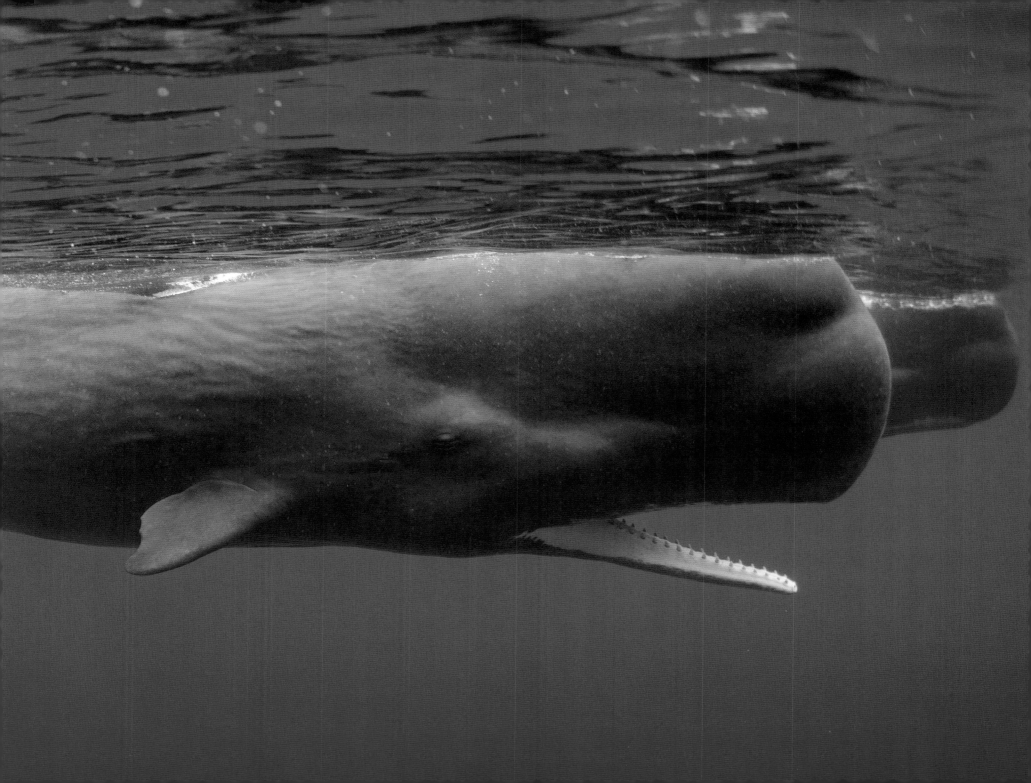

The female with the half-moon scar reunited with a baby
and we had a playful interaction with them. I recognized the
baby from the distinct markings around its mouth.

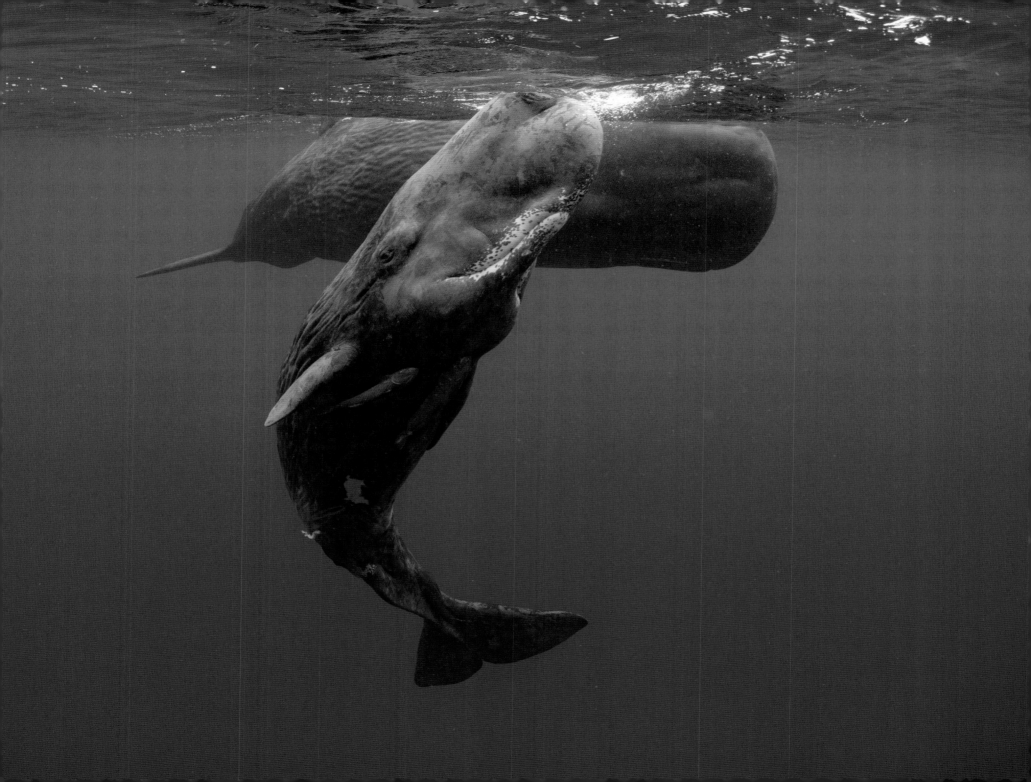

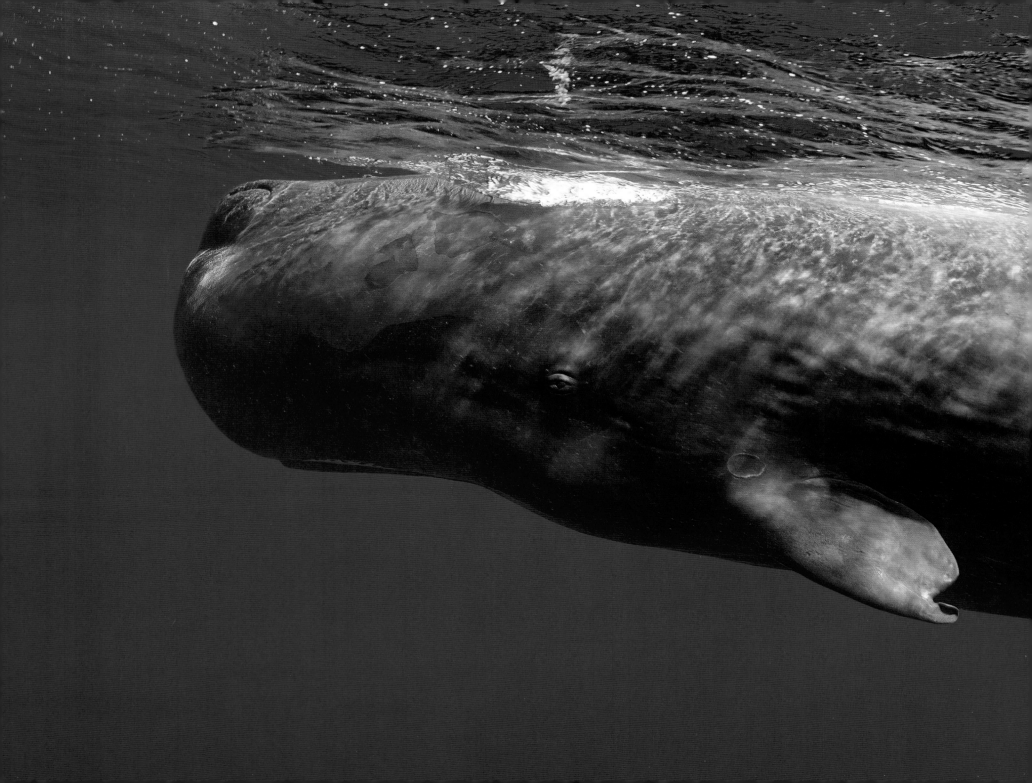

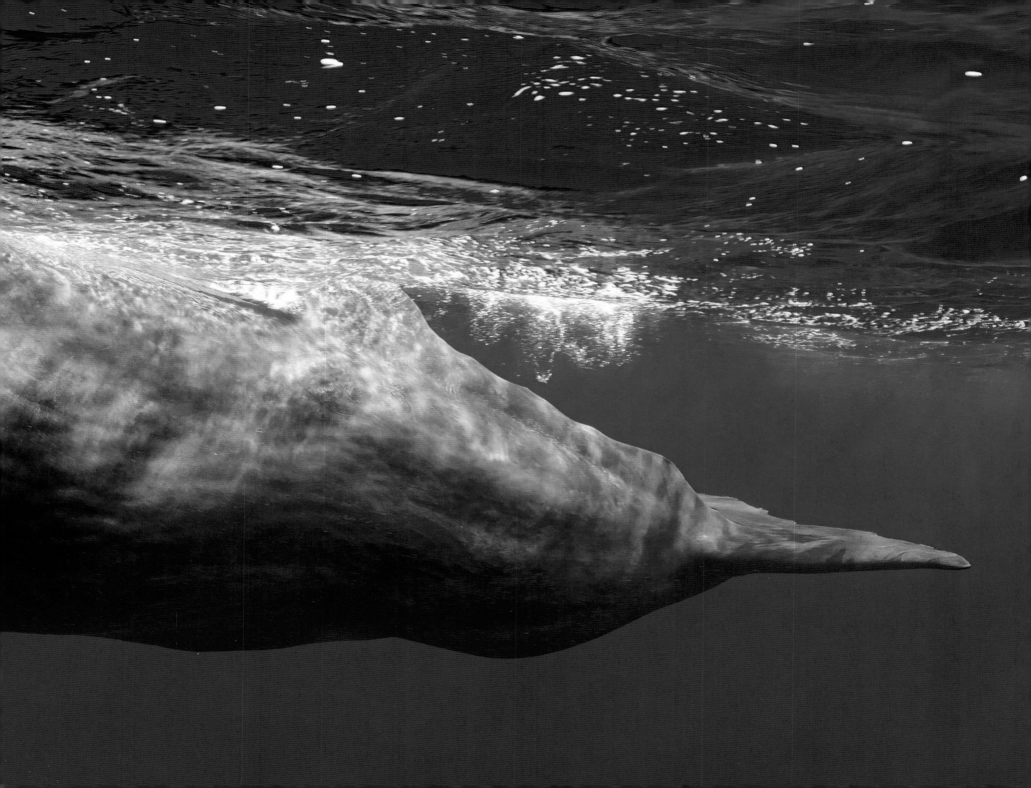

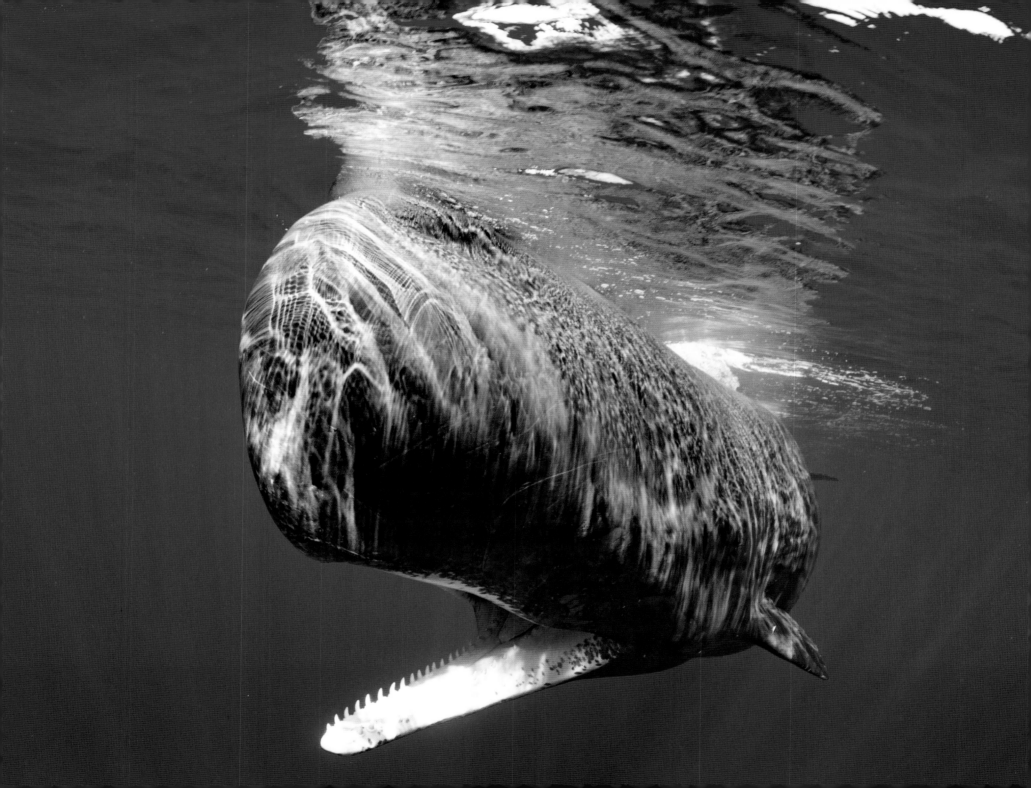

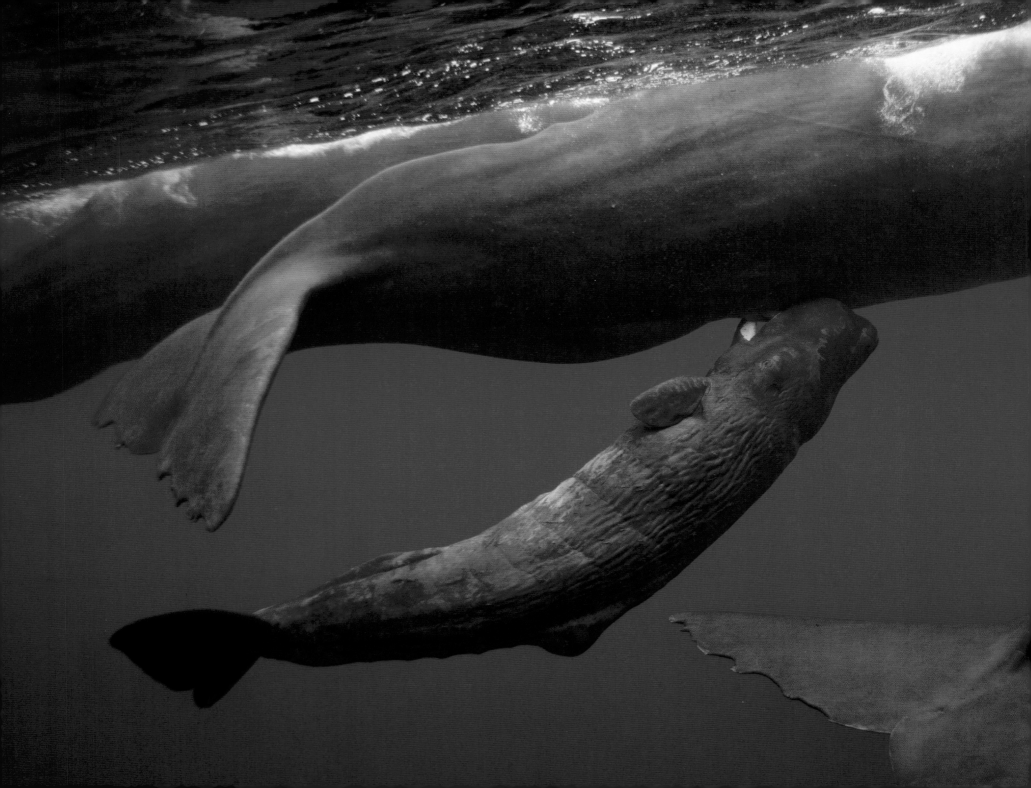

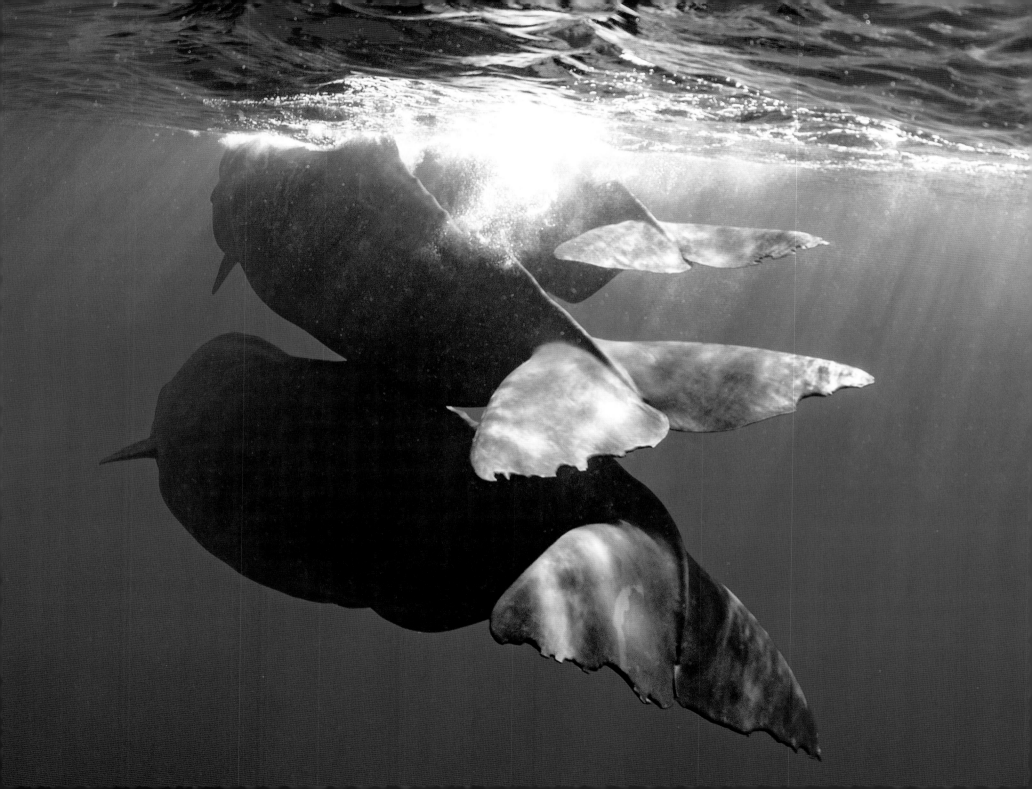

A young male whale dives into the depths. This whale was
about the size of Physty when he was in captivity. Large
enough to dive but not ready to be on his own, he will stay
with his family unit until he reaches sexual maturity around
10 years of age, when he will leave and head toward higher
latitudes. These young males are sometimes found in bachelor
groups until they are older and head off on their own. Then,
when ready to breed, they will return to the warm Caribbean
waters where the females spend their lives. In addition to
their different social organization and geographic range,
male sperm whales grow to be larger than females, upwards
of 100,000 pounds and 65 feet. Their female counterparts
reach only 33,000 pounds and 35 feet.

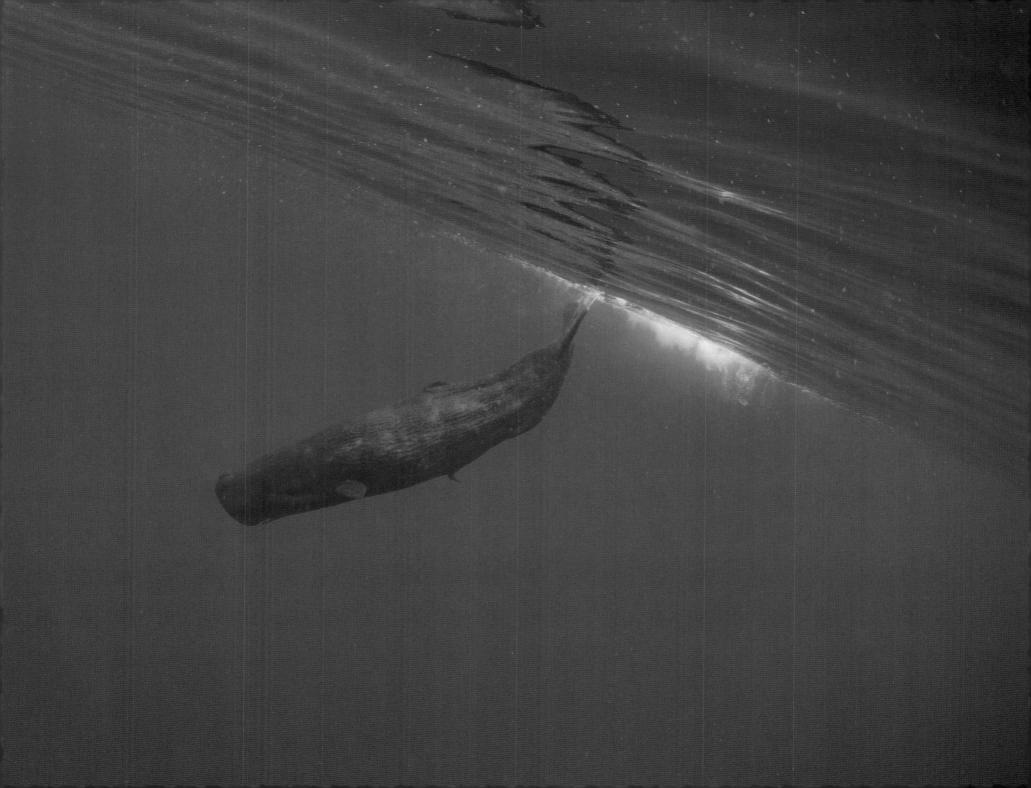

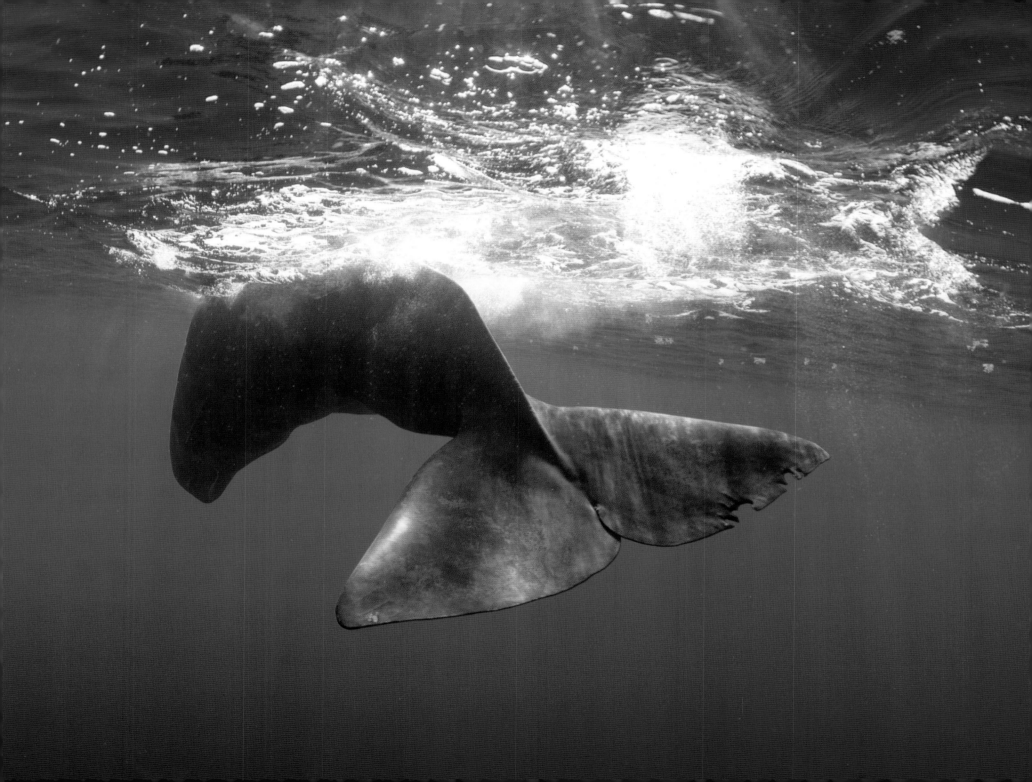

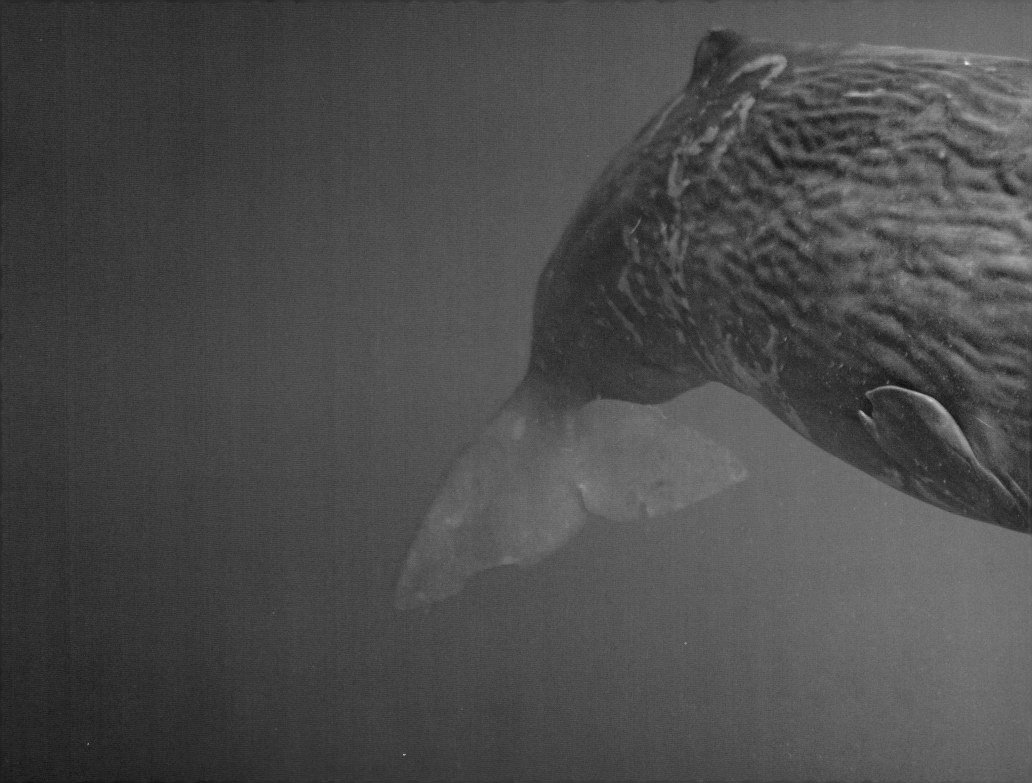

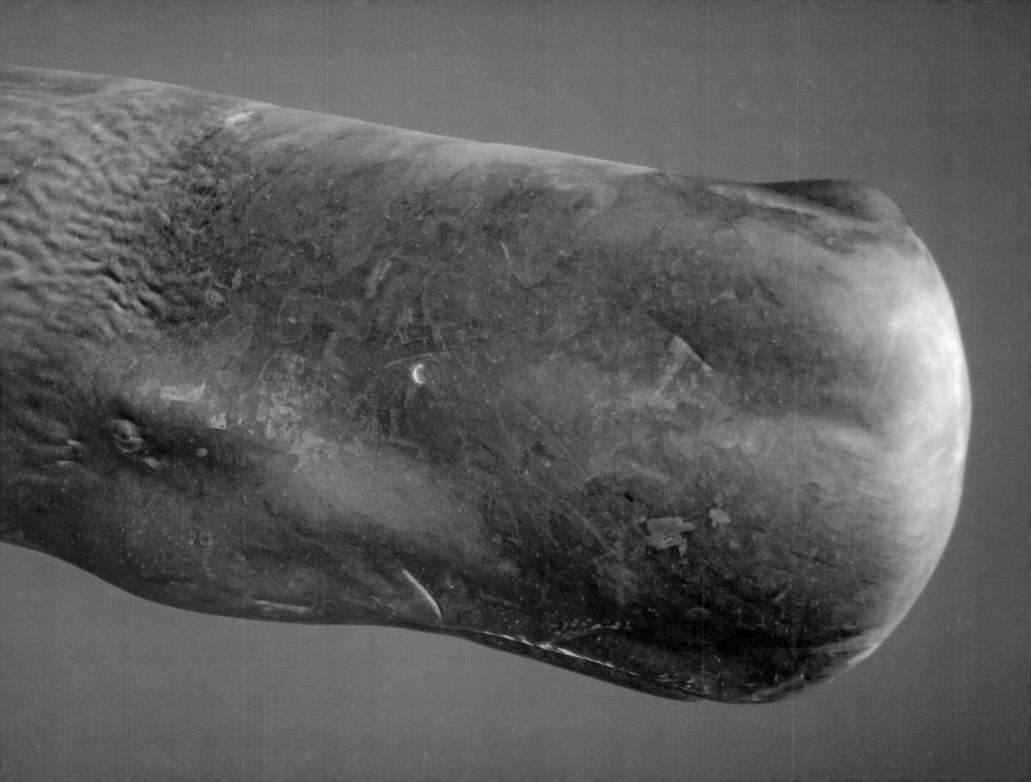

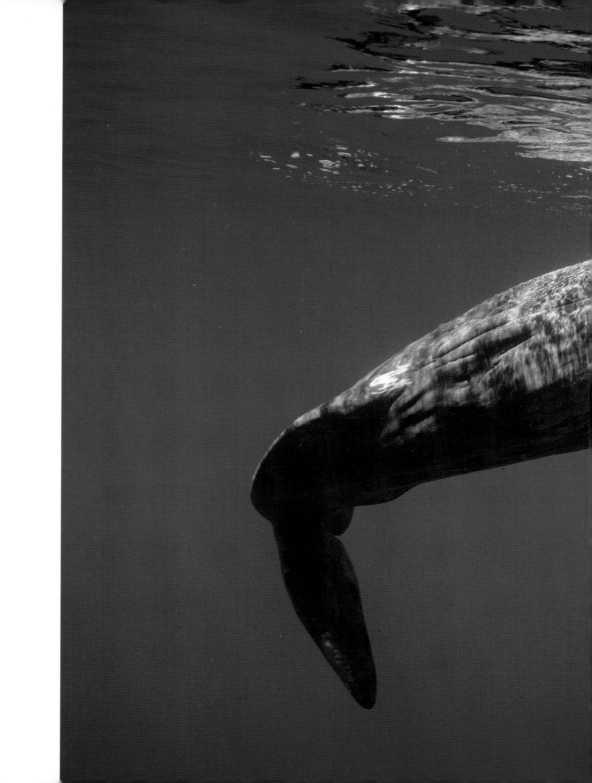

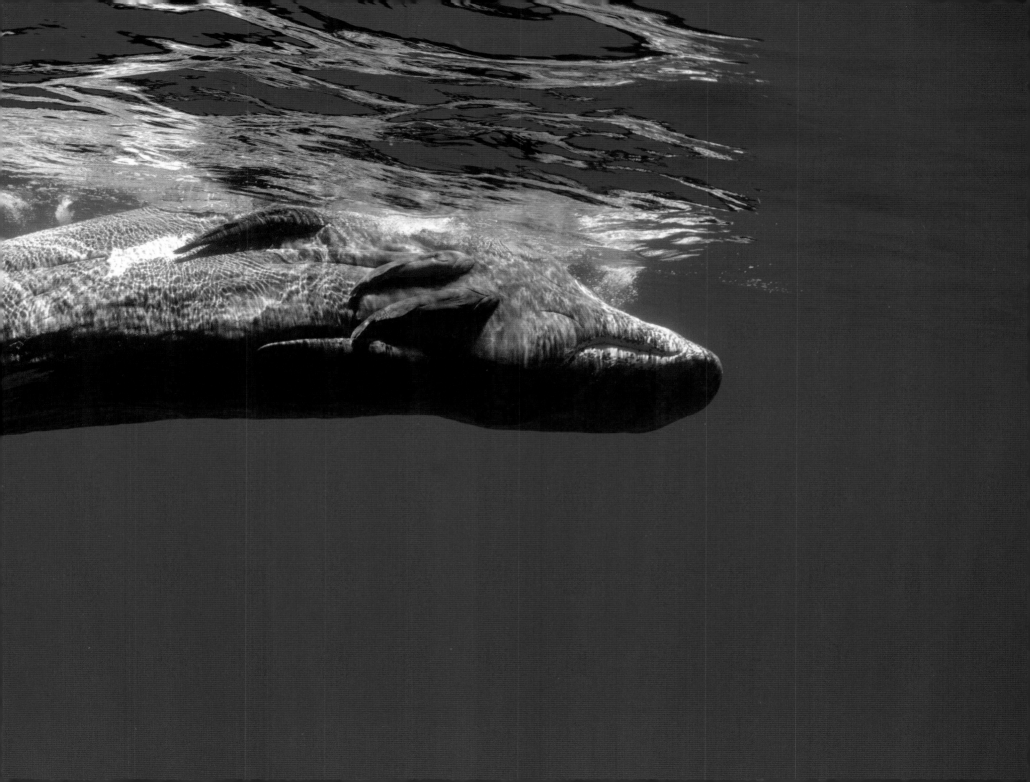

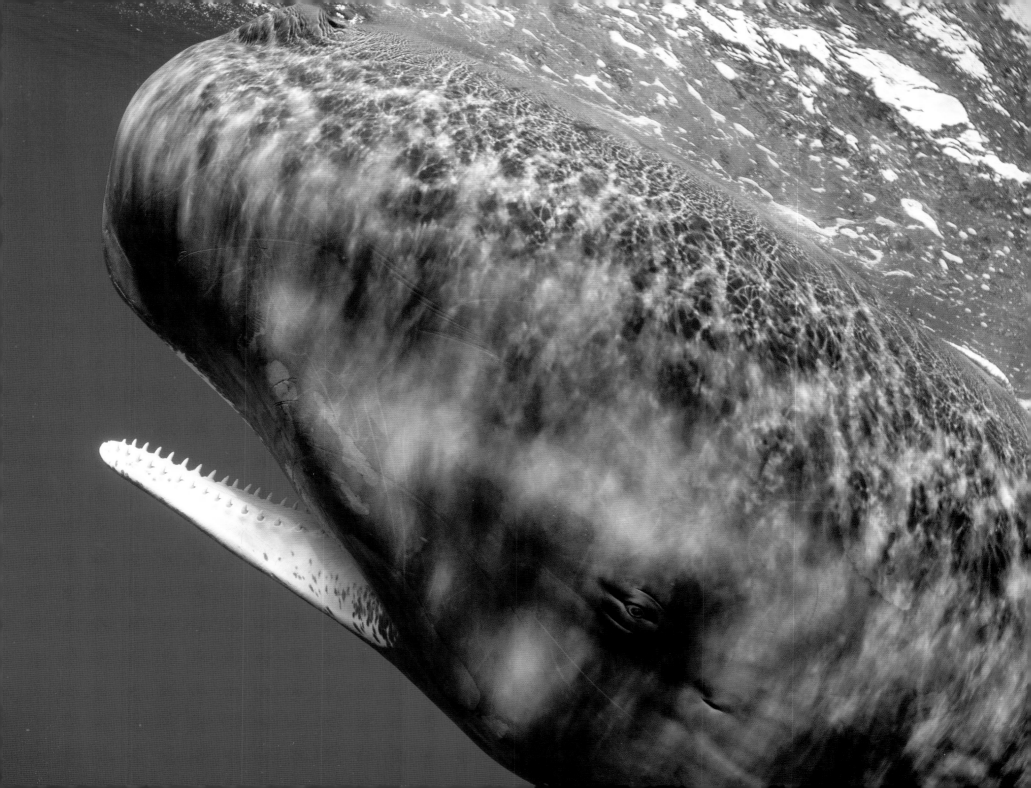

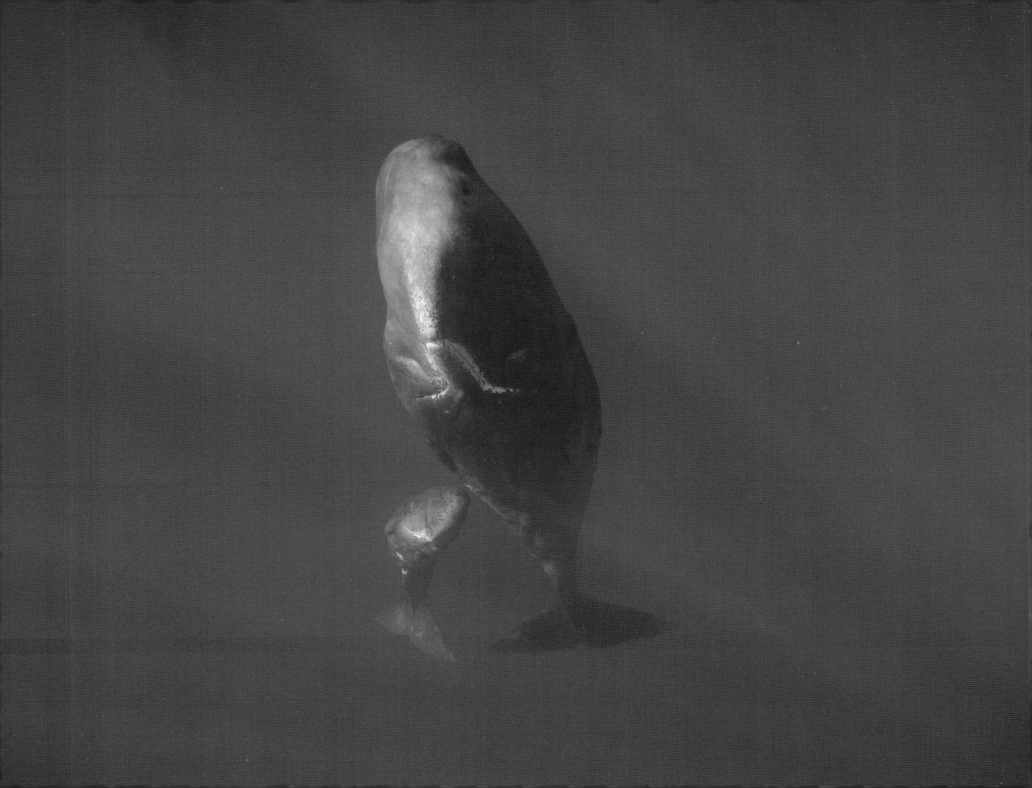

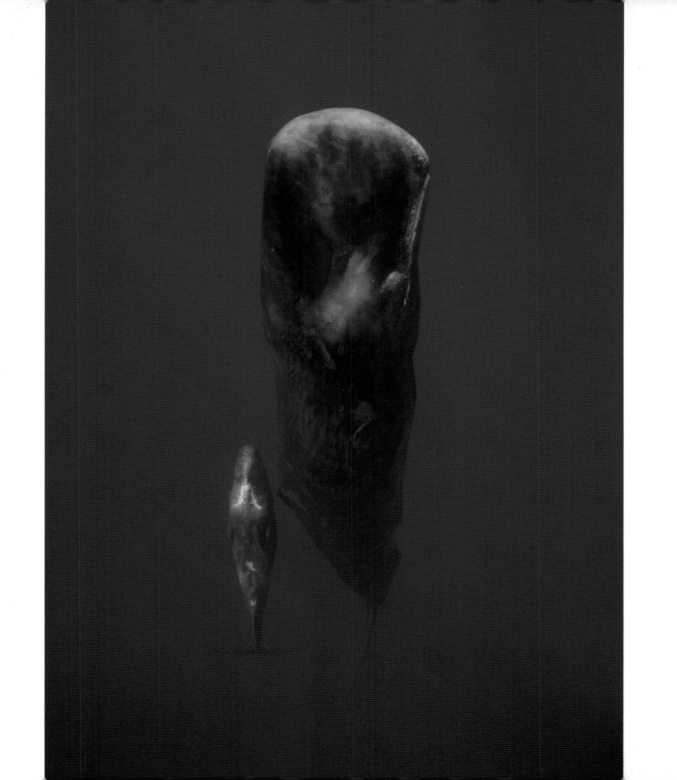

Sperm whales have a single blowhole on the left side of
their heads, which is why their blow is at a 45-degree angle
instead of straight up like other whales. A whale breathes
through its blowhole, which is essentially a nostril that is
connected to its trachea and lungs. Toothed whales, like
the sperm whale, have one blowhole, while baleen whales,
like the humpback or blue whale, have two blowholes.

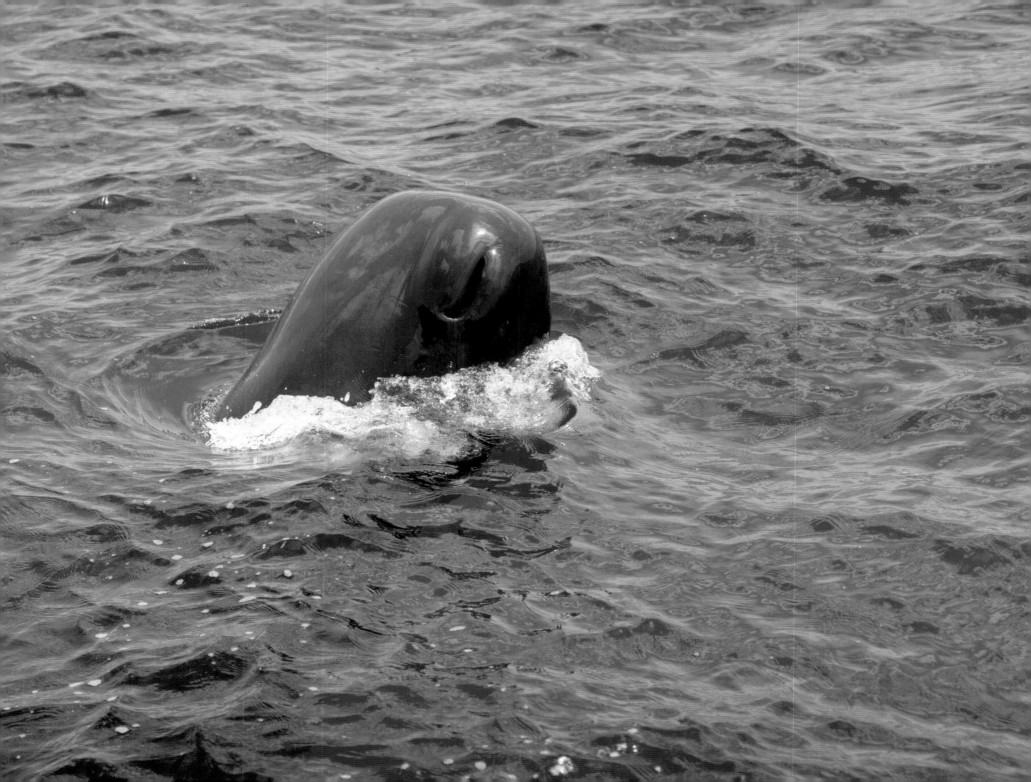

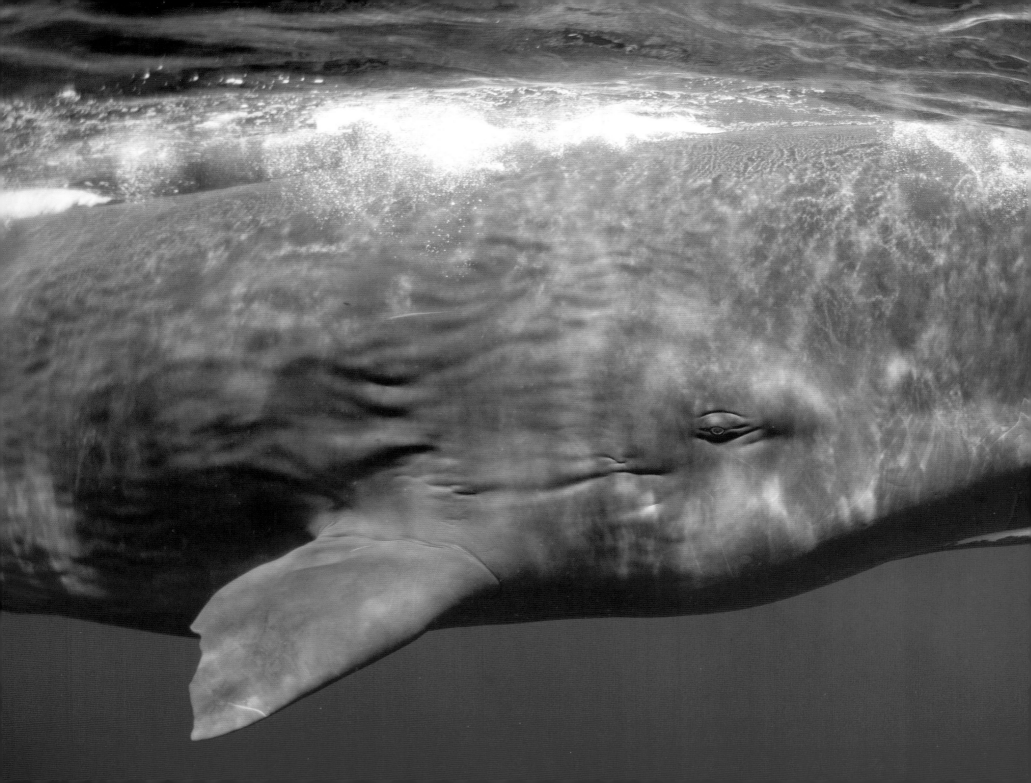

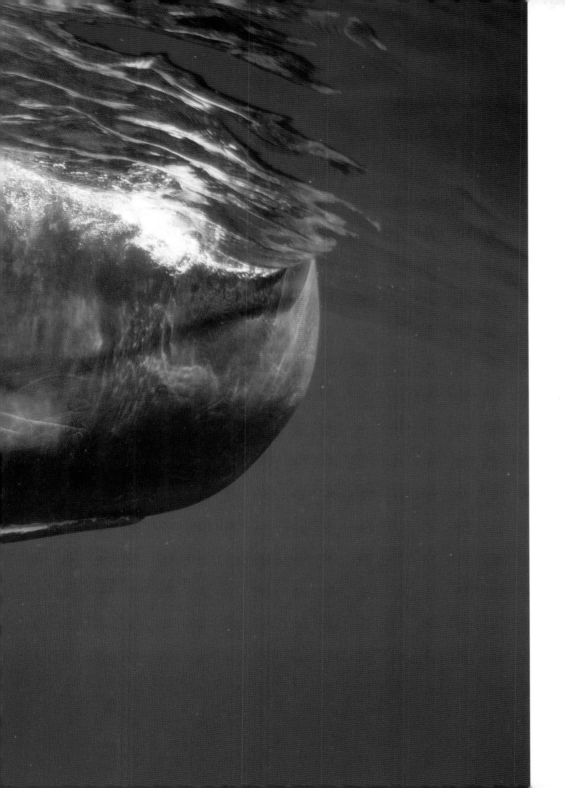

A mother and baby dive in tandem. Adult sperm whales can
dive to more than 3,280 feet and stay down for more than
45 minutes while hunting, an impressive amount of time to
hold their breath, making them one of the best free divers
on the planet. They have specialized adaptations for their
deep-diving lifestyle, including increased myoglobin, an
ability to slow their heart rate, and a collapsible rib cage that
allows lung compression without injury at great depths.

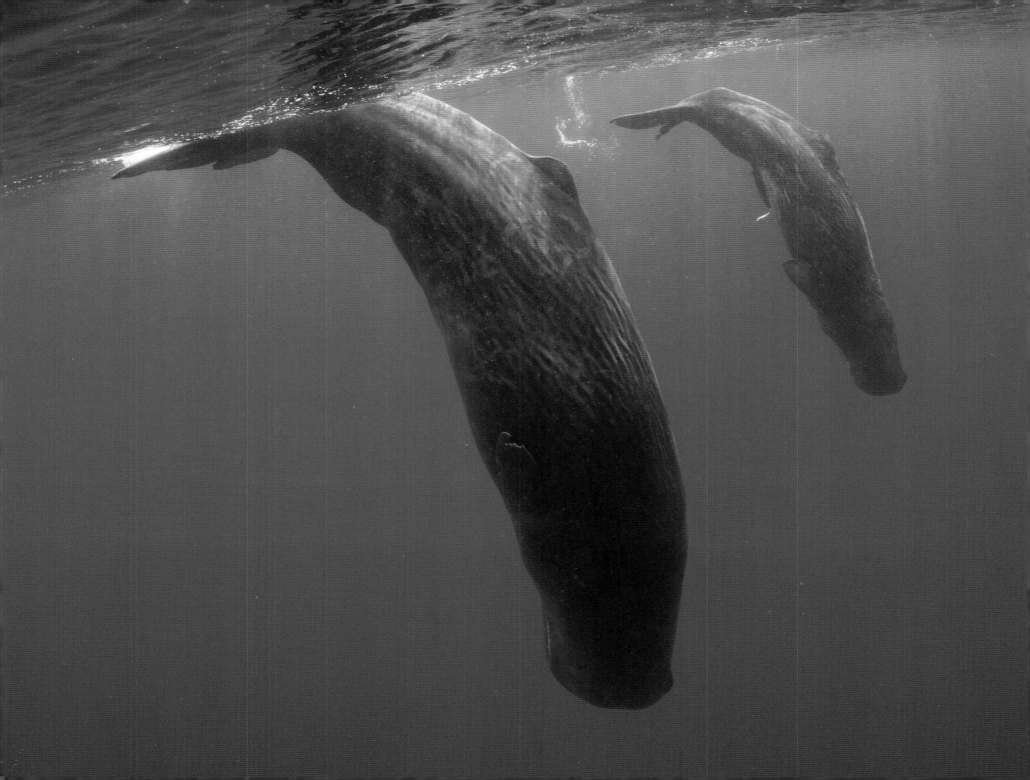

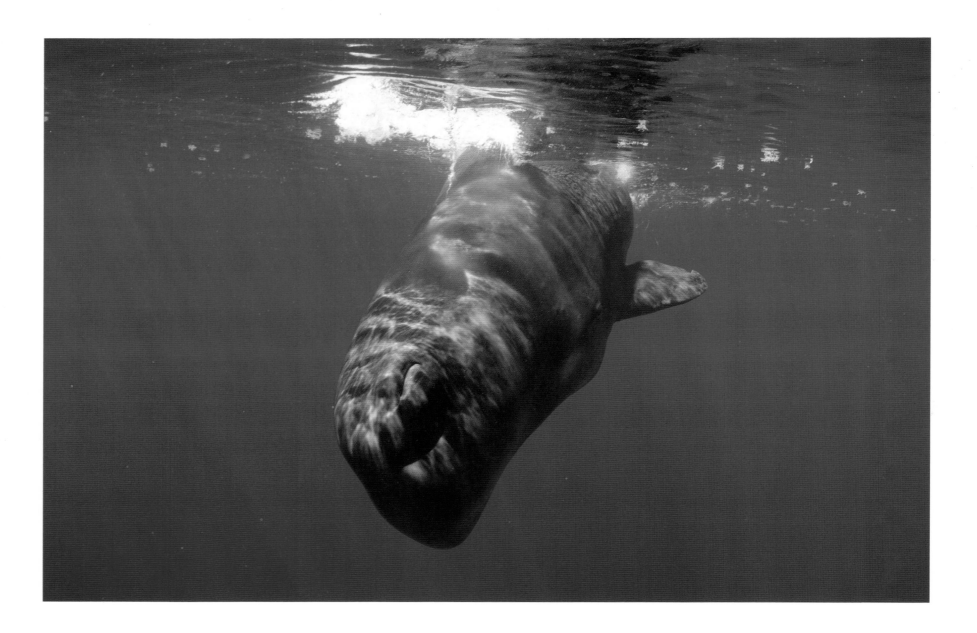

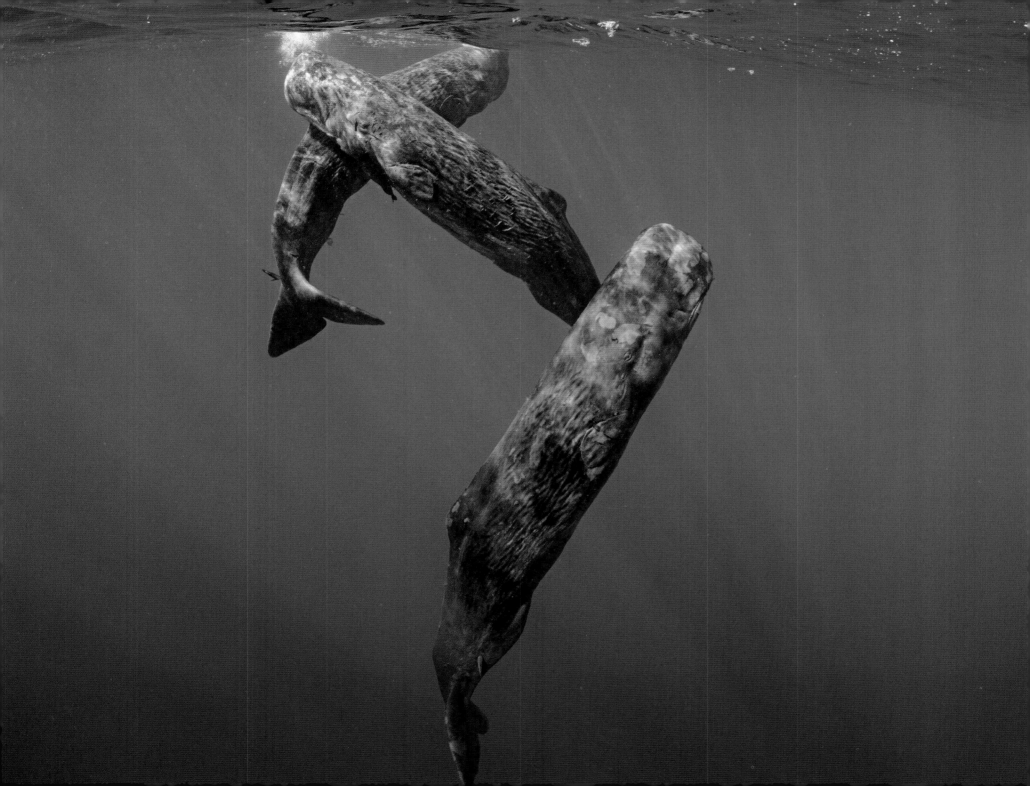

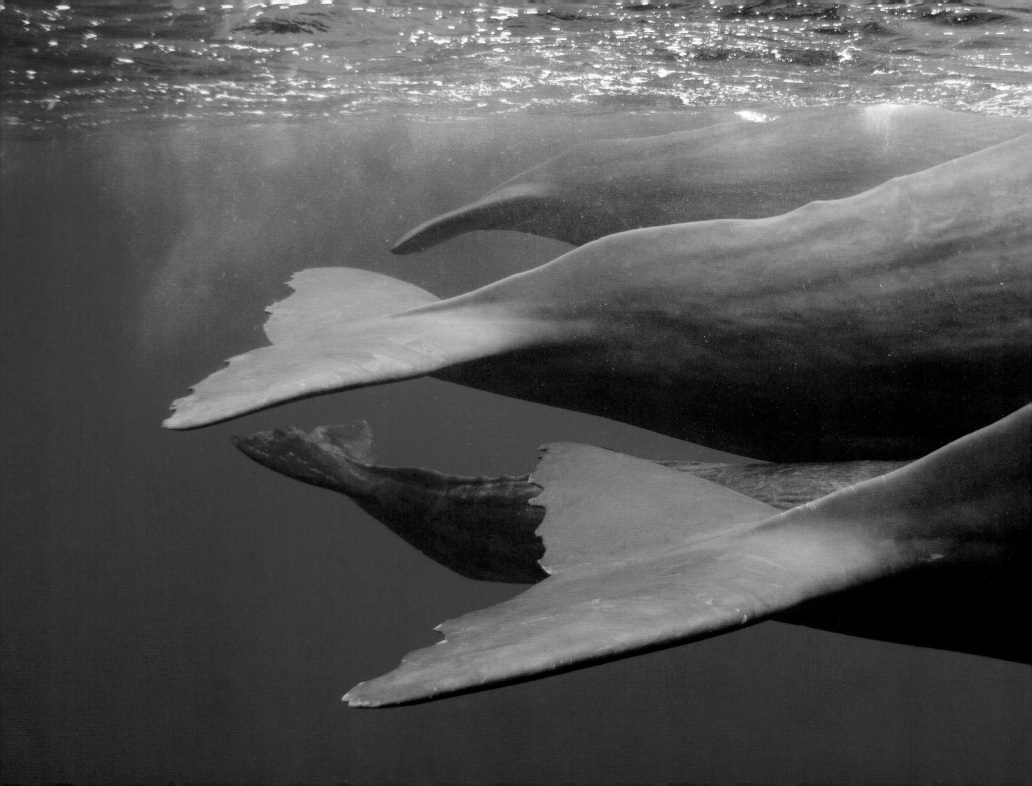

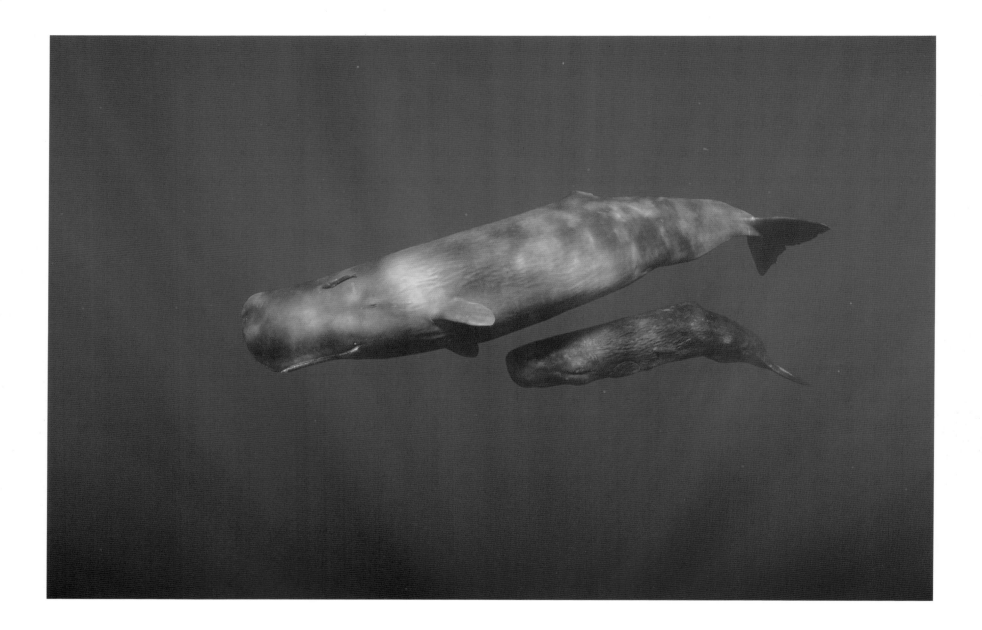

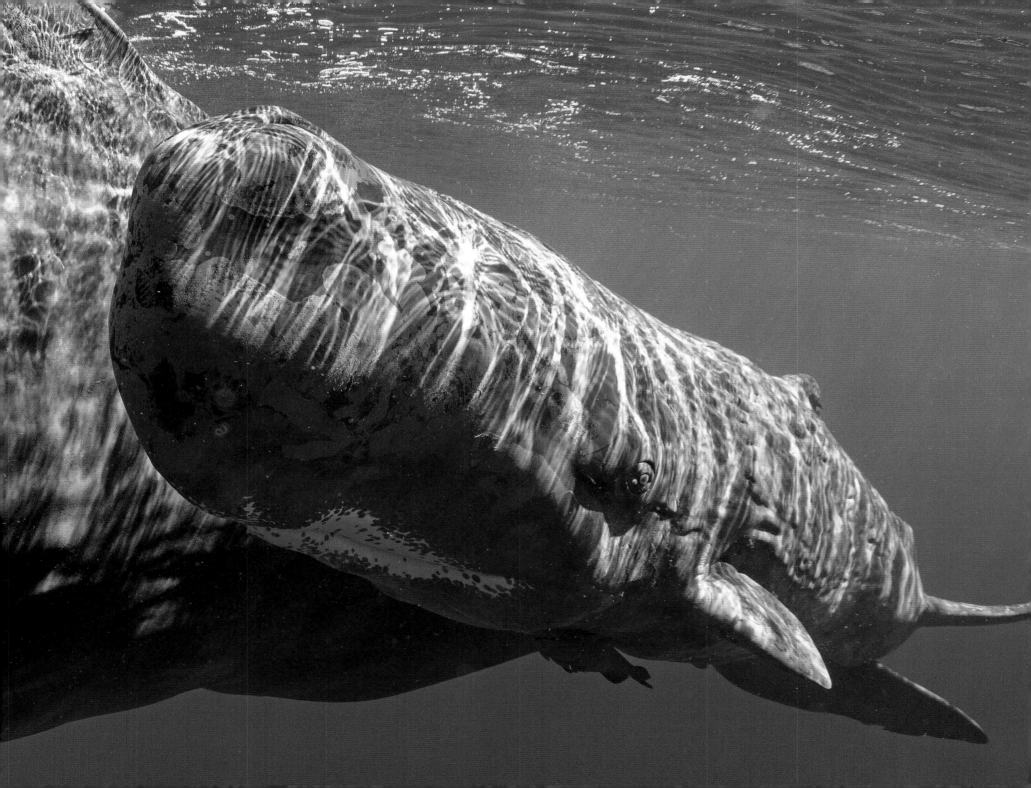

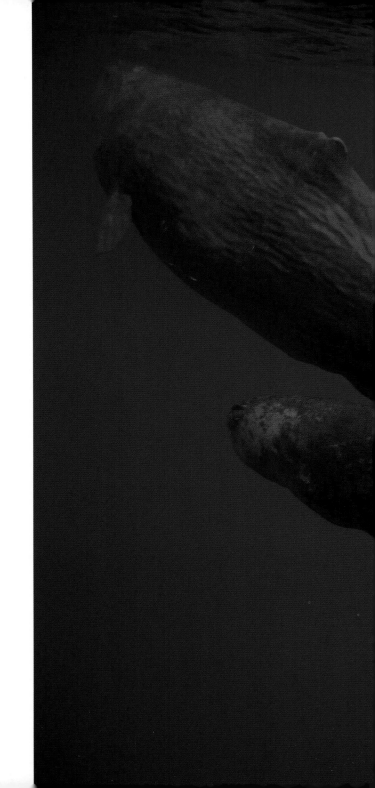

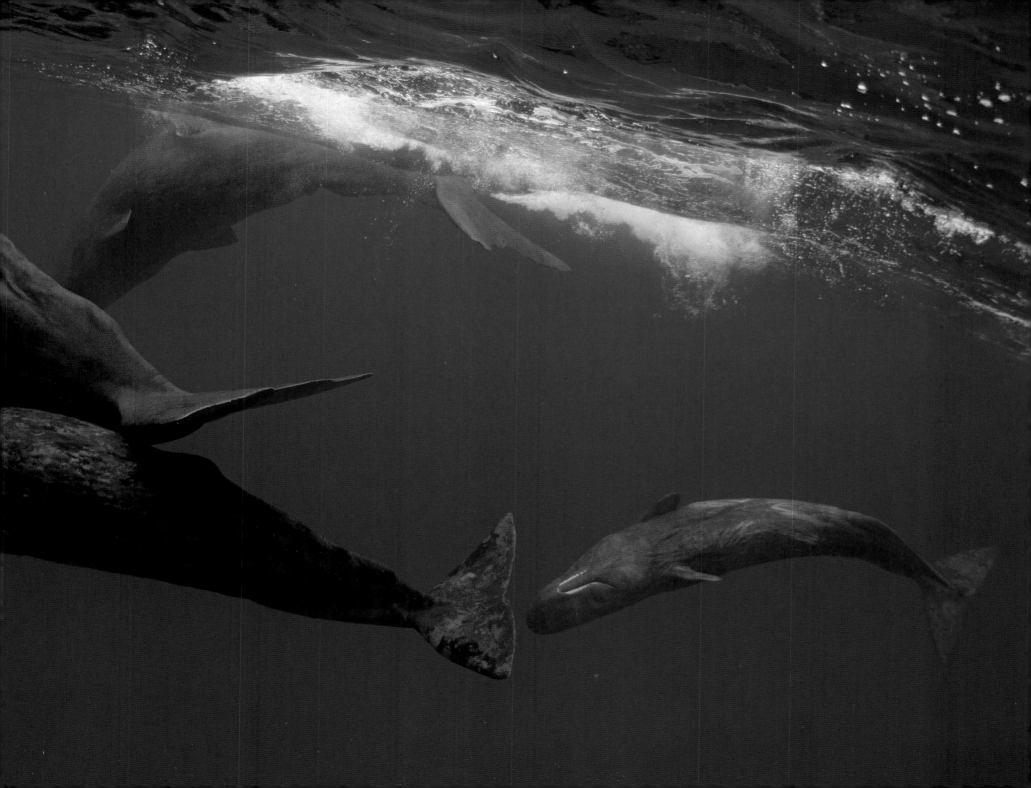

A newborn sperm whale looks into my eyes with curiosity. This young whale has a long life ahead of it. Much of what we know about the life span of sperm whales comes from whaling data and estimates from tooth layering, which may underestimate age, as growth rates slow later in life. What we do know is sperm whales, like humans, live for more than 70 years, but many probably live well into their 80s or even beyond.

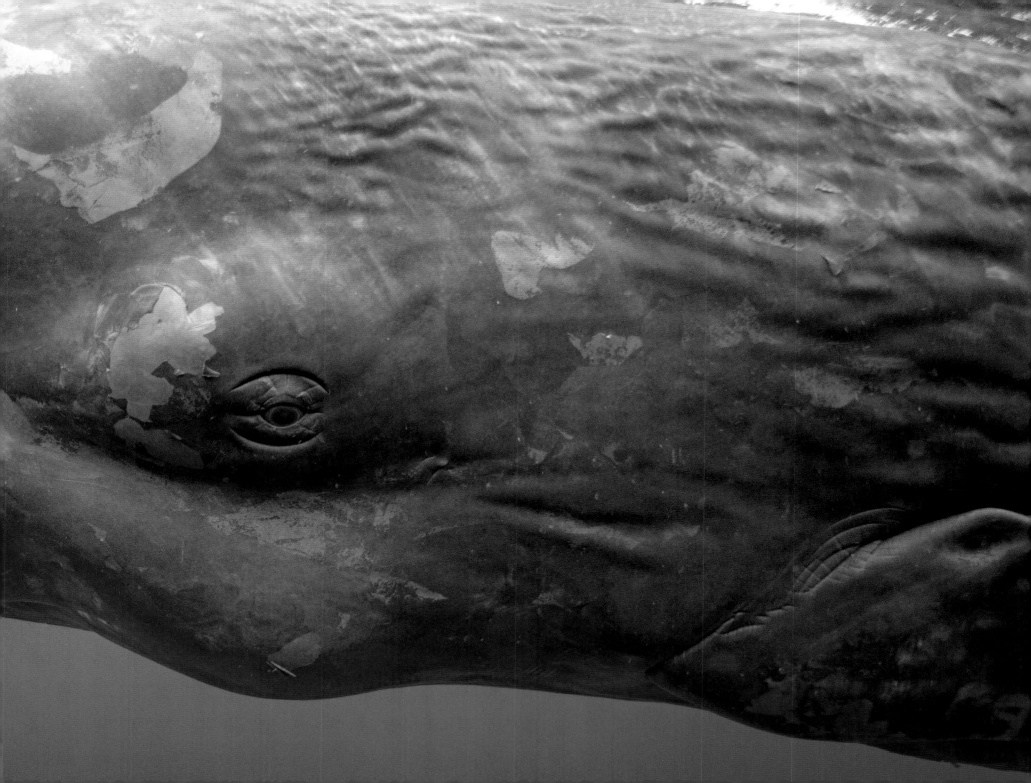

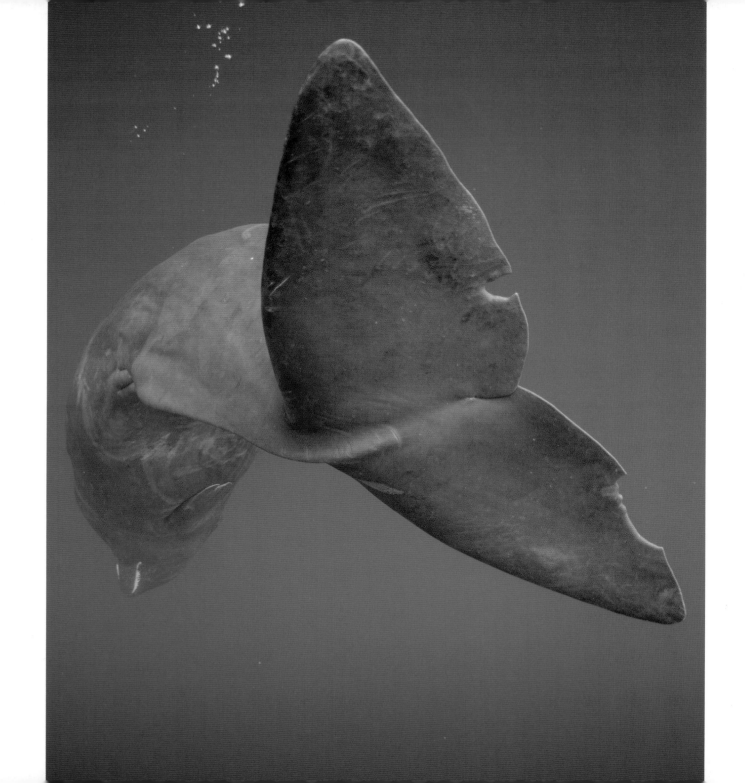

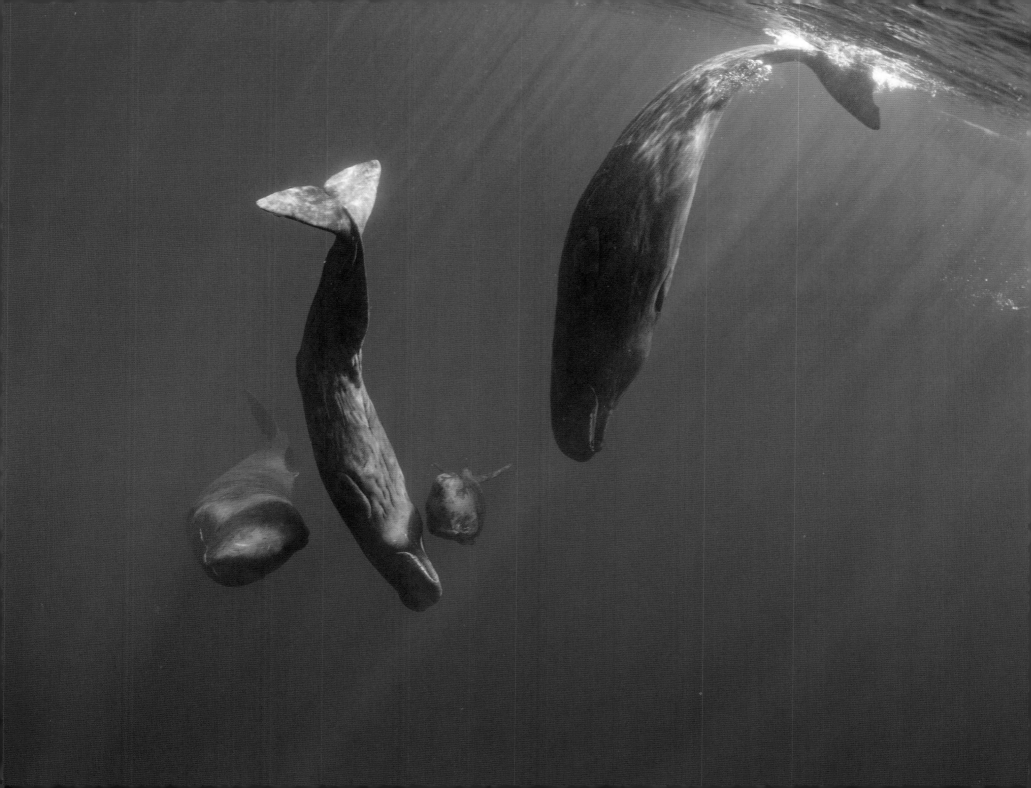

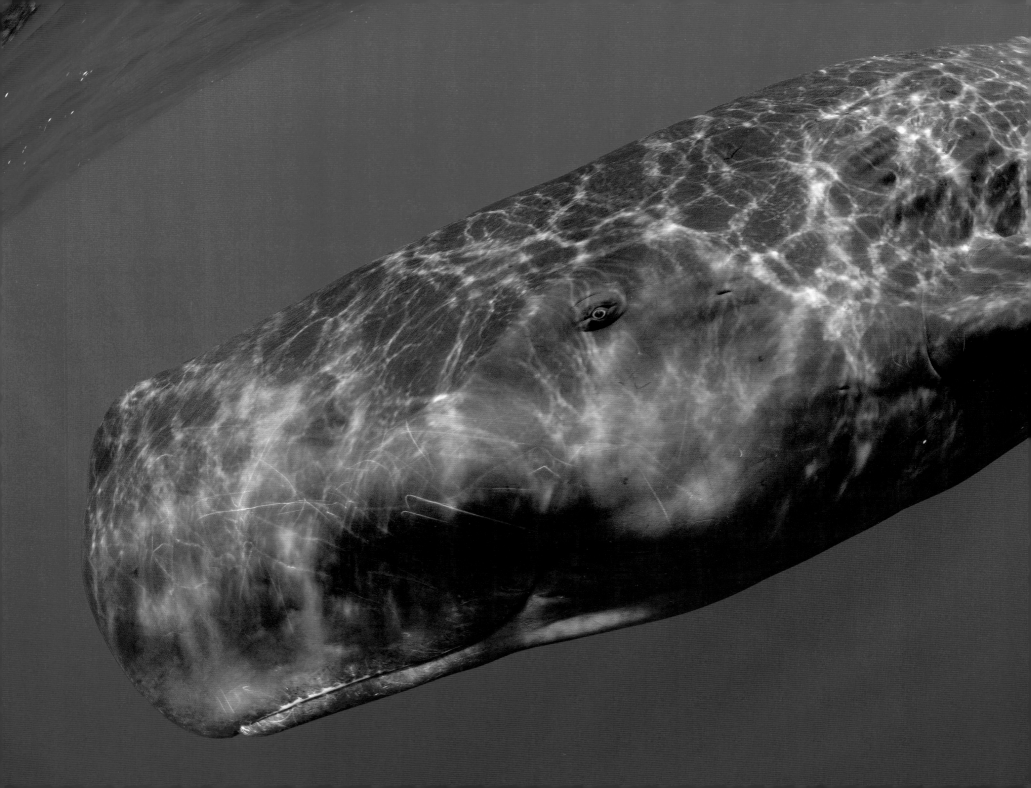

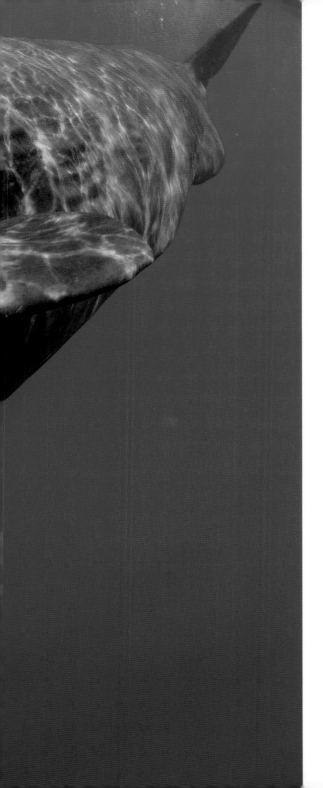

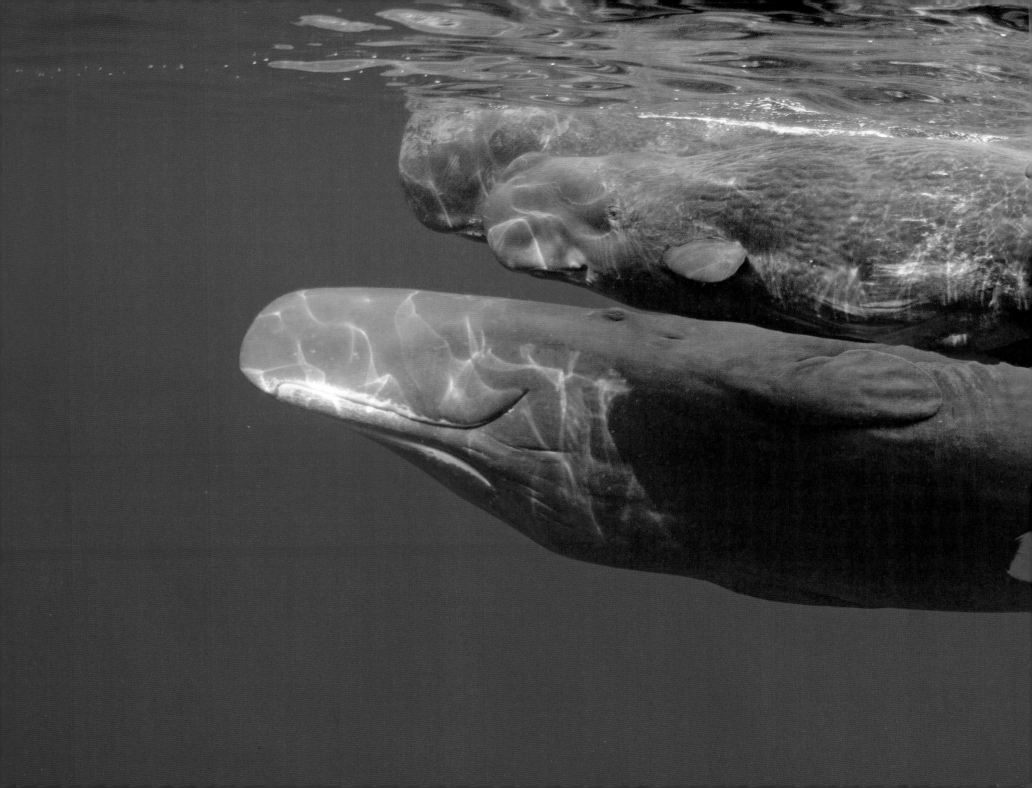

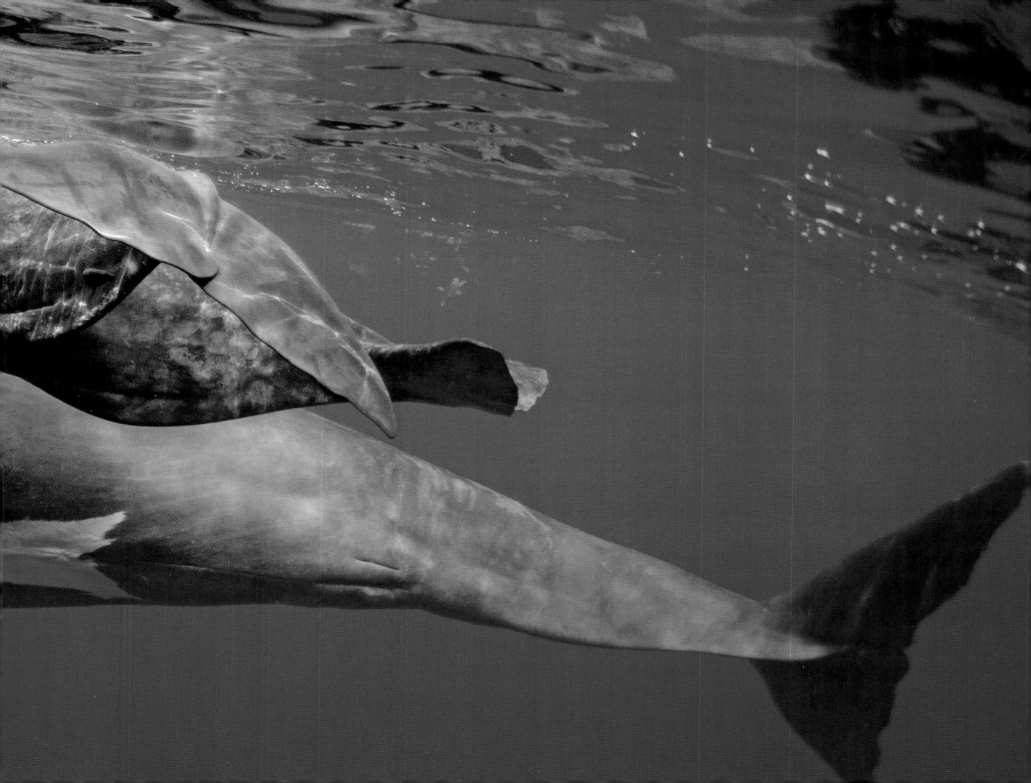

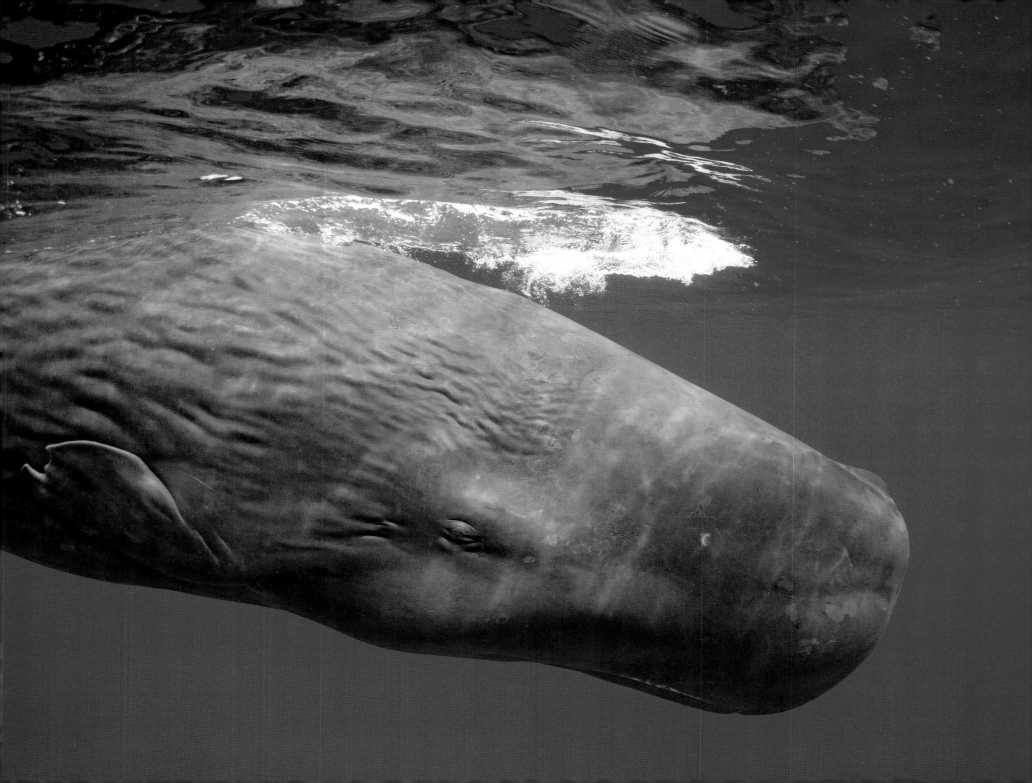

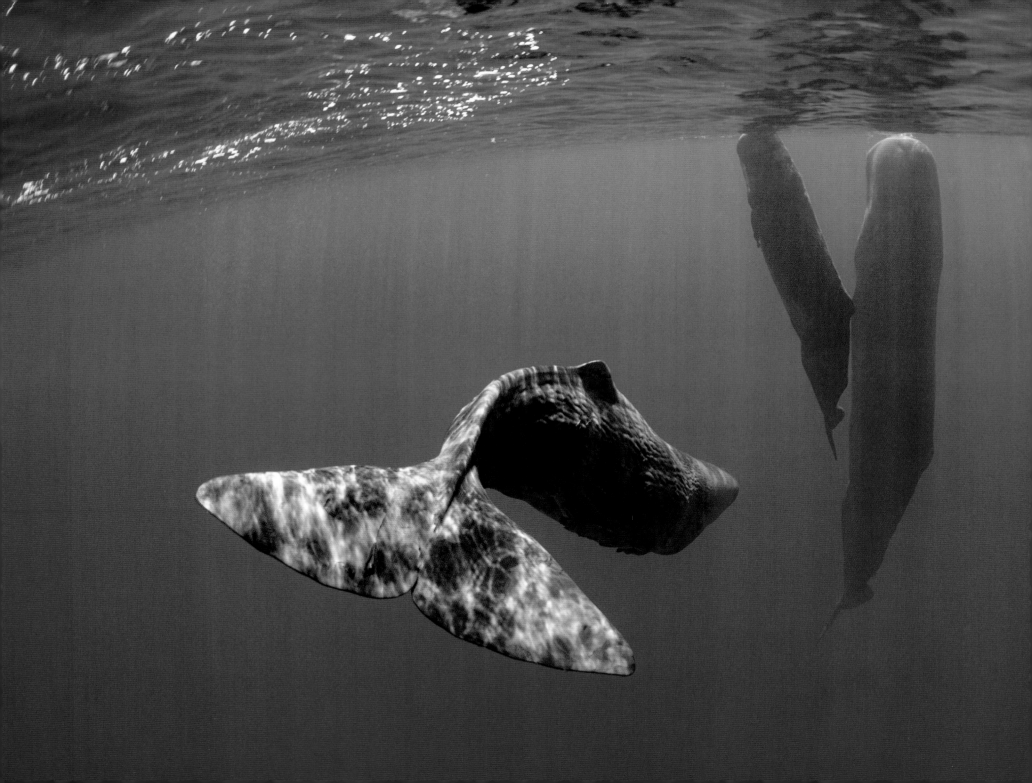

A baby spots a sleeping mother and another baby and swims toward them acrobatically. Even over long distances, the whales are able to find one another with sonar clicks. They have distinct codas used to identify their families and a series of rhythmic clicks they use while socializing. This young whale could be miles away from its family, hear the clicks, and be reunited with them shortly thereafter.

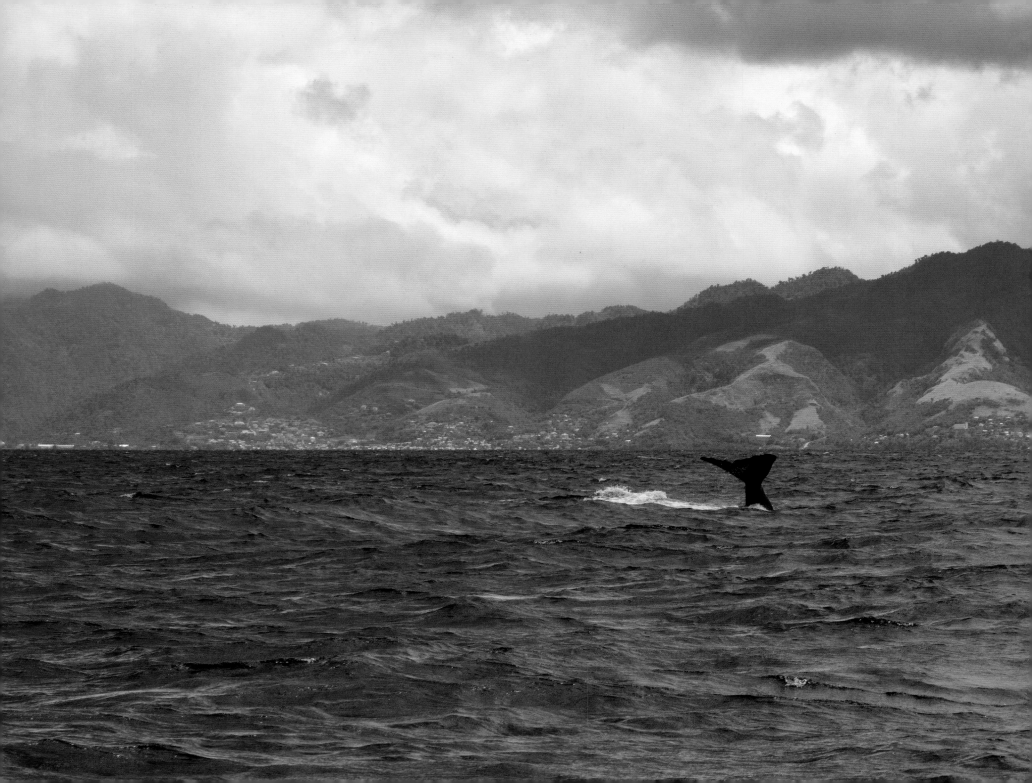

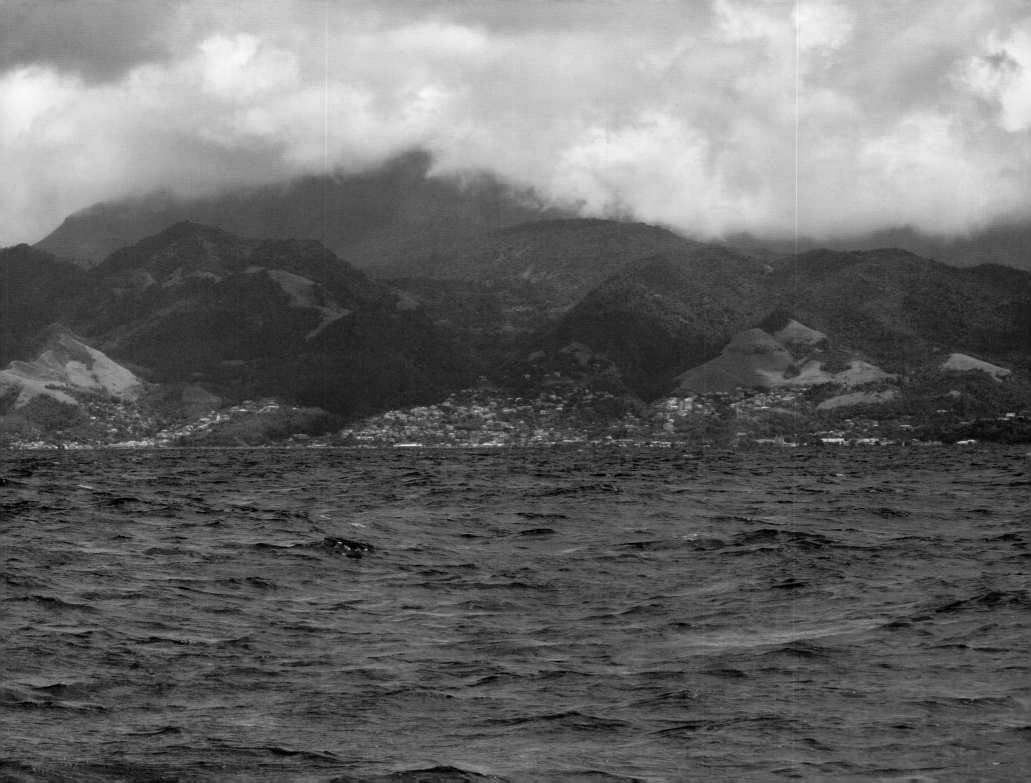

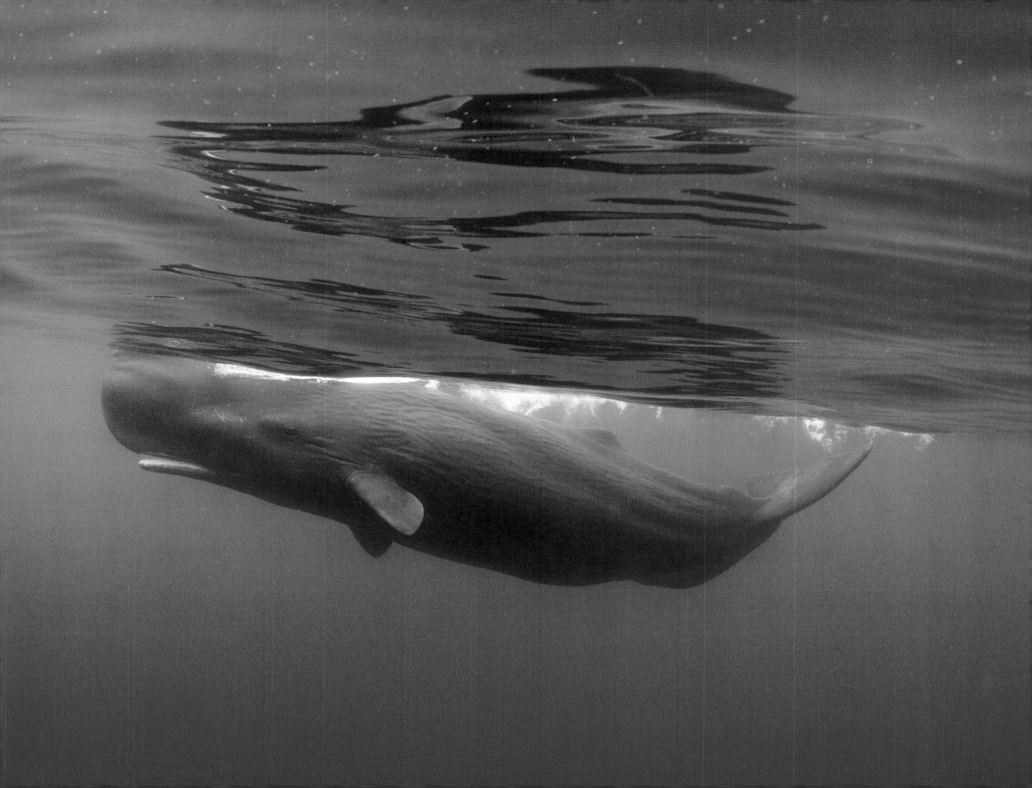

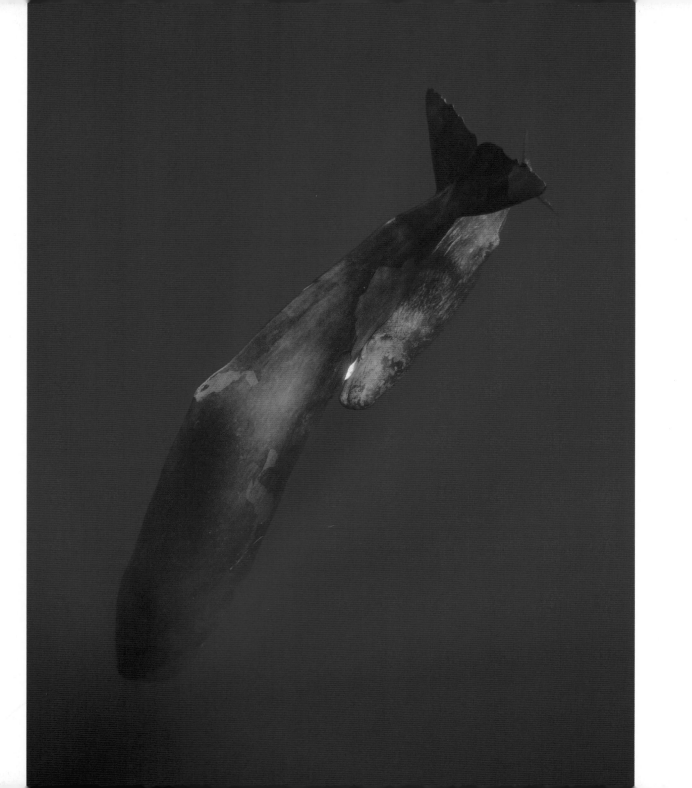

LEFT: In the depths, a baby gets one last drink of milk before its mother dives to hunt.

OPPOSITE: While the mother hunts, another female from the family takes a rest while looking after two babies near the surface.

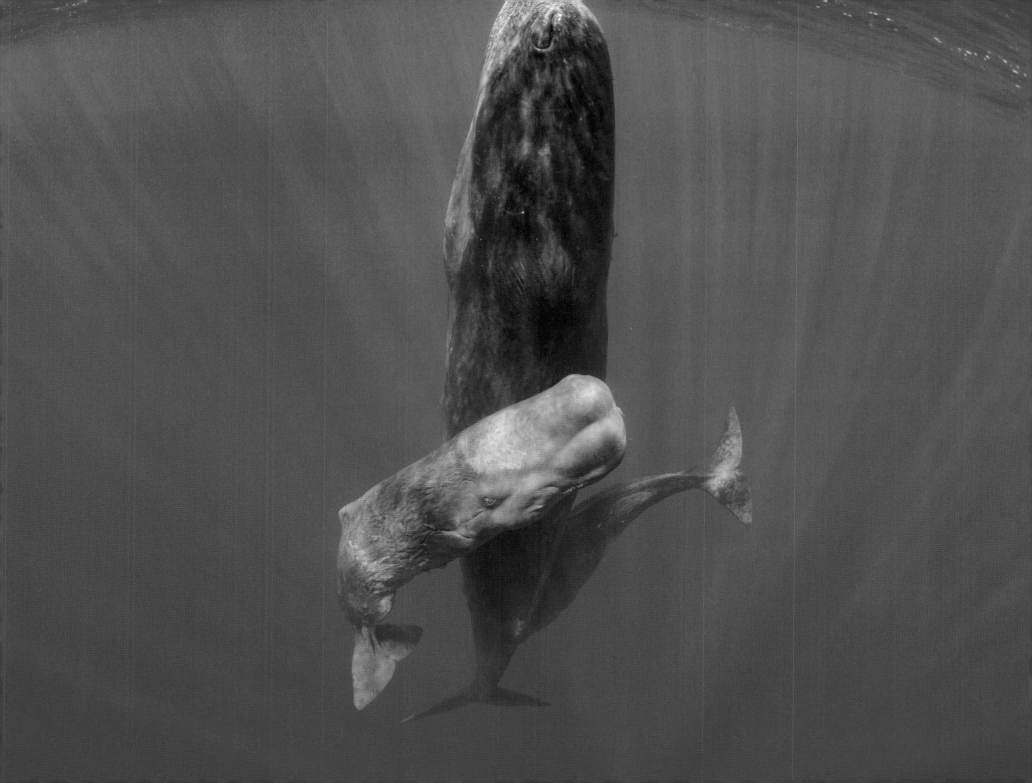

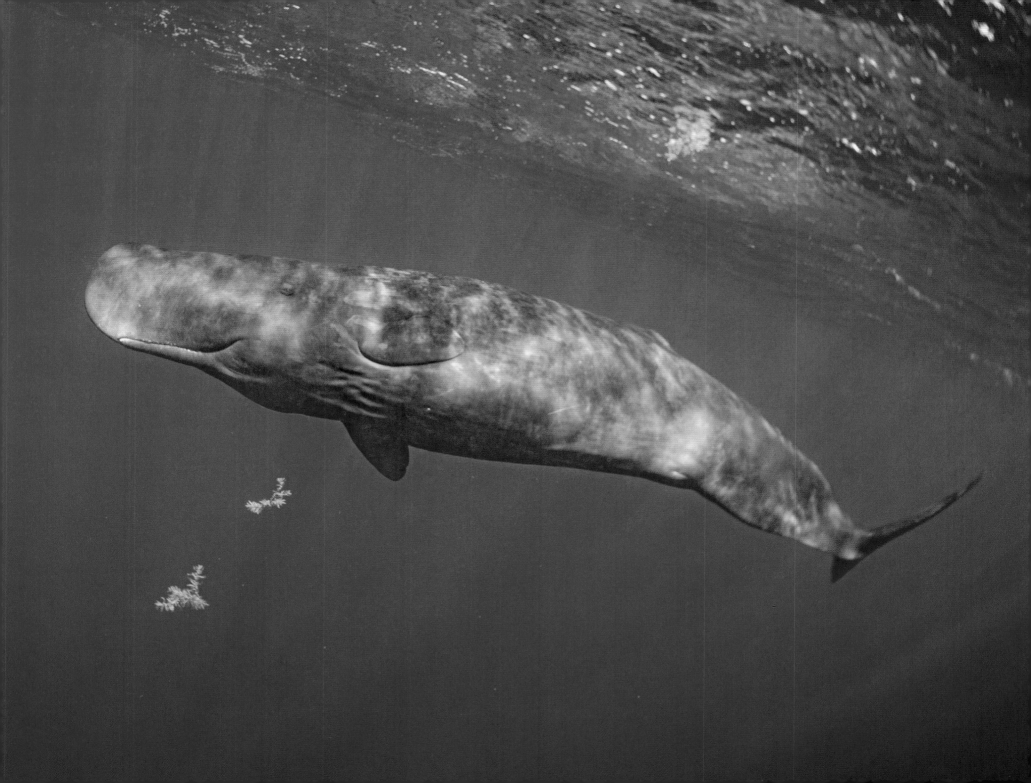

Accra, a female from Unit A, has unmistakable markings on her fluke, making her easy to recognize. Sperm whales, like many other whales, have unique flukes (tails), which allow scientists and observers to identify individuals. Many of the sperm whales in Dominica have been identified and named in this way, helping scientists keep tabs on individuals and families. While it is not known how the whales get all of these nips out of their flukes, one possibility is bites or attacks from predators like pilot whales.

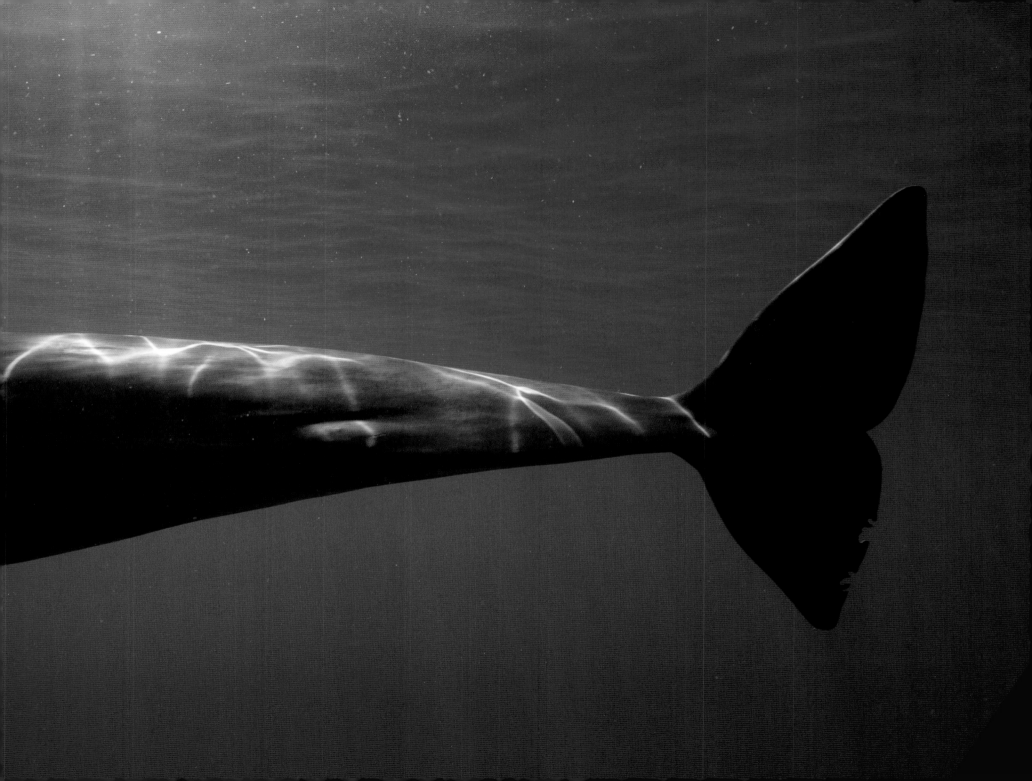

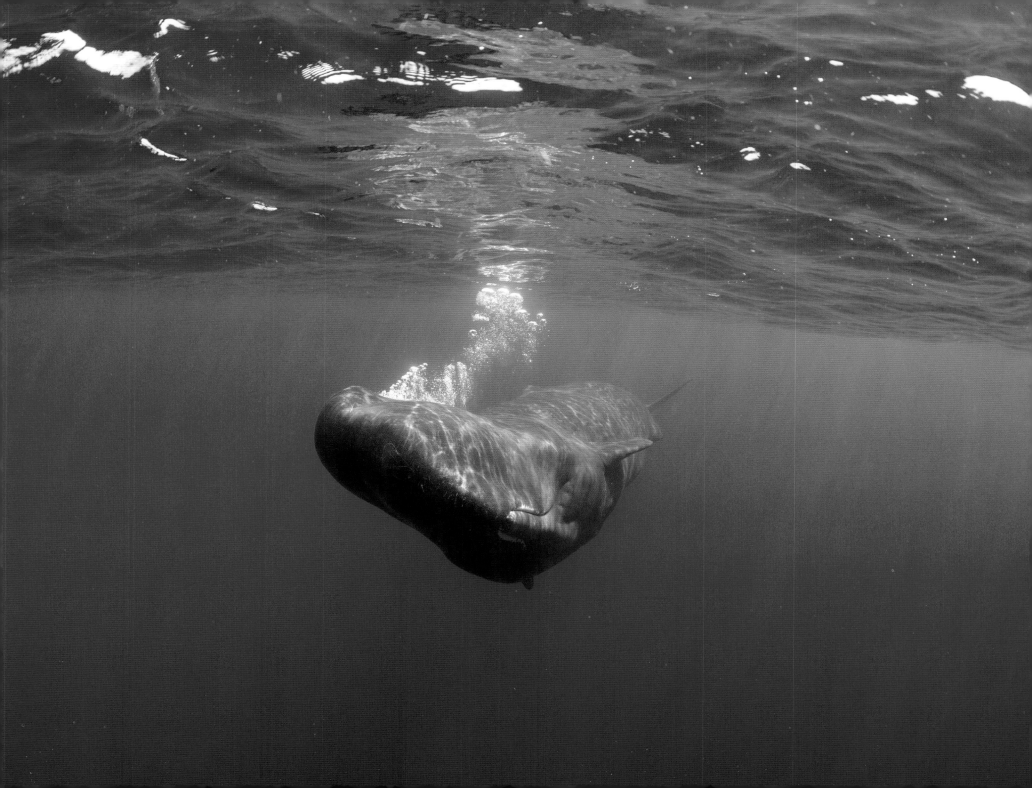

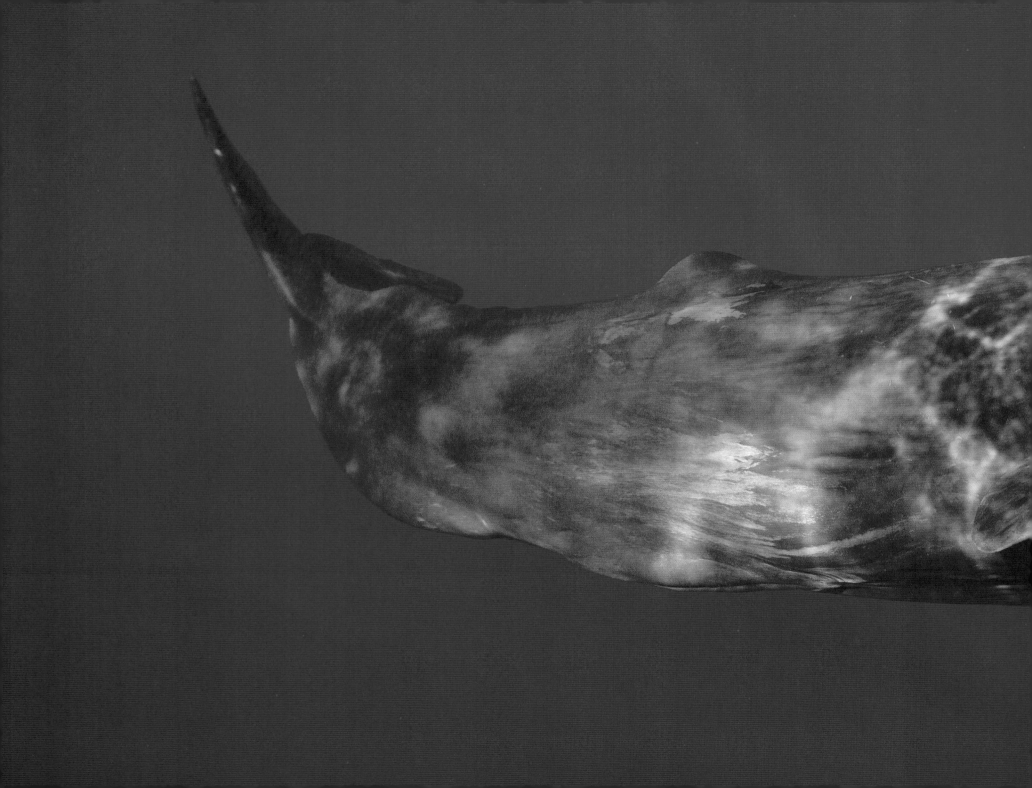

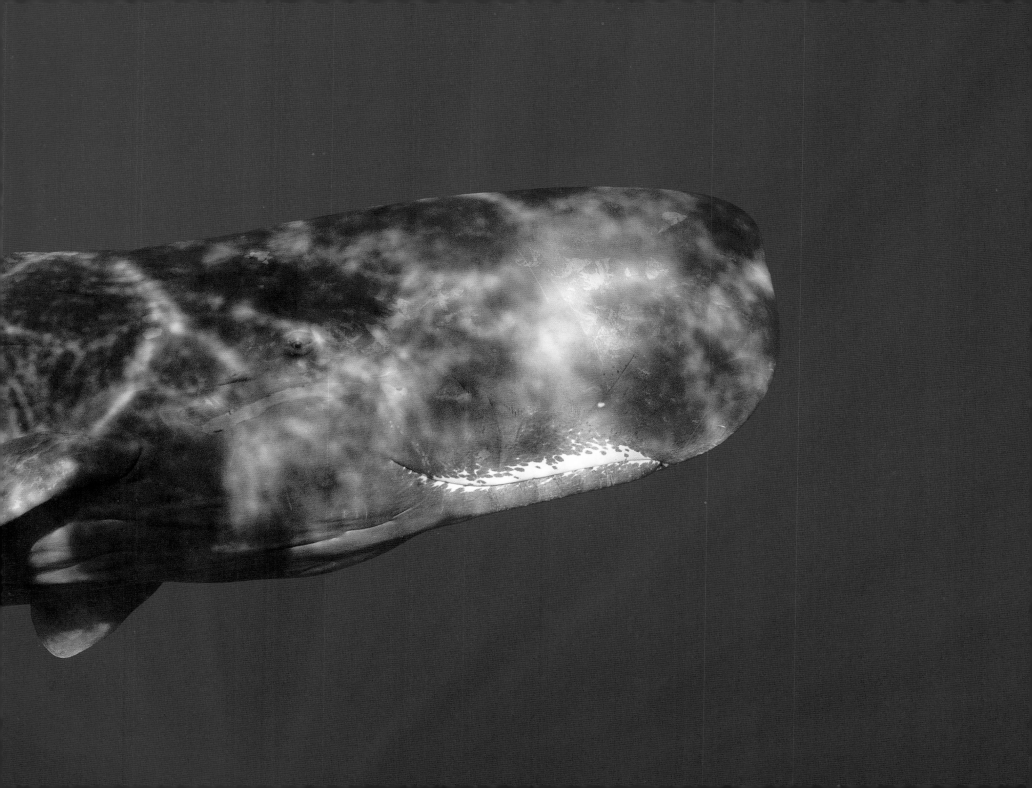

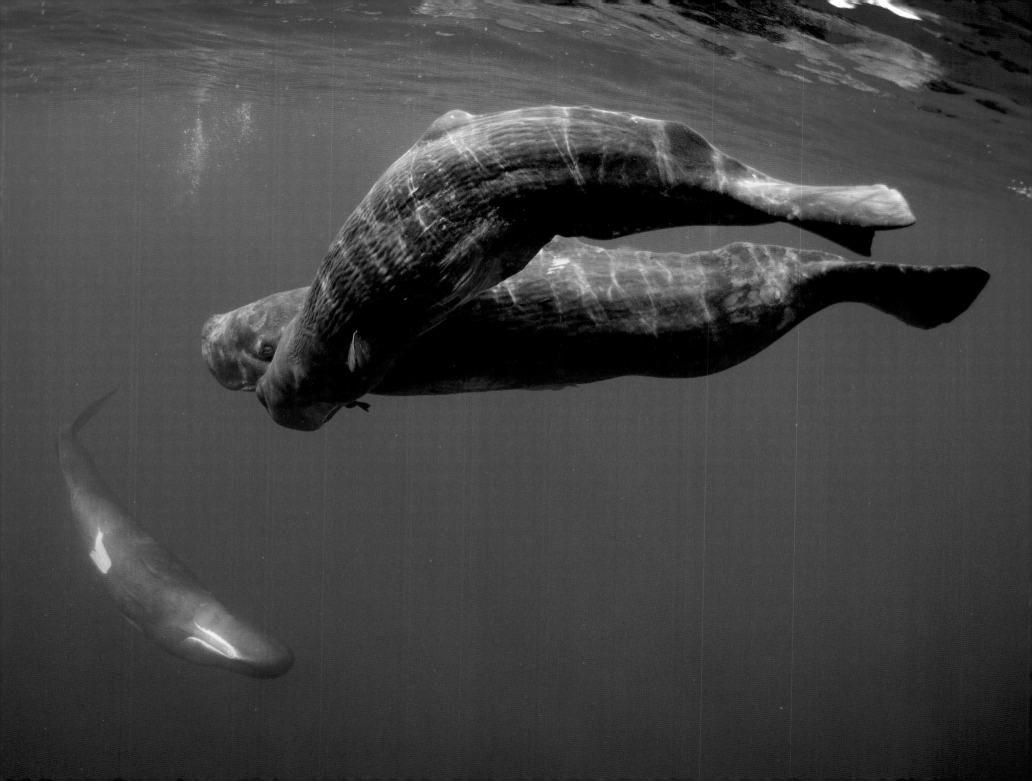

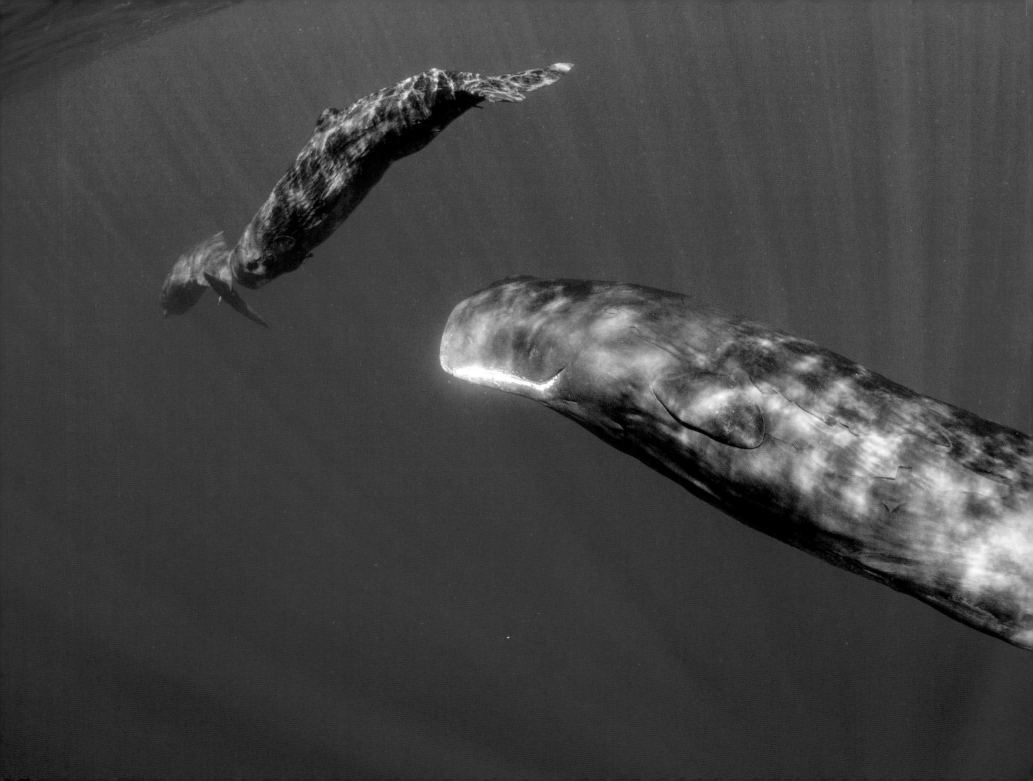

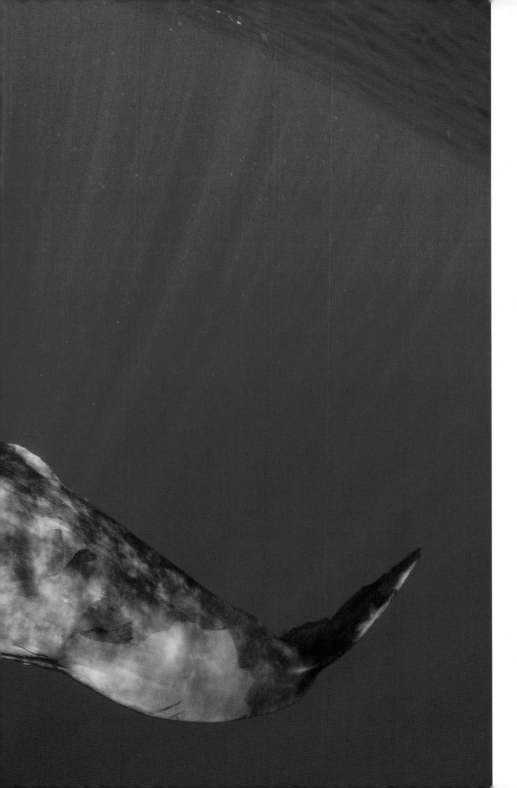

A female follows two calves while babysitting at the surface. Females reach sexual maturity at around nine years old and begin having calves around 10 years old. They will have a single calf approximately every five years until they reach their 40s, at which time that fecundity decreases by about one-third. It is not known if sperm whales go through menopause, but it does seem that, like humans, they live well beyond their reproductive years. Males, on the other hand, reach sexual maturity in their teens but likely do not breed until well into their 20s, when they migrate back to the warm waters to find the females.

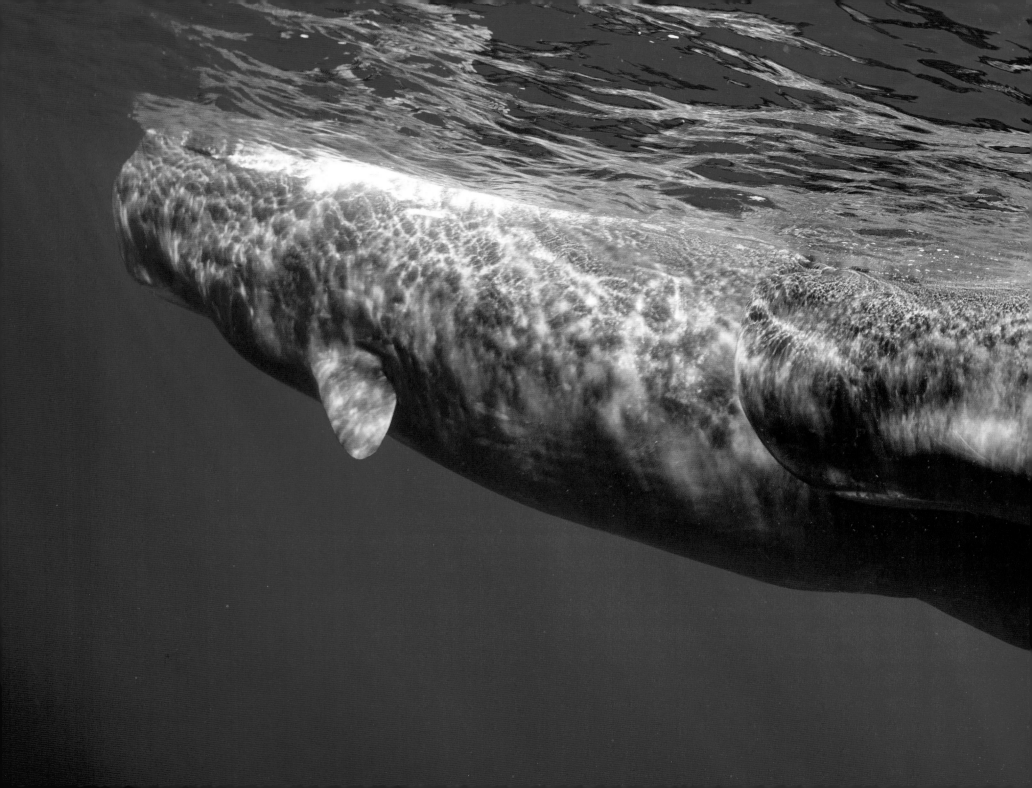

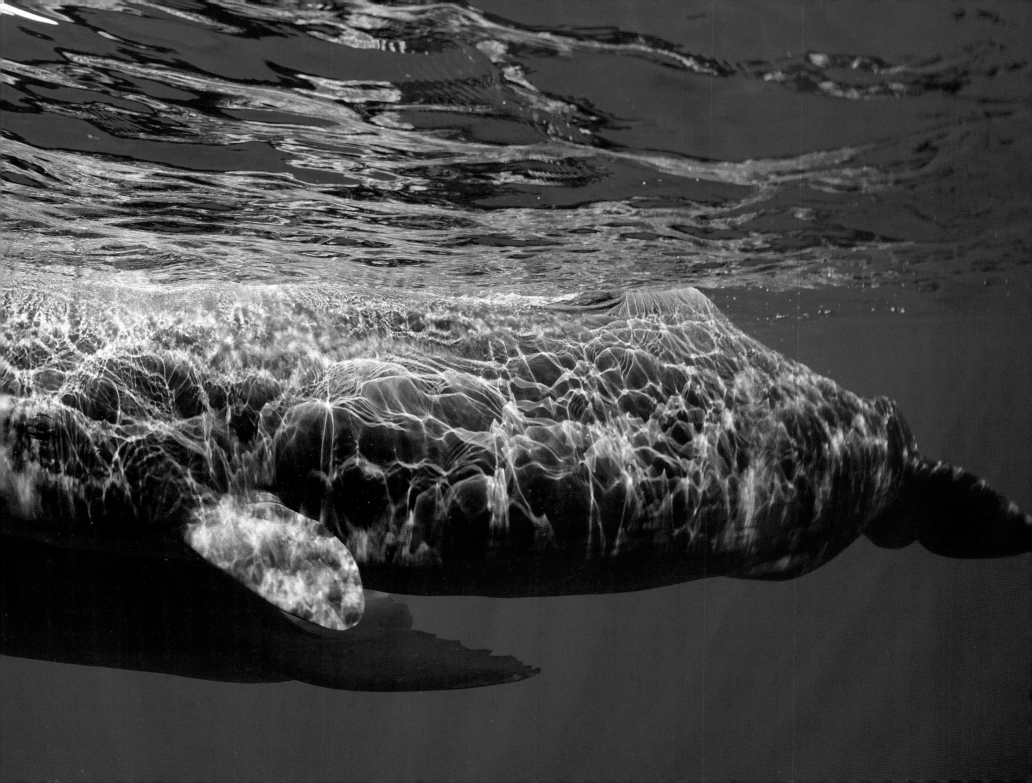

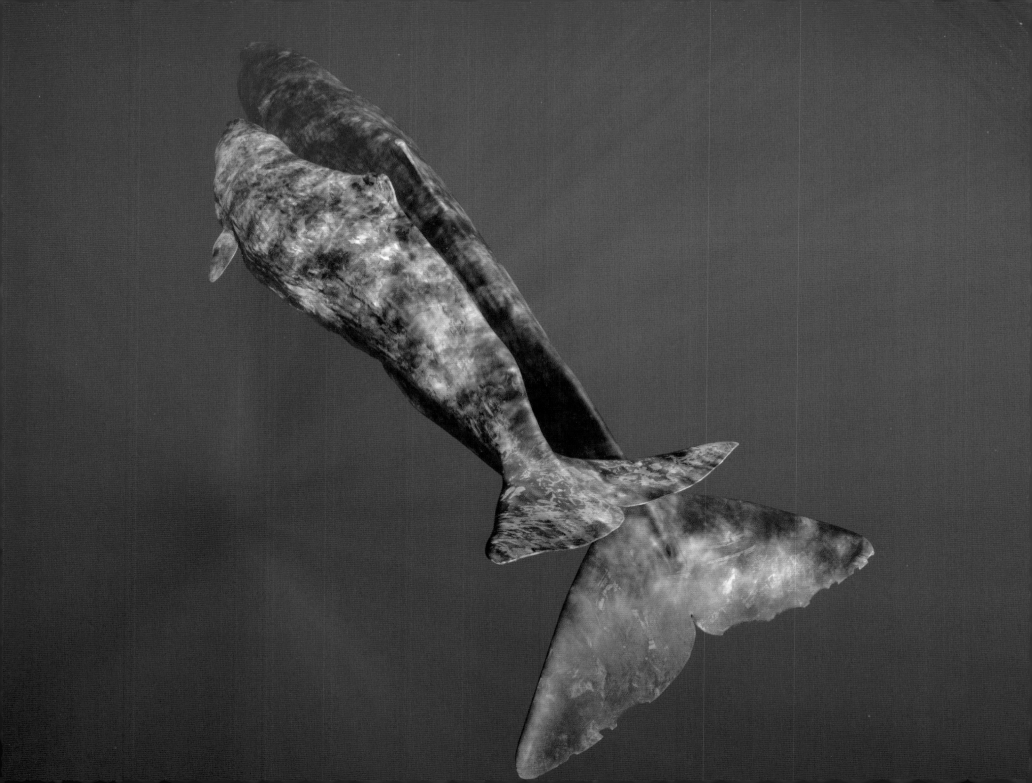

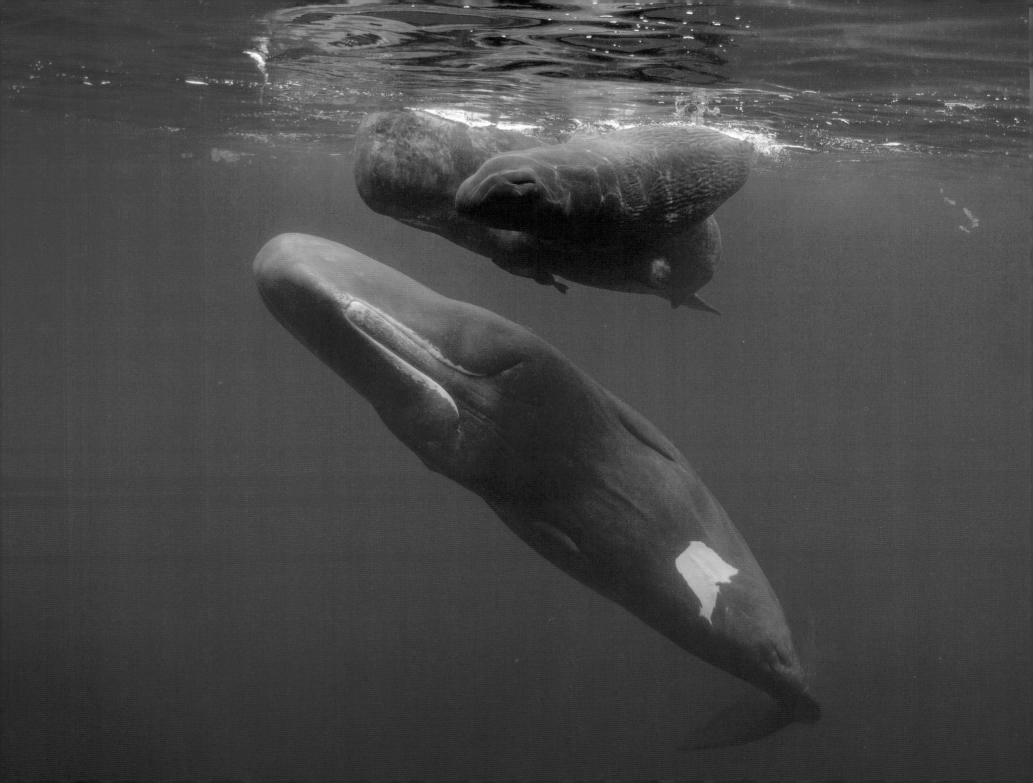

While the sperm whale gets its scientific name from the
sheer size of its head, its common name comes from the
spermaceti organ located there. The spermaceti organ
takes up 25 to 33 percent of the whale's body and is
filled with spermaceti oil, which early hunters mistakenly
thought looked like semen, hence the name "sperm whale."
Spermaceti in Latin translates to "whale sperm." This organ
is part of the whale's highly developed sonar echolocation
system, which it uses for both hunting and communication.

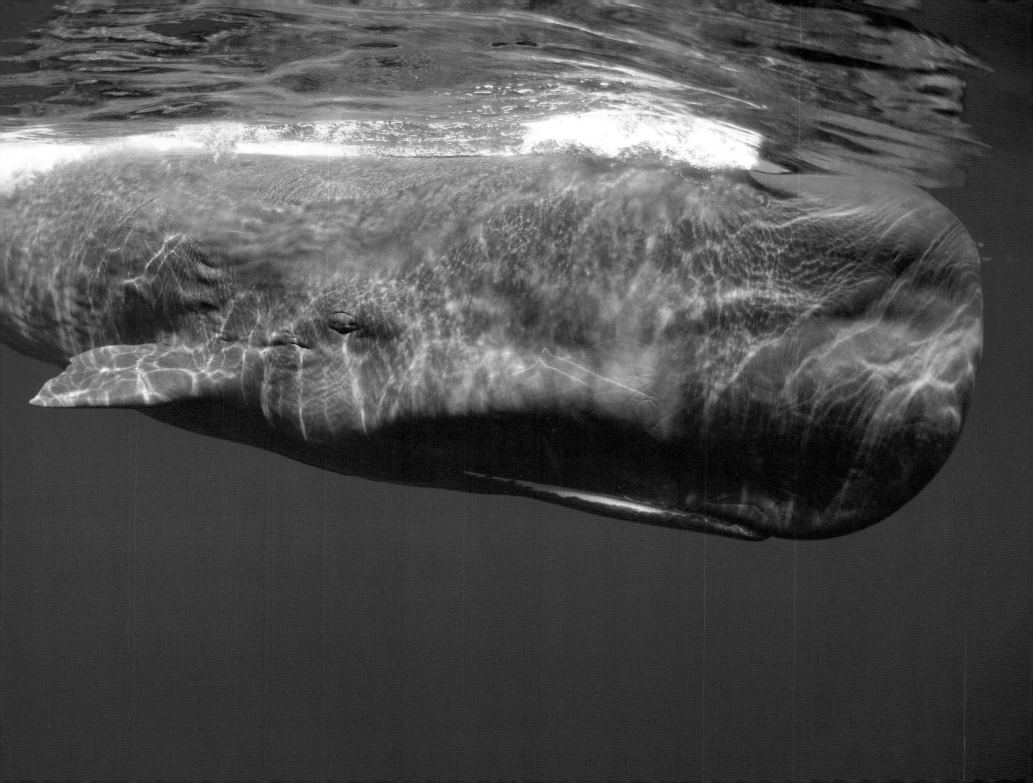

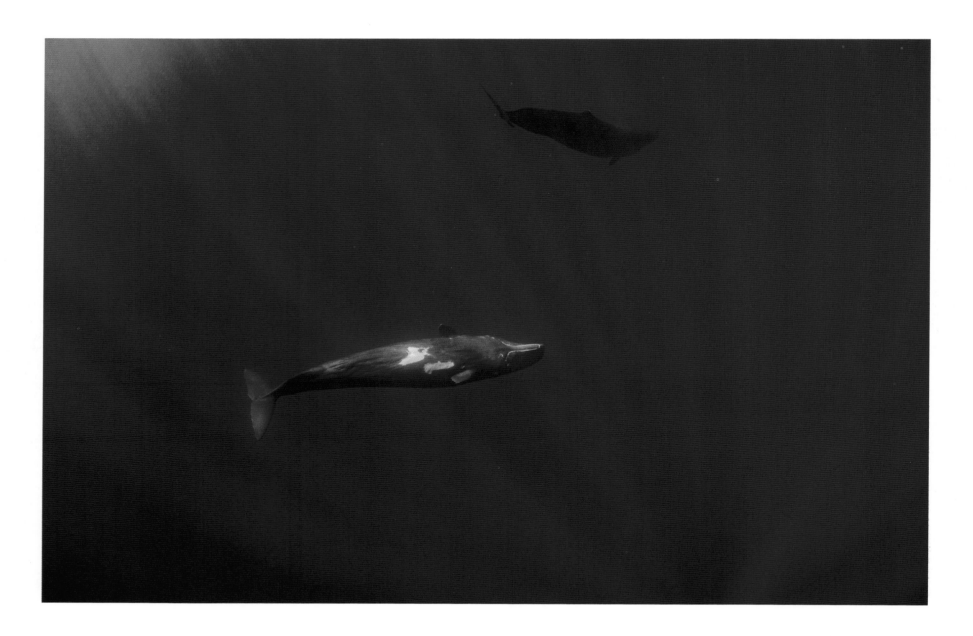

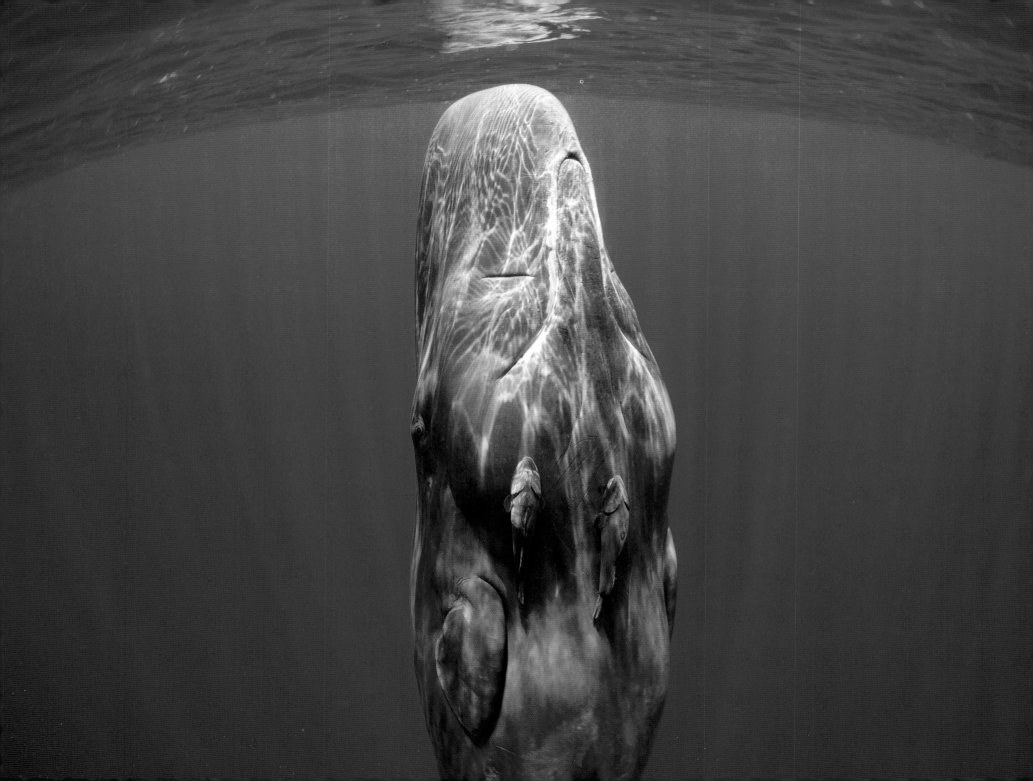

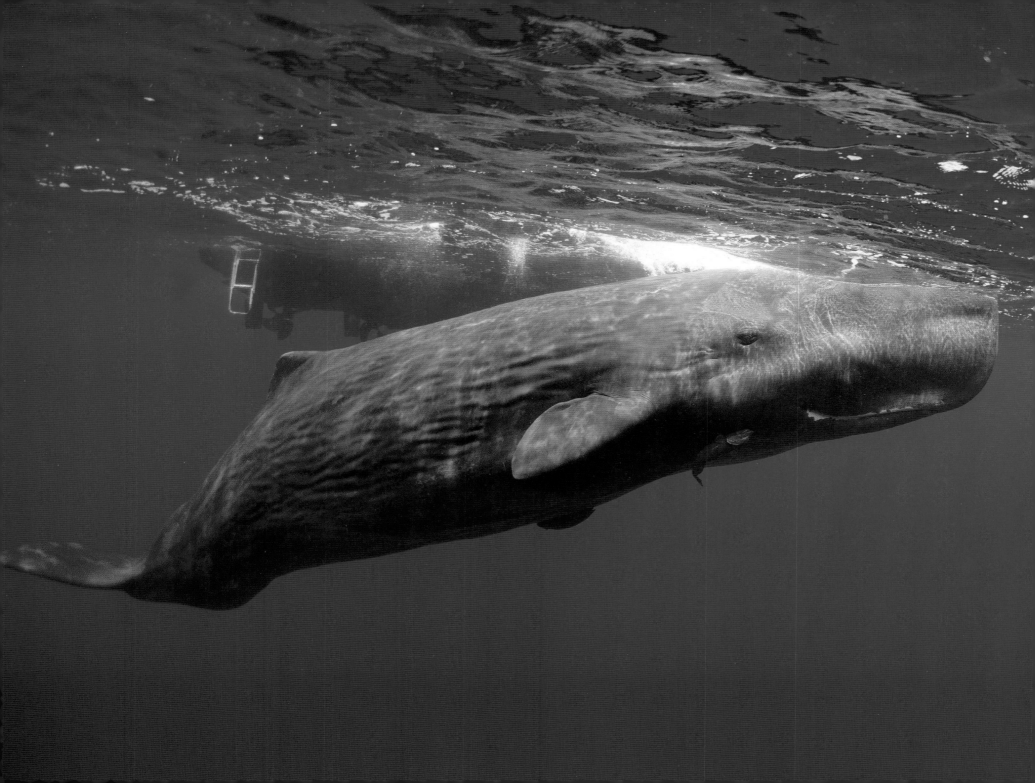

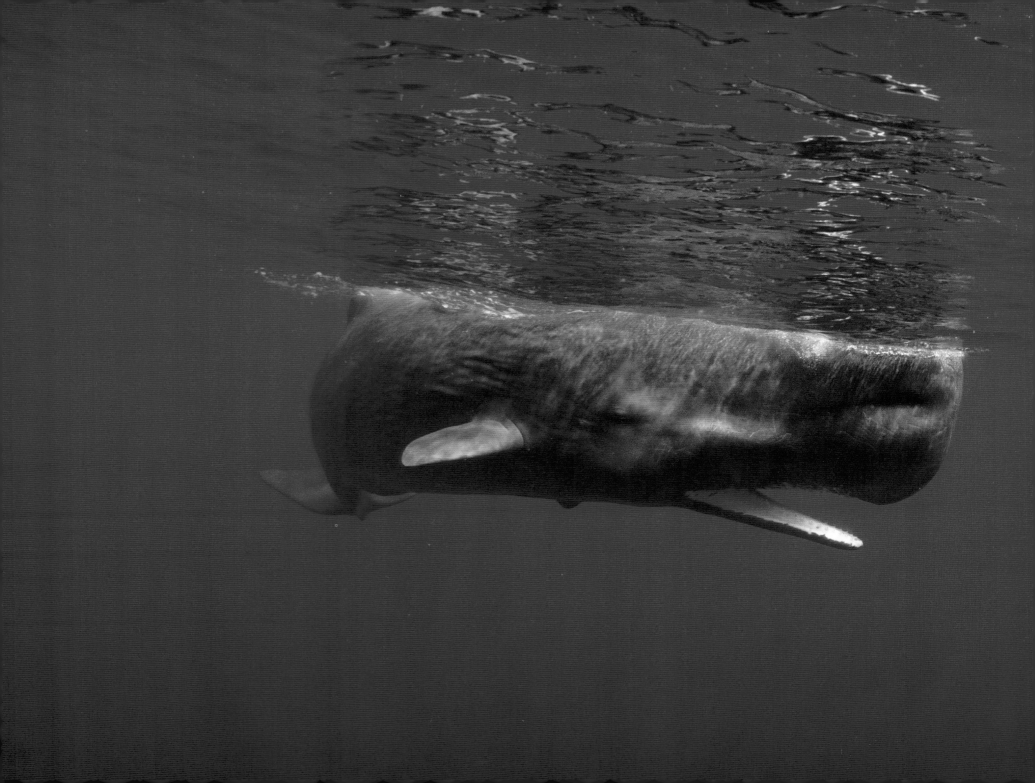

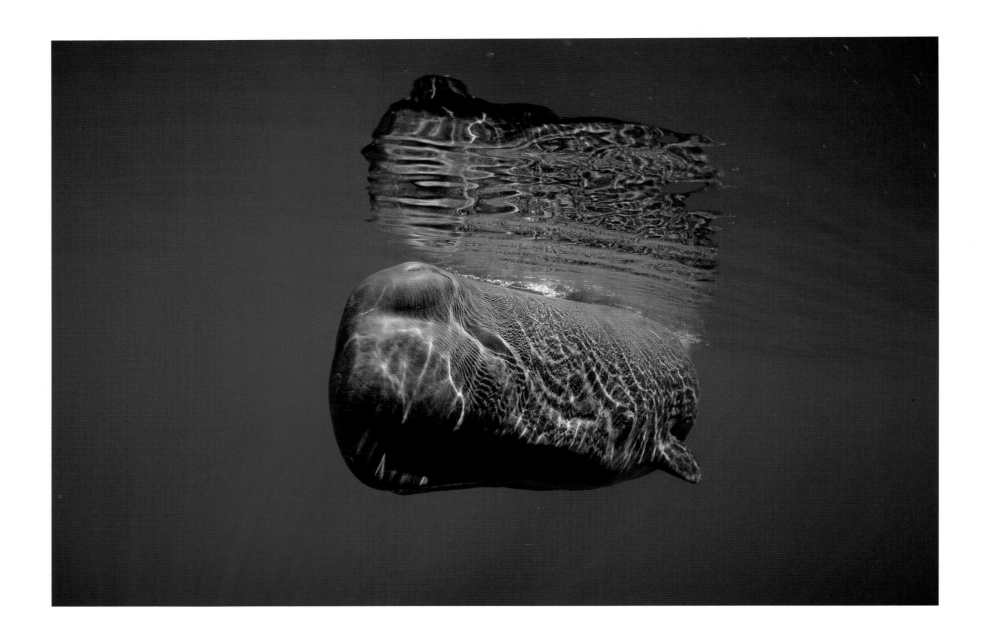

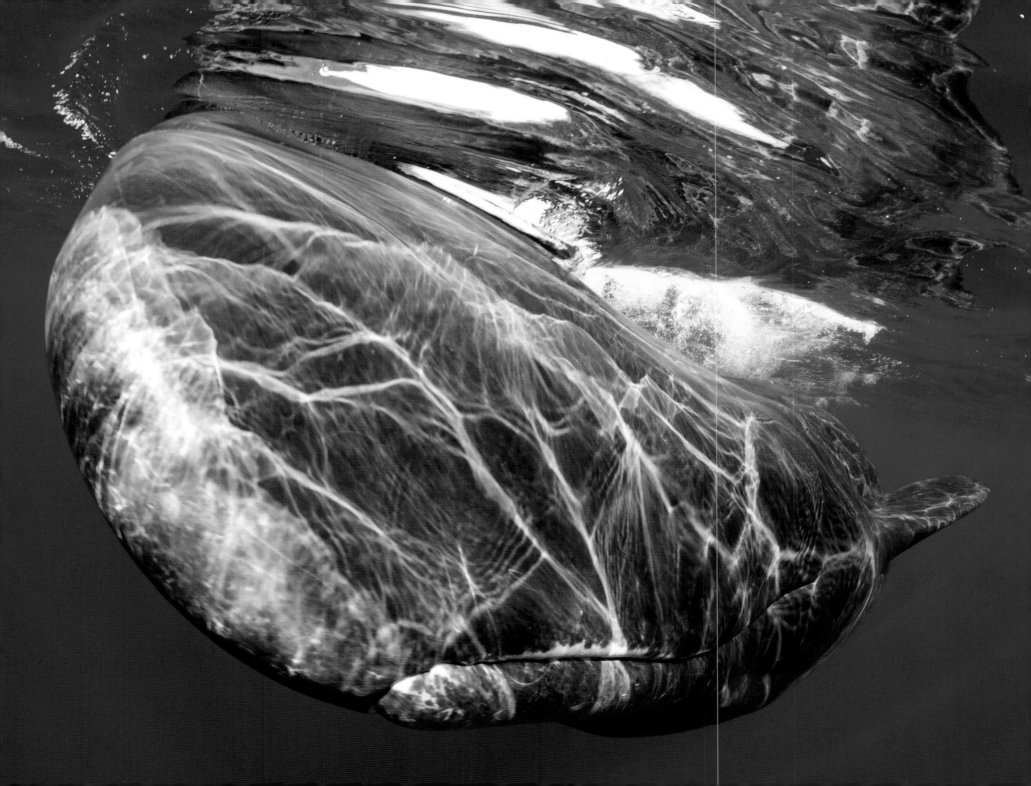

An adult and baby swimming off into the blue gives
me hope for the future of these whales that were
hunted almost to extinction. Witnessing the addition
of newborns to this vulnerable population has been
a privilege. While we know that humans killed many
whales in the past, we have little way of knowing the
tremendous impact that hunting and other human
behavior has had on the culture and life history of
these whales. However, moving ahead, we can play an
active role in protecting them so they will remain in
the ocean for years to come. We can view them as a
part of our collective world rather than a commodity.

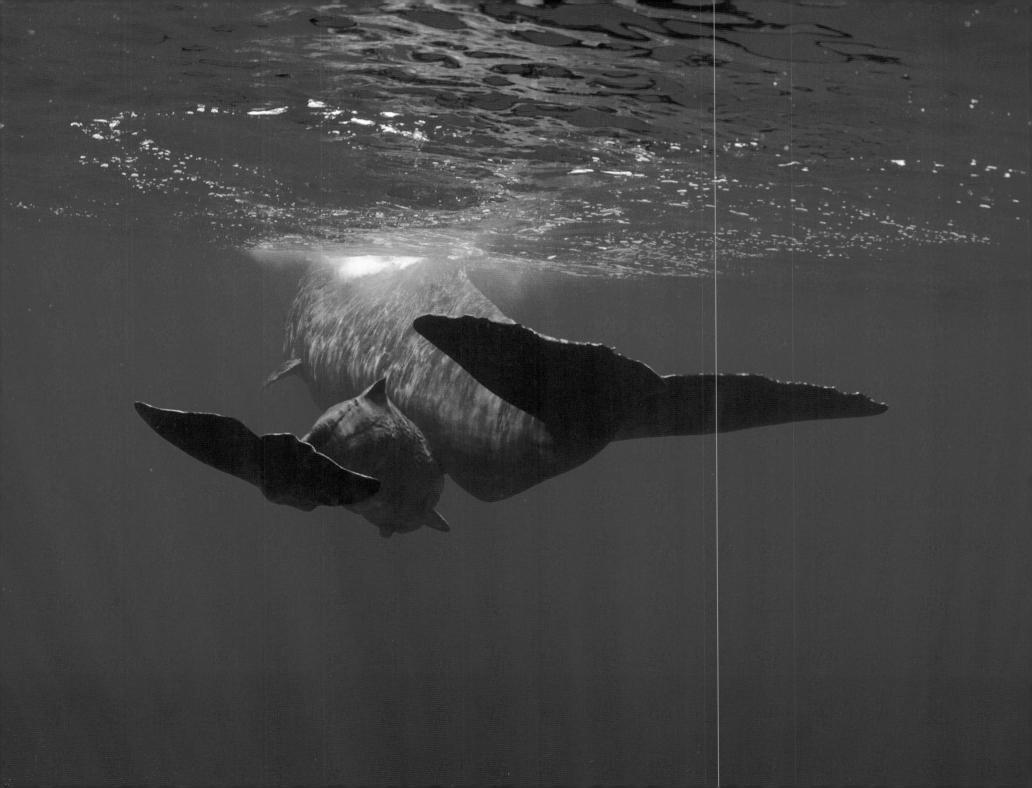

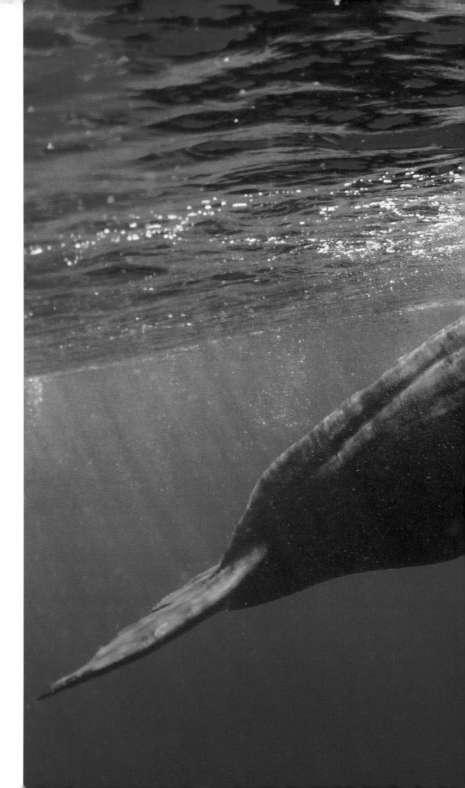

ACKNOWLEDGMENTS

I would like to thank the following people, without whom this work would not have been possible, for their support:

Stacy and Zev Rosenwaks, Jim Muschett, Carl Safina, Susi Oberhelman, Candice Fehrman, AJ Correale, David Rosenwaks, Ava and Ella, Gillian Kolodny, Pernell Francis, Jerry and Sheinel Daway, Vener Seamans, Jefferson Charles, the Government of Dominica, Bill Rossiter, Jennifer Arnold, Alison Wright, Myda El-Maghrabi, Kevin and Lee from Reef Photo, Stefani Gordon, Will Allen, Matt Peters, Rowan Jacobsen, *Outside Magazine*, Brooke Kanani, Blundstone Boots, Steve Libonati, Costa Sunglasses, Joe Gugino, Kayla Lindquist, WINGS WorldQuest, The Explorers Club, Scientific Exploration Society, Society of Women Geographers, and Physty and all of his rescuers.

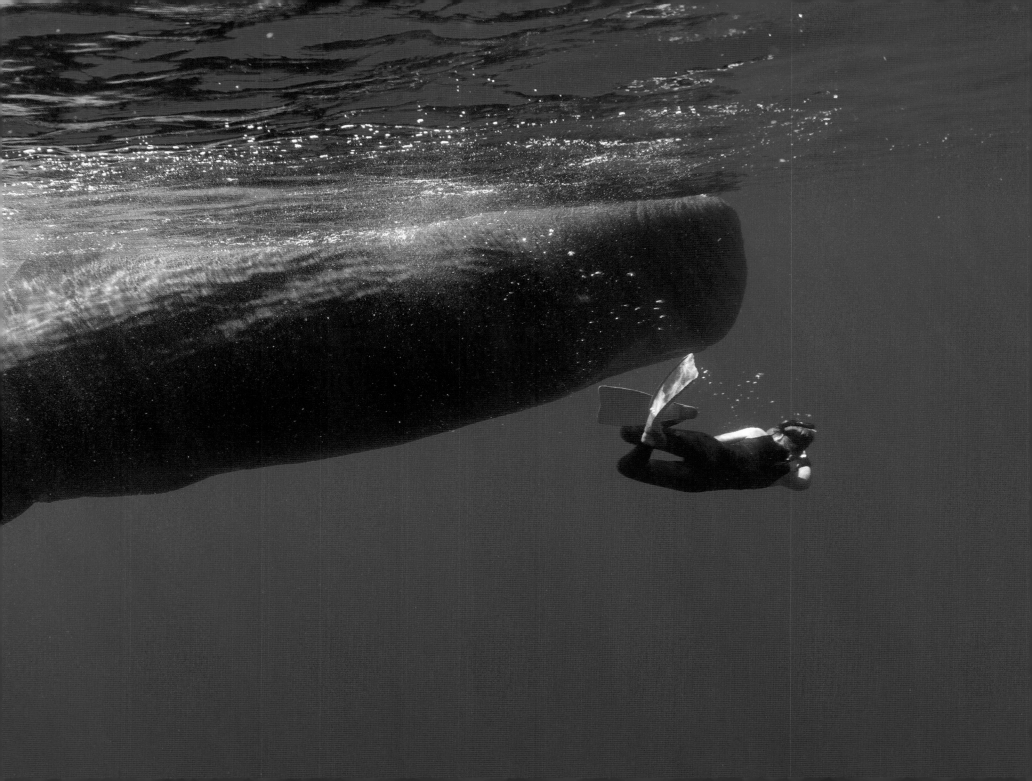

First published in the United States of America in 2022 by
Rizzoli International Publications, Inc.
300 Park Avenue South
New York, NY 10010
www.rizzoliusa.com

Publisher: Charles Miers
Associate Publisher: James Muschett
Managing Editor: Lynn Scrabis
Editor: Candice Fehrman
Design: Susi Oberhelman

Printed in China

2022 2023 2024 2025 / 10 9 8 7 6 5 4 3 2 1

ISBN: 978-0-8478-7232-9

Library of Congress Control Number: 2022933695

Visit us online:
Facebook.com/RizzoliNewYork
Twitter: @Rizzoli_Books
Instagram.com/RizzoliBooks
Pinterest.com/RizzoliBooks
Youtube.com/user/RizzoliNY
Issuu.com/Rizzoli

Global Ocean Exploration Inc. (GOE) is a company devoted to bringing cutting-edge expedition research science to the public through photography, writing, and film. The mission of GOE is to bring the work of current research expeditions into classrooms and homes around the world in real time, to organize our own expeditions focused on making connections between people and the marine resources they use in everyday life, and to create films that can be used to inspire people to share a passion for the ocean and our planet as a whole. For more information, please visit globaloceanexploration.com and gaelinrosenwaks.com.